Robert Frank HOLD STILL_keep going

Museum Folkwang, Essen
Museo Nacional Centro de Arte Reina Sofia, Madrid

Edited by Ute Eskildsen

Scalo Zurich—Berlin—New York

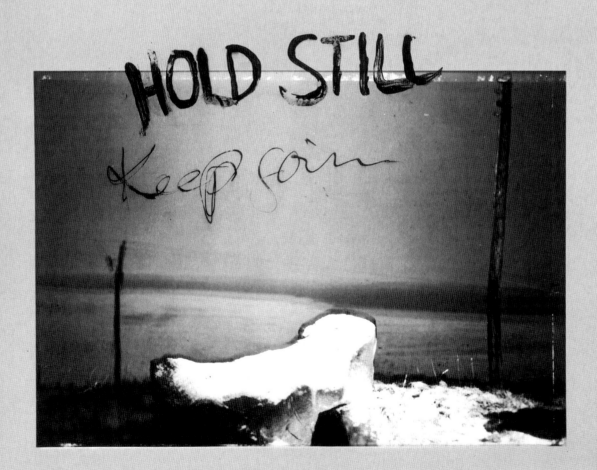

HOLD STILL ___ __ _ keep going

robert frank

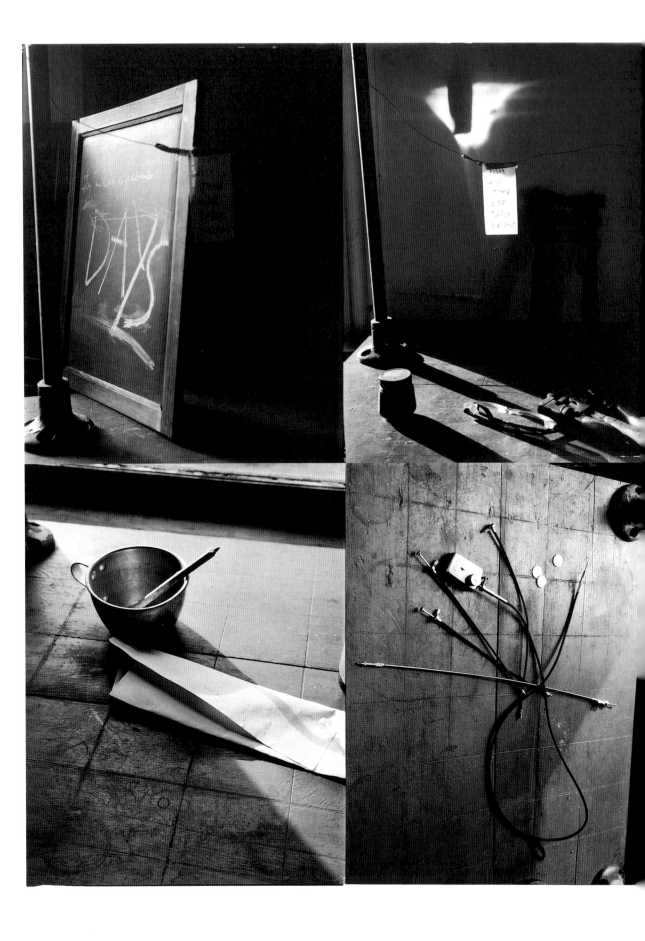

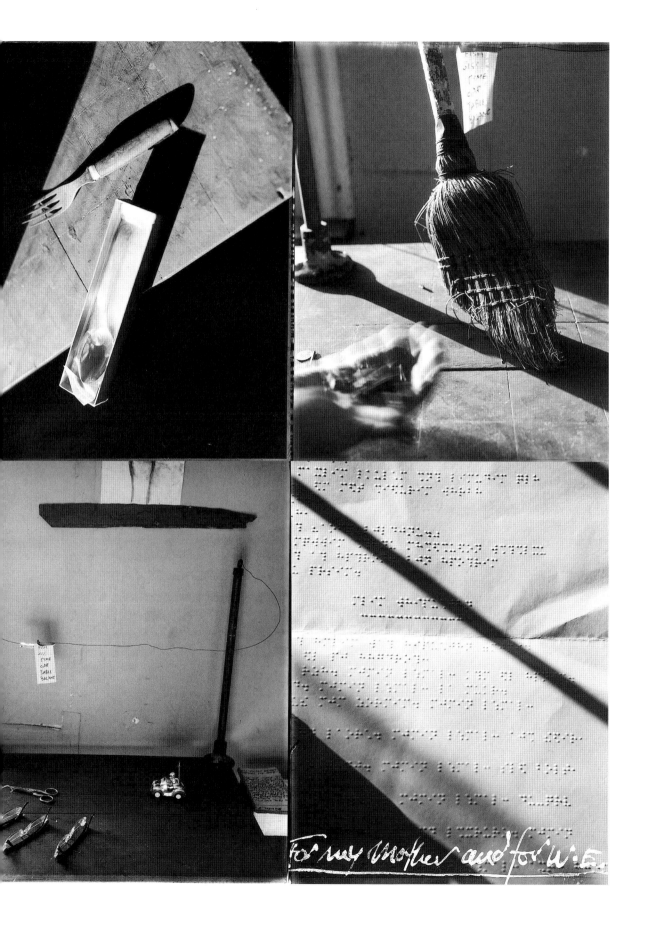

For my mother and for W.E.

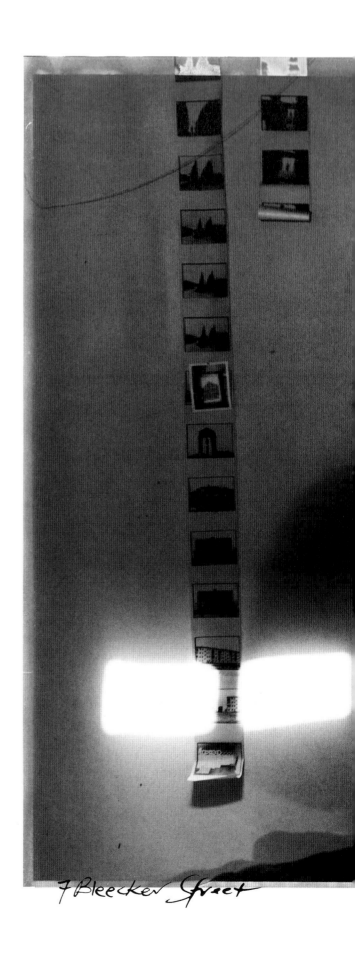

7 Bleecker Street

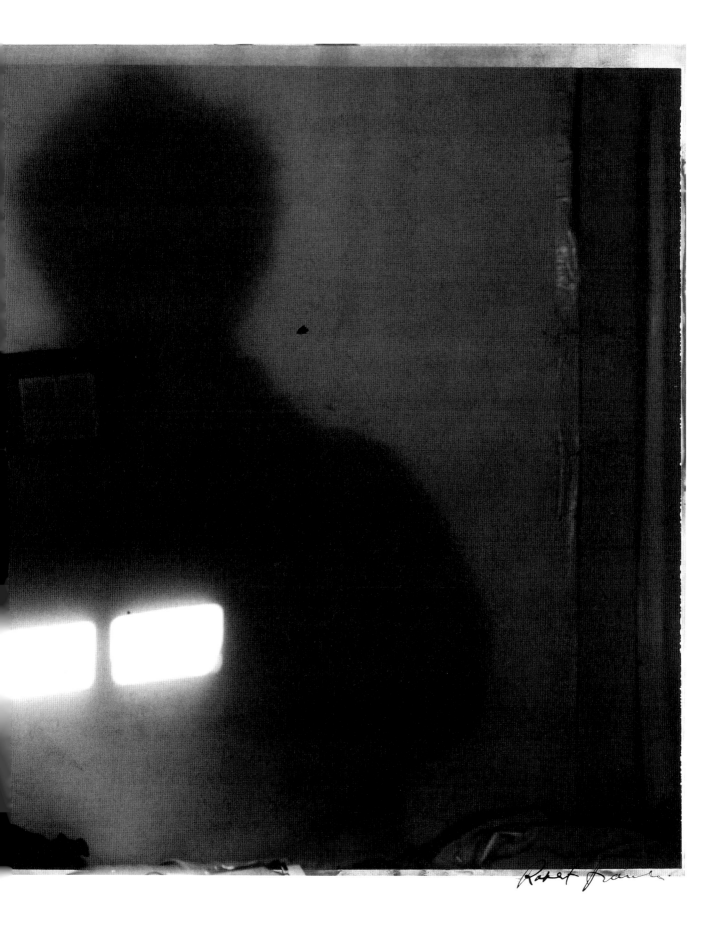

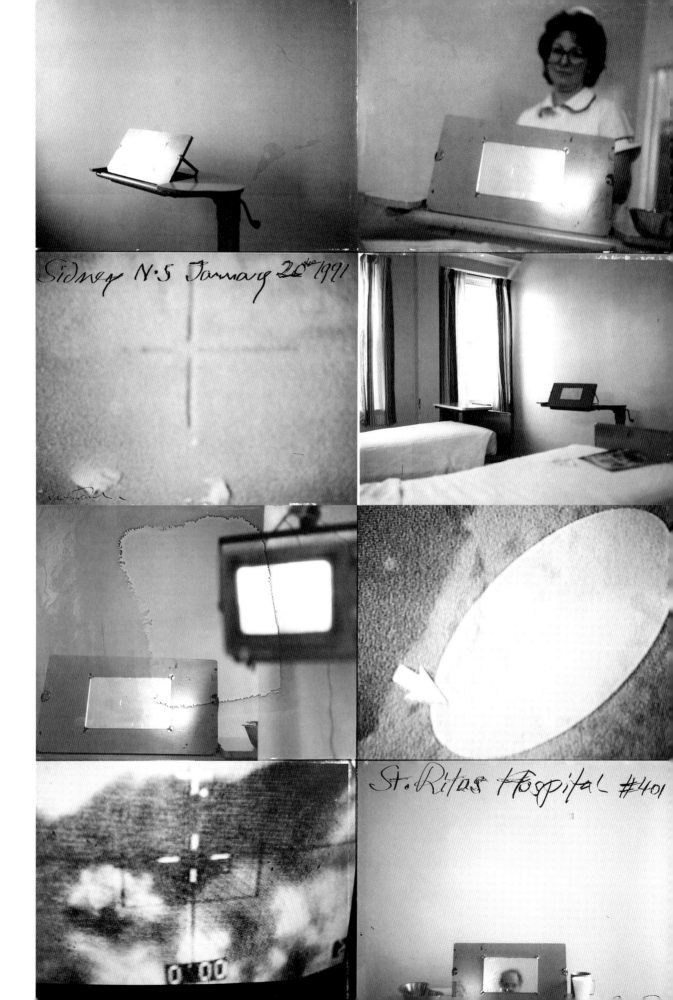

Sidney N.S January 20th 1991

St. Ritas Hospital #401

MEMORY OF DESTRUCTIO
CRUSHED STONES—STAIRS TO NOWH
ELEGANCE OF WHAT WAS.....
AMONGST THE RUBBLE OF THE POLICE
NEGATIVE A PORTRAIT OF SOMEO
WAR IS OVER A FOOT
ROCKS. A HAND PLAYS AN OLD C
POSTCARDS TO REMEMBER THE GO
A TORN FRAME FROM THE SHADOW
THE SKY CHANGES
PAINTED ON WALLS THE LEBAN

Beyrouth November 18

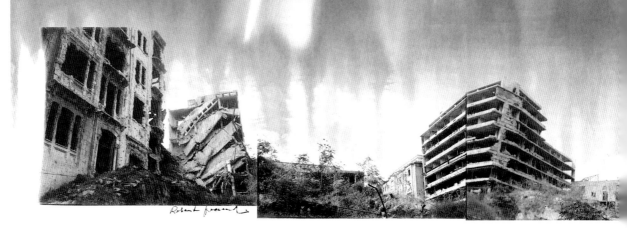

Robert Frank

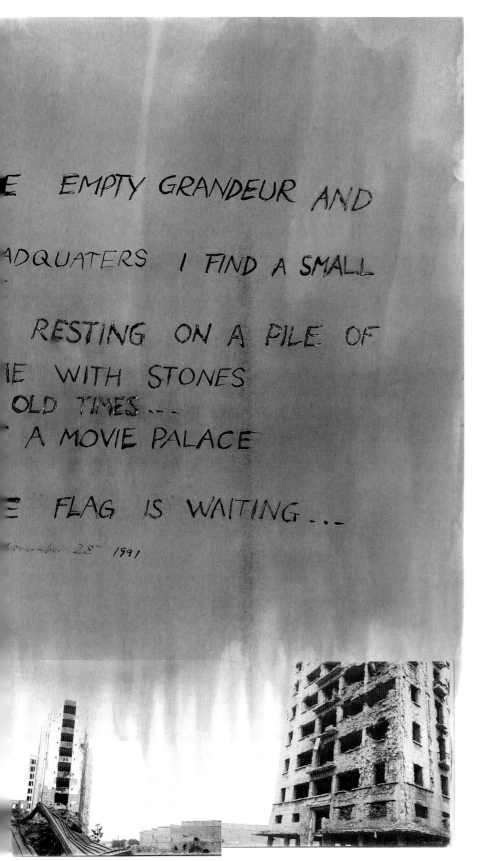

E EMPTY GRANDEUR AND

ADQUATERS I FIND A SMALL

RESTING ON A PILE OF

IE WITH STONES
OLD TIMES...
A MOVIE PALACE

E FLAG IS WAITING...

November 28ᵗ 1991

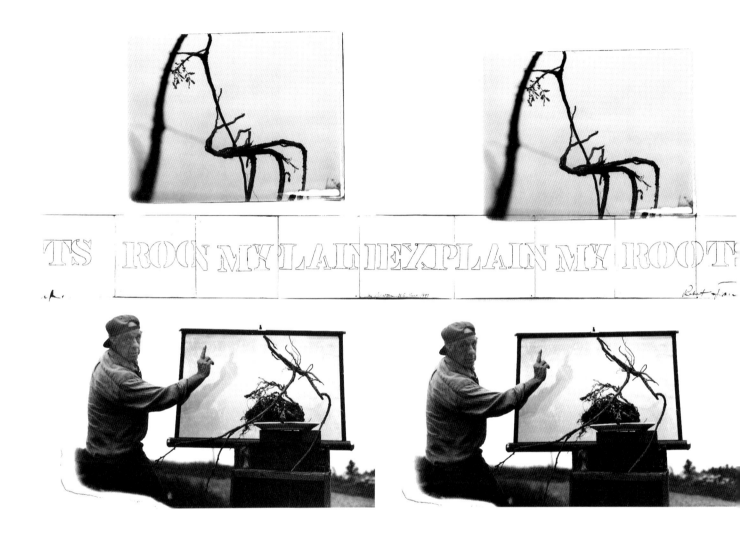

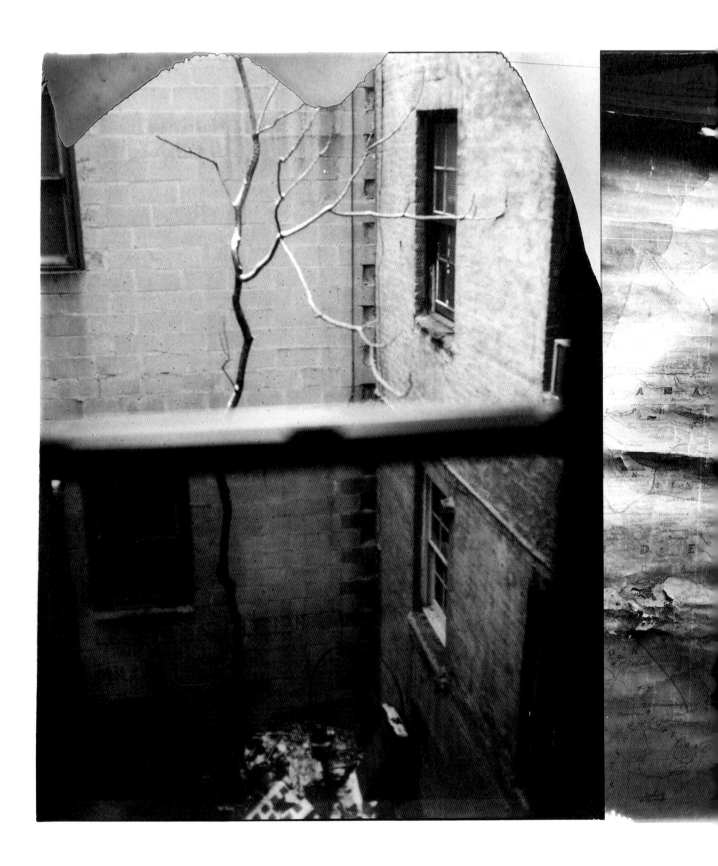

They will travel with

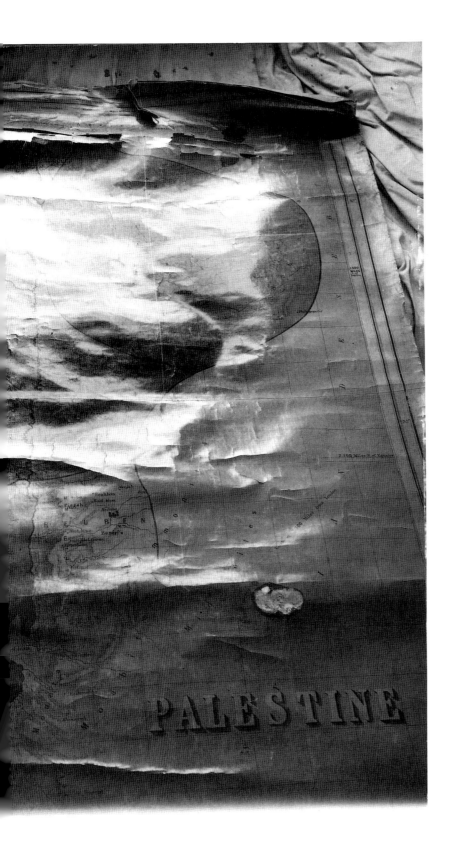

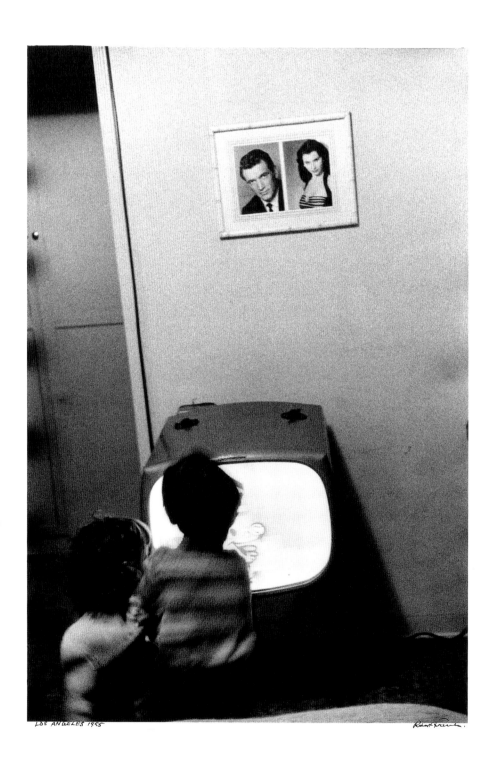

LOS ANGELES 1955

Robert Frank

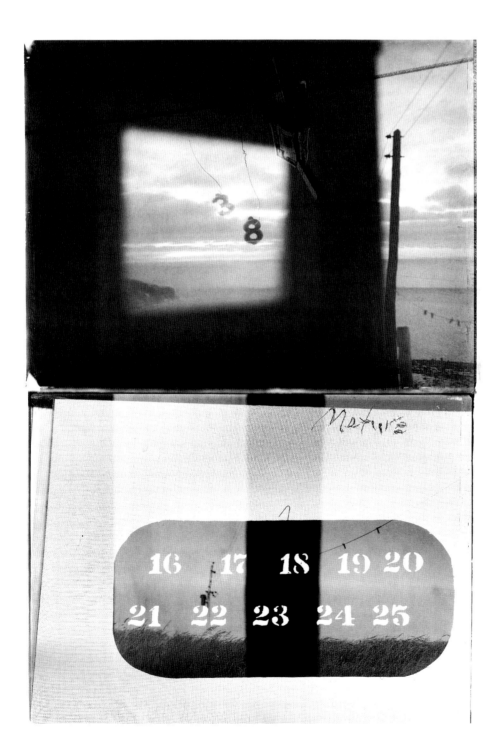

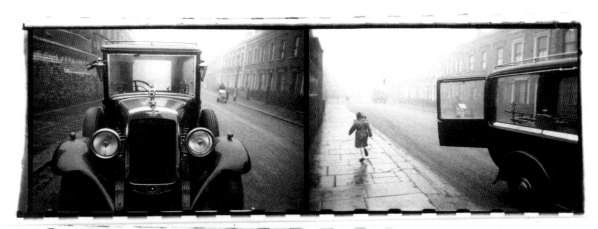

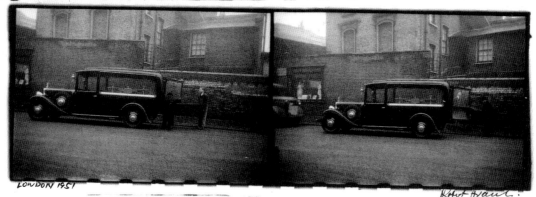

LONDON 1951

Robert Frank

Port Gibson Mississippi Sept. 1955 in front of High-School

Kids: what are you doing here? are you from New York?
 Me: I am just taking pictures
Kids: why?
 Me: for myself - just to see
Kids: he must be a communist - he looks like one
why don't you go the other side of town and watch
the niggers play

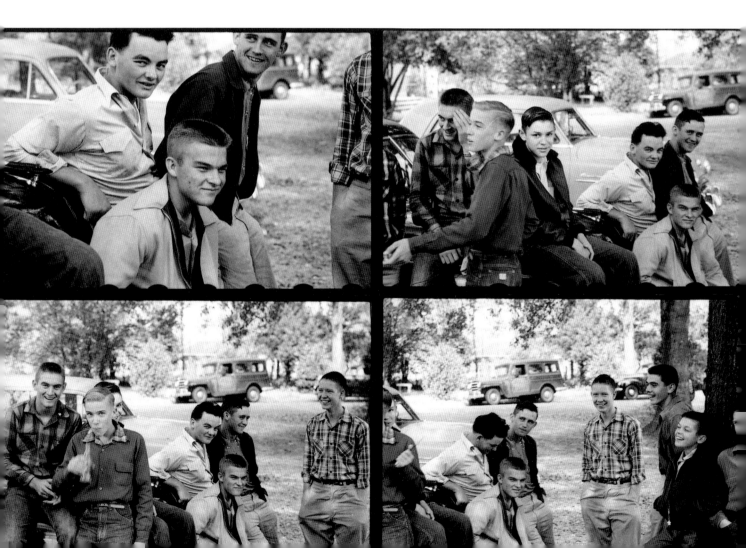

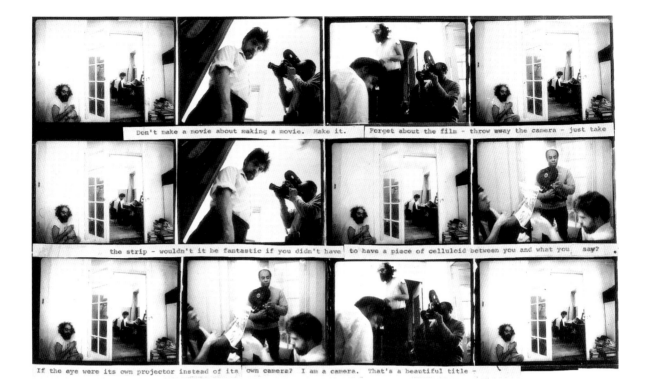

Don't make a movie about making a movie. Make it. Forget about the film - throw away the camera - just take

the strip - wouldn't it be fantastic if you didn't have to have a piece of celluloid between you and what you say?

If the eye were its own projector instead of its own camera? I am a camera. That's a beautiful title -

I mean where's your one to one relationship? That's what I want to know.

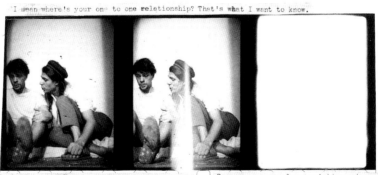

You're a creep. You are some Blackmailer. Wow! Because you are always watching privacy.

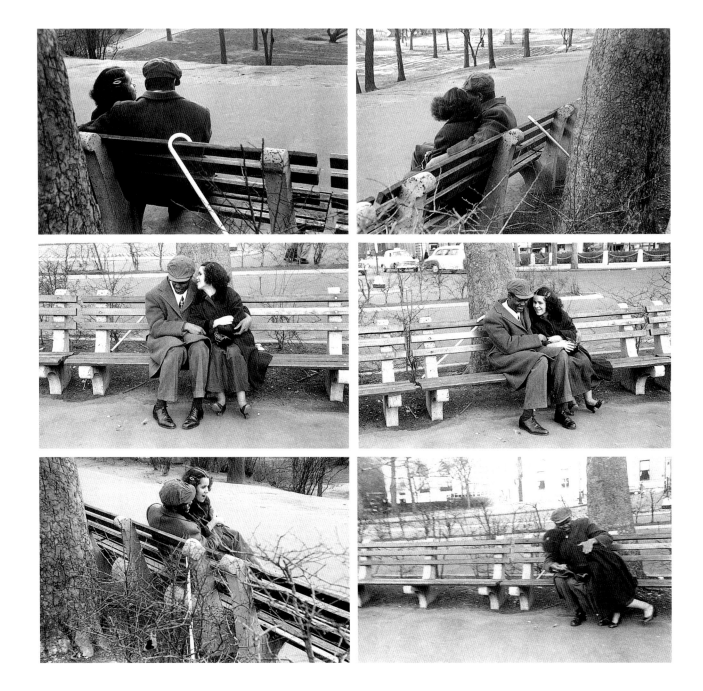

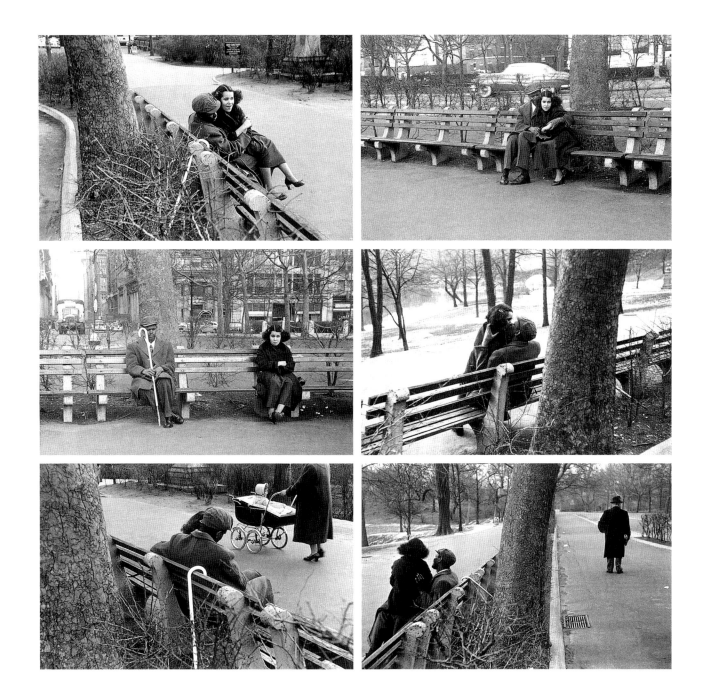

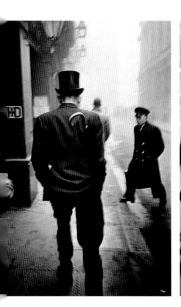
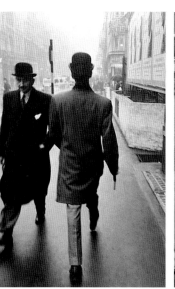
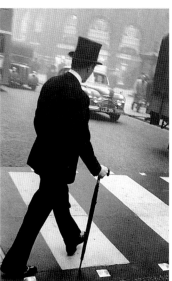
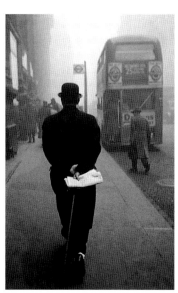

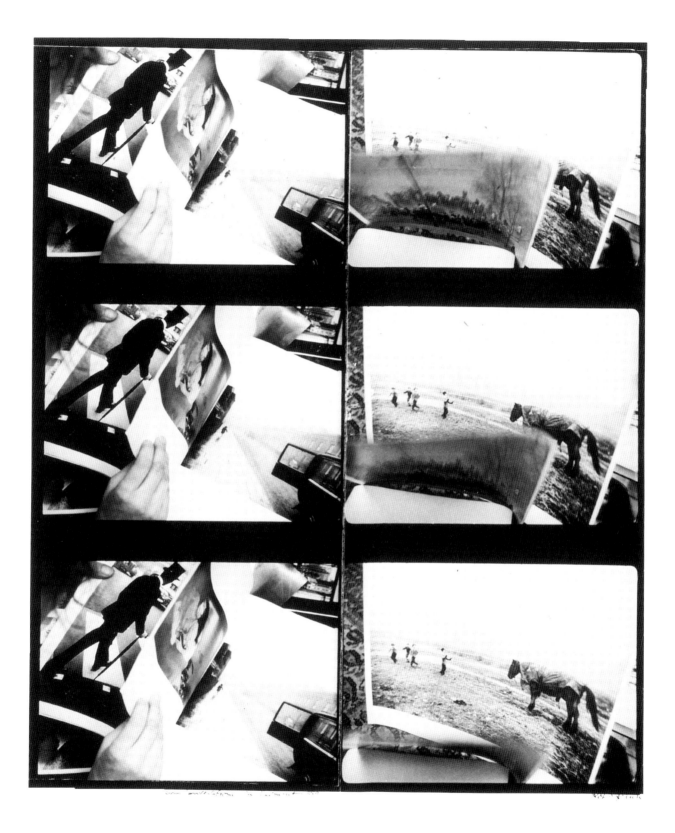

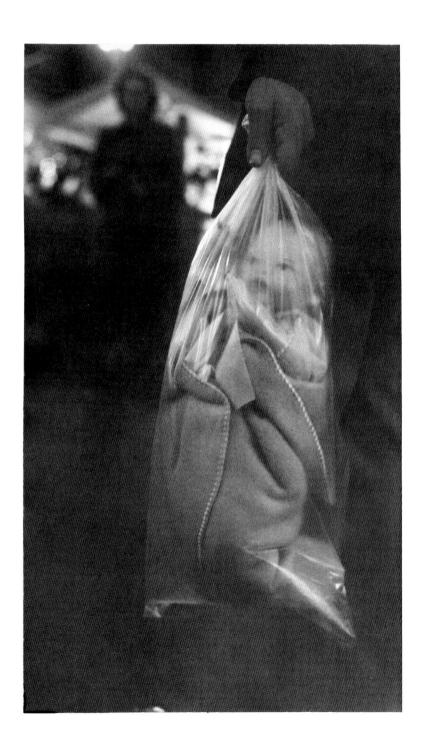

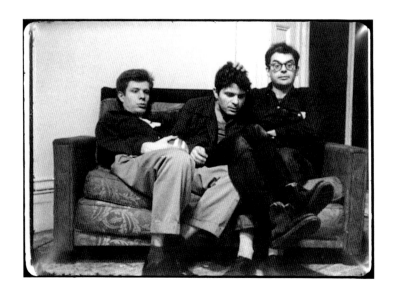

He says, Ah, shut up, I didn't do nothing, you know.
I didn't do nothing and it's not bad.
These are nice fellas.
They're just sitting -
now they're getting up and they're leaving.
I don't blame them for leaving.

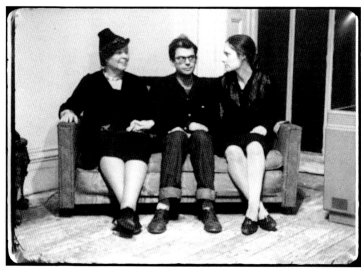

Hearing these people talk about holy,
I thought I would pretend
to play some little inspirational number.
Uh, darling (to her daughter),
she says, will you come and pump for me?

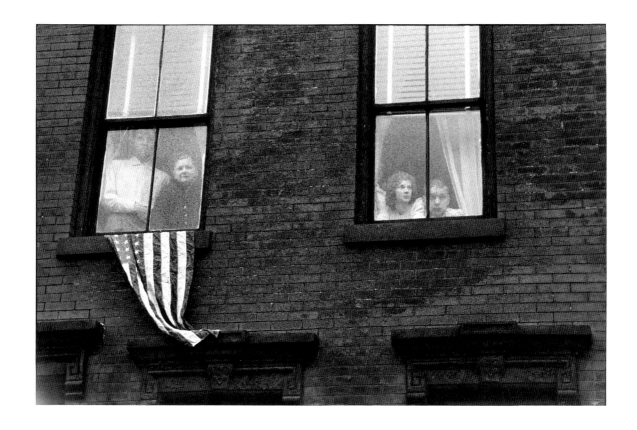

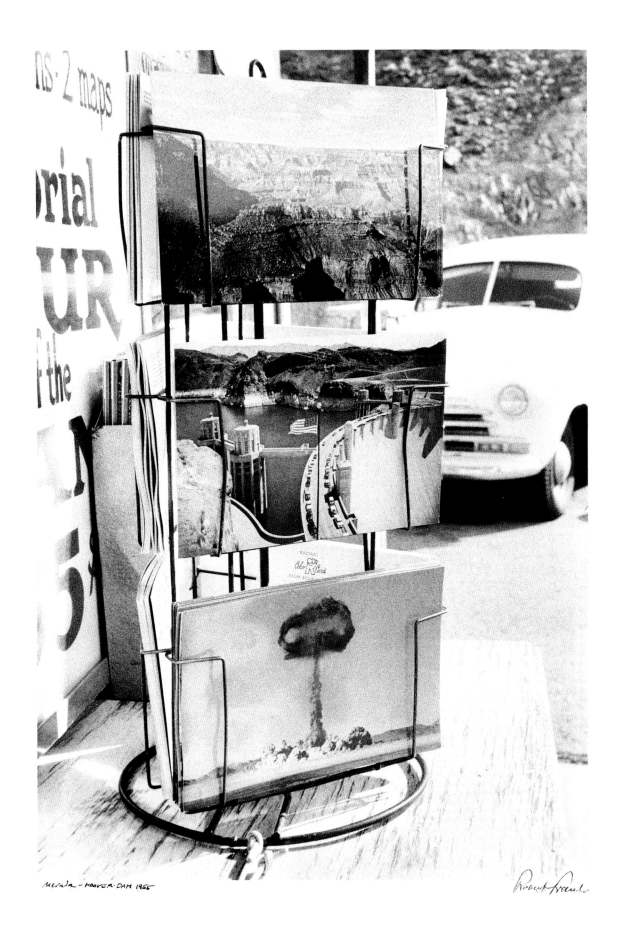

NEVADA - HOOVER-DAM 1955

Robert Frank

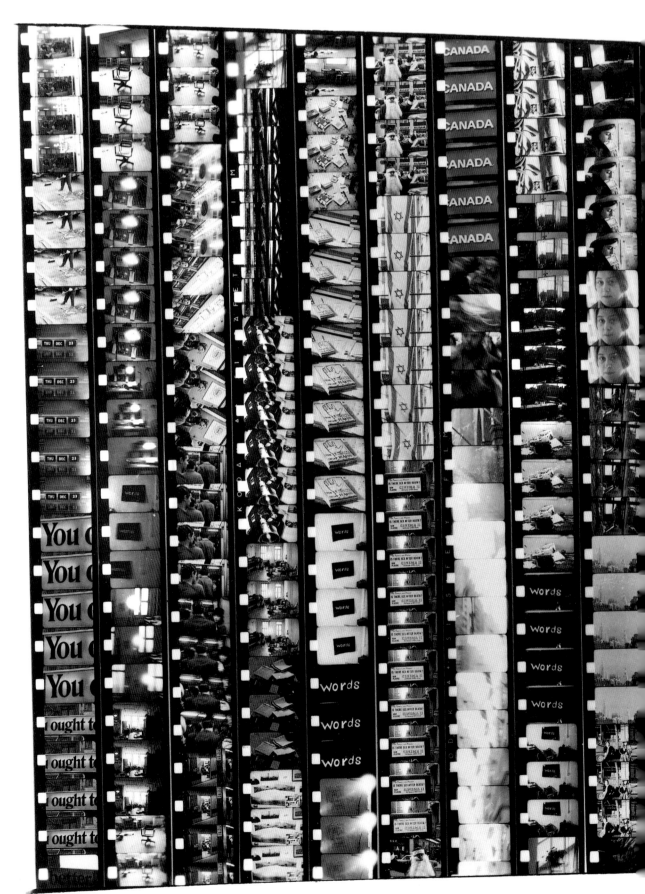

GOOD BYE MR BRODOVITCH I AM LEAVING NEW YORK DECEI

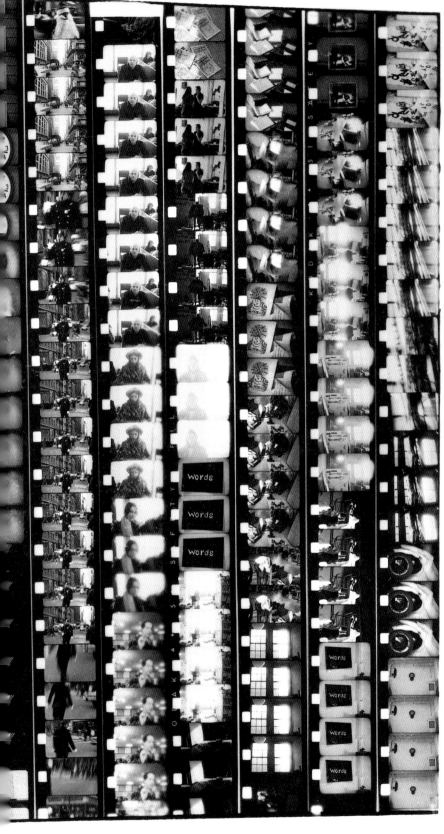

1971 Robert Frank

projector could do justice to his magnificent image small slides had to be enlarged to grand proportions where the modern manufromd works behind the sale disp other times he would save animals flowers and birk when lying on thraass waiting to be loweral shows the

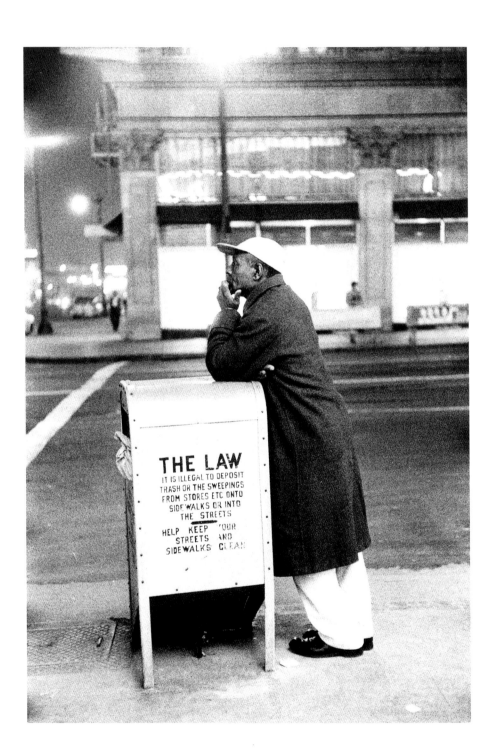

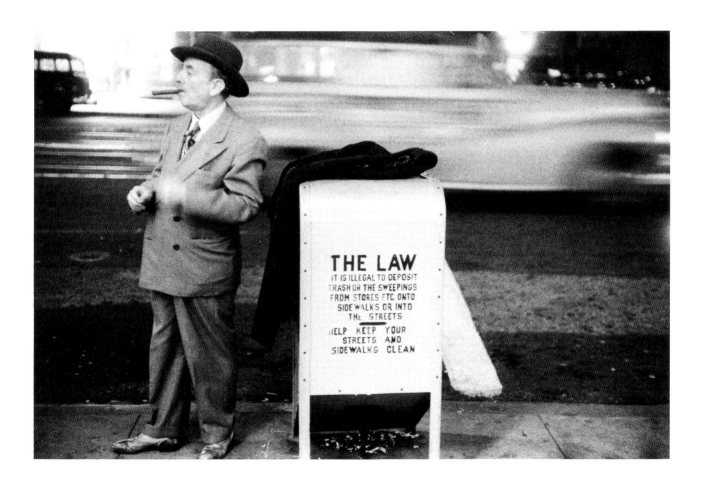

with Julius Orlovsky
and Joseph Chaiken

with Julius Orlovsky
and Joseph Chaiken

us Orlovsky
eph Chaiken

s Orlovsky
n Chaiken

Orlovsky
n Chaiken

Orlovsky
Chaiken

Orlovsky
Chaiken

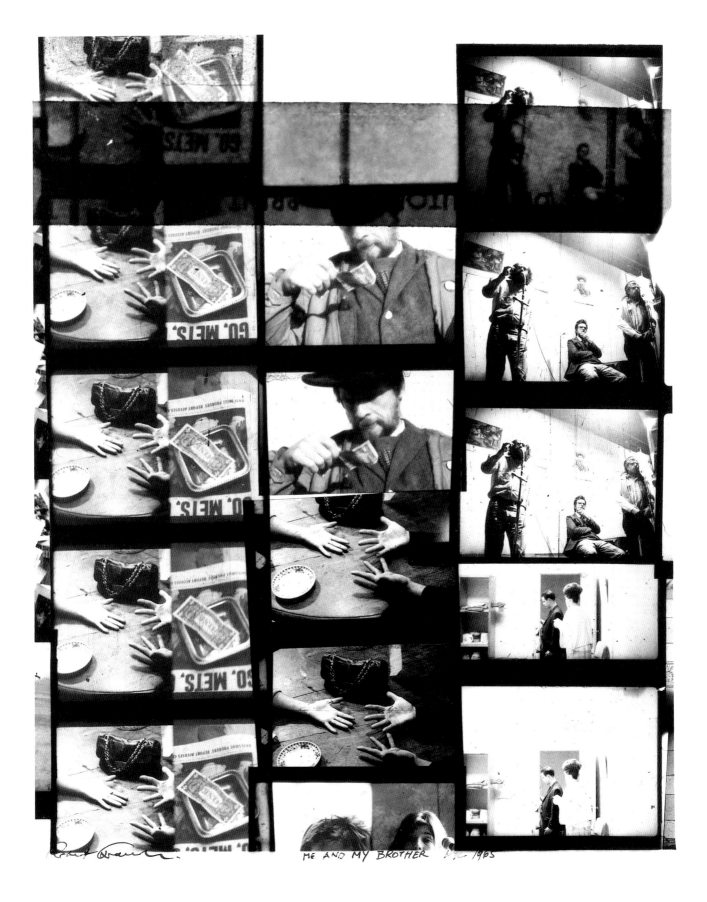

ME AND MY BROTHER NYC 1965

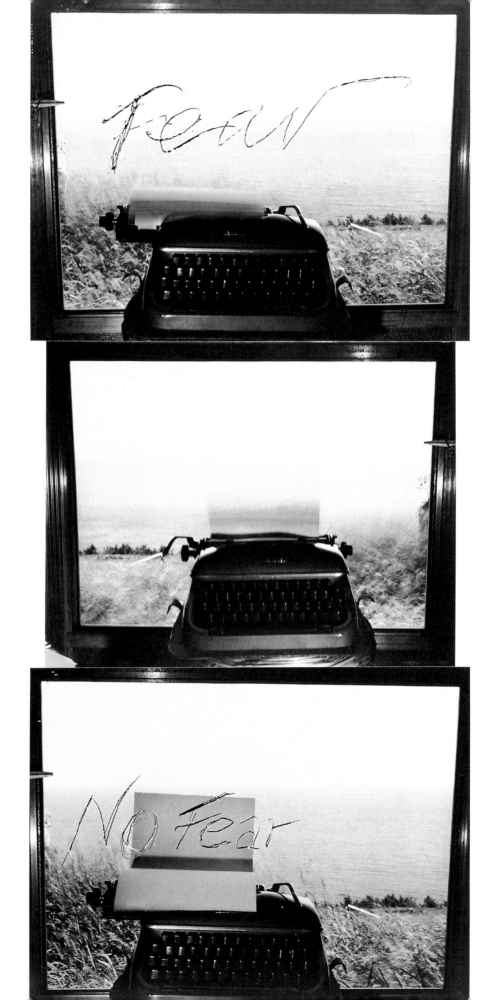

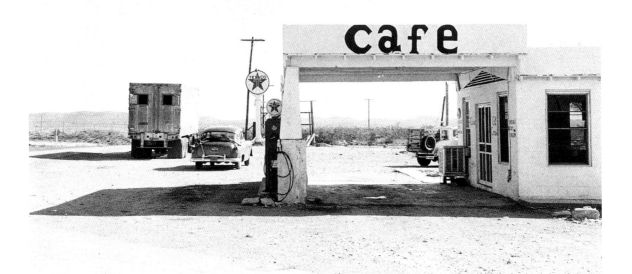

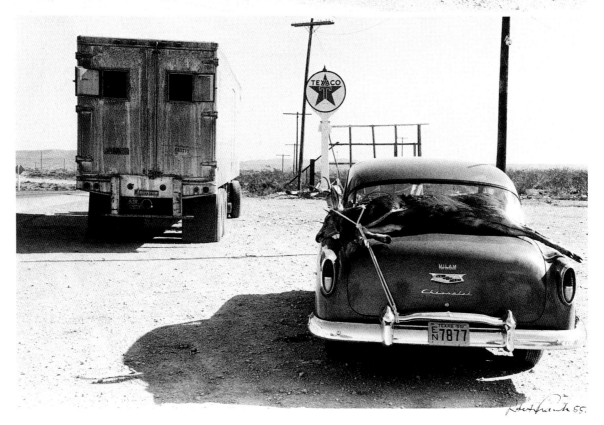

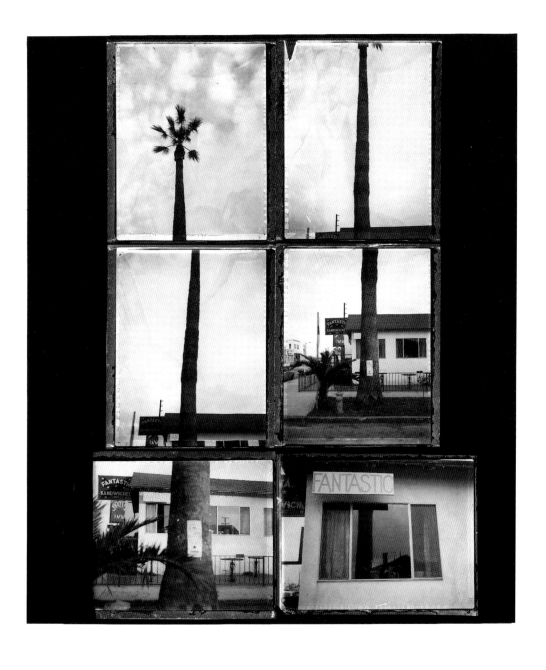

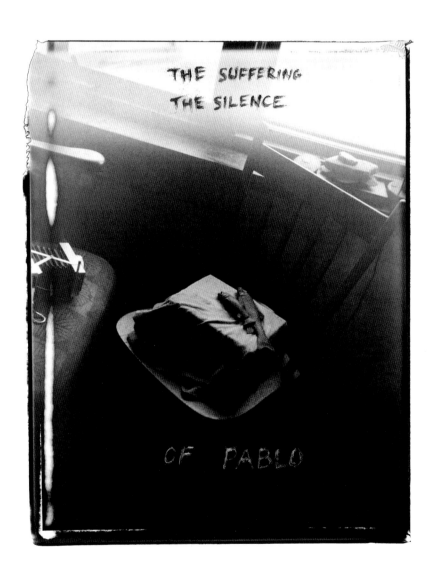

THE SUFFERING
THE SILENCE

OF PABLO

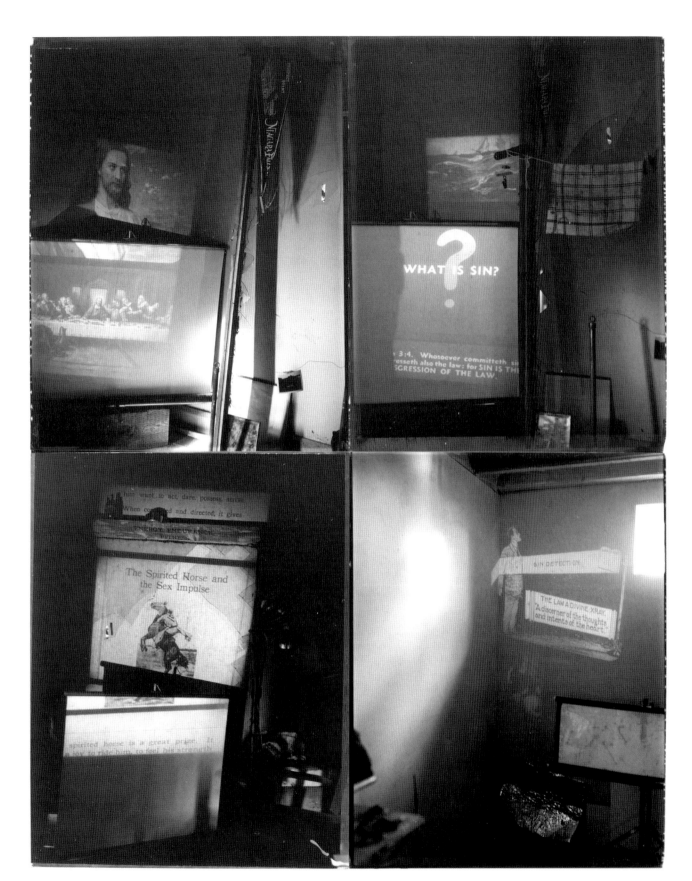

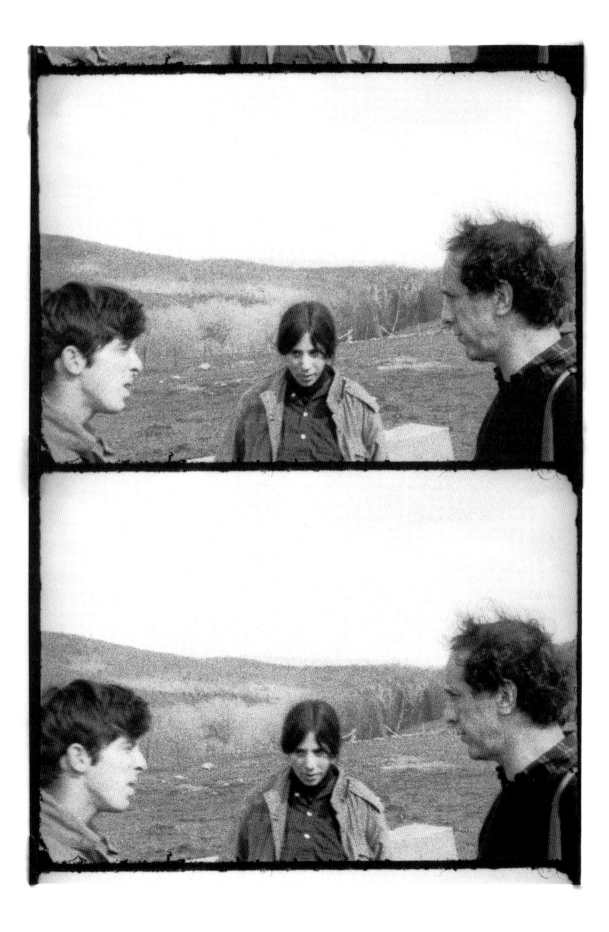

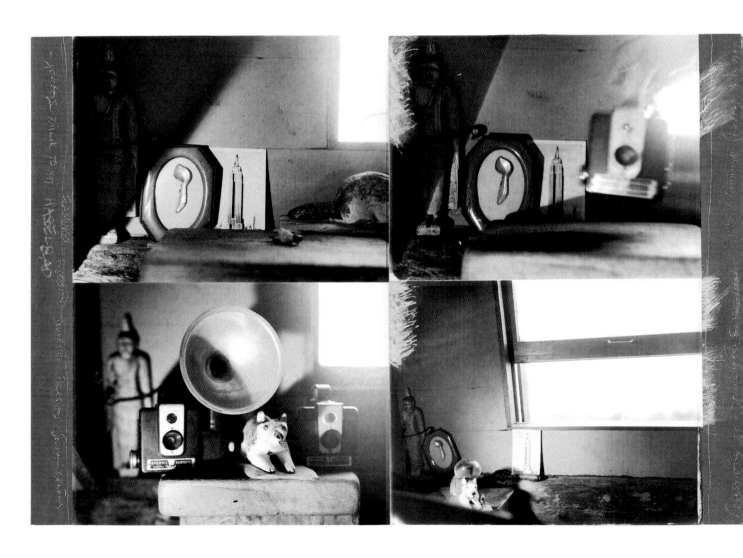

I remember (Stieglitz)
1998 Mabou

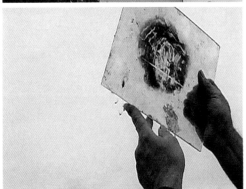

waiting for the sun to appear thru the clouds

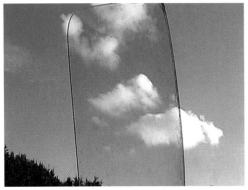

more photographs

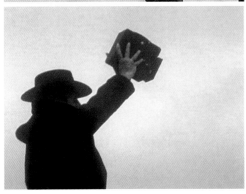

without saying a word he took my portrait

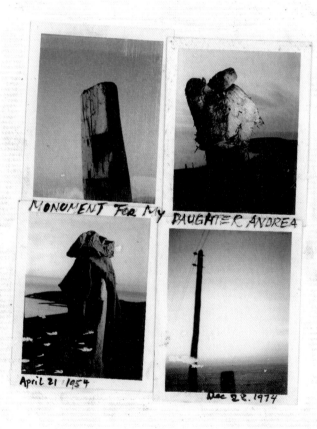

MONUMENT FOR MY DAUGHTER ANDREA

April 21 1954

Dec 22 1974

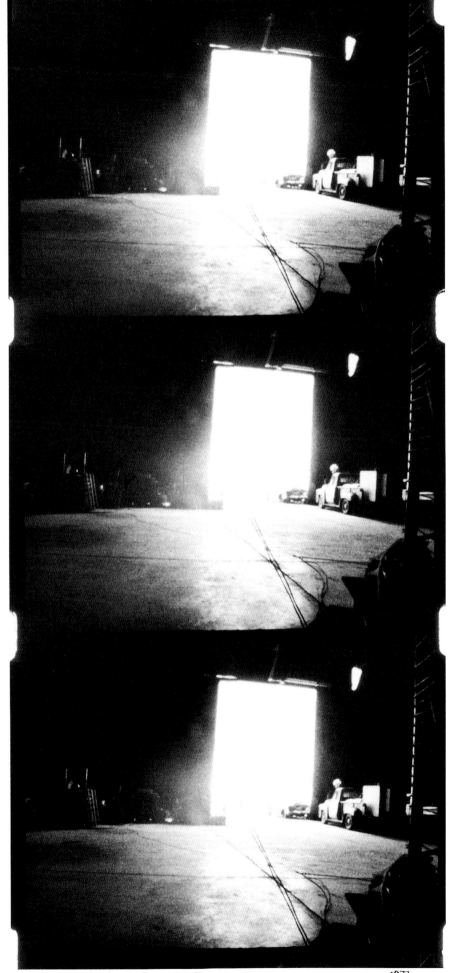

ENERGY AND HOW TO GET IT 1977

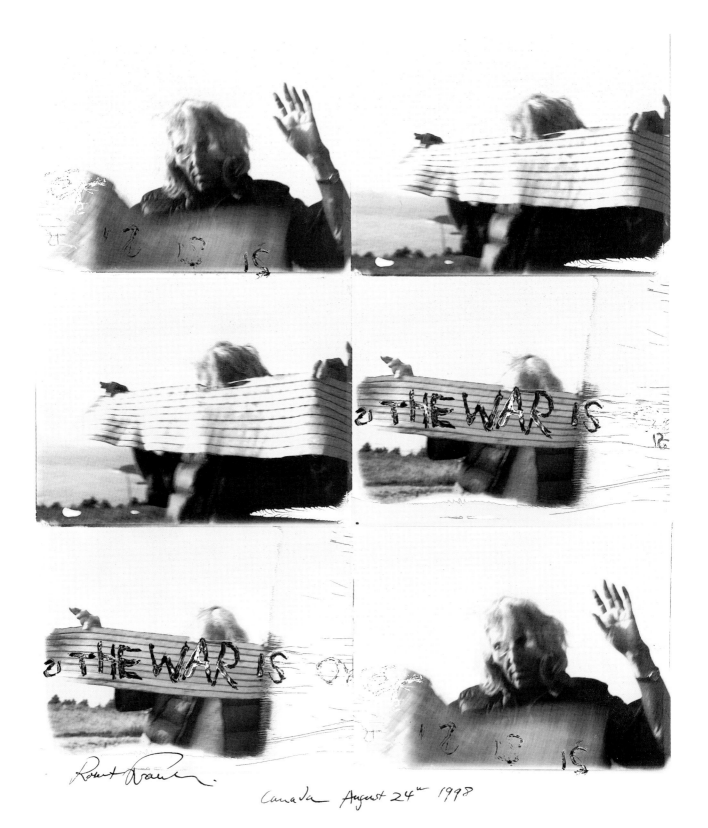

Robert Frank

Canada August 24th 1998

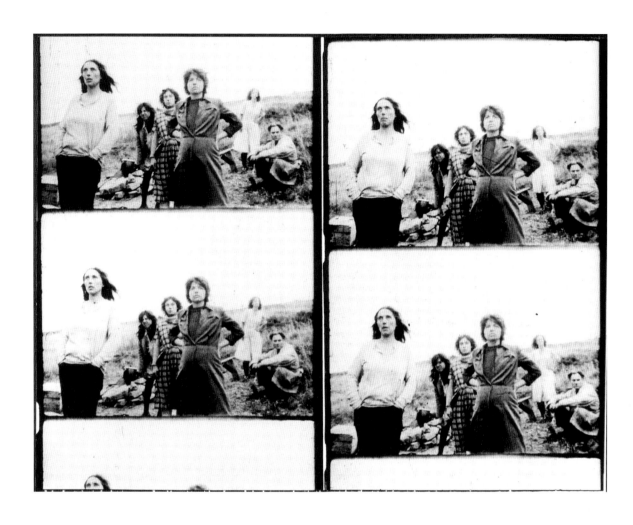

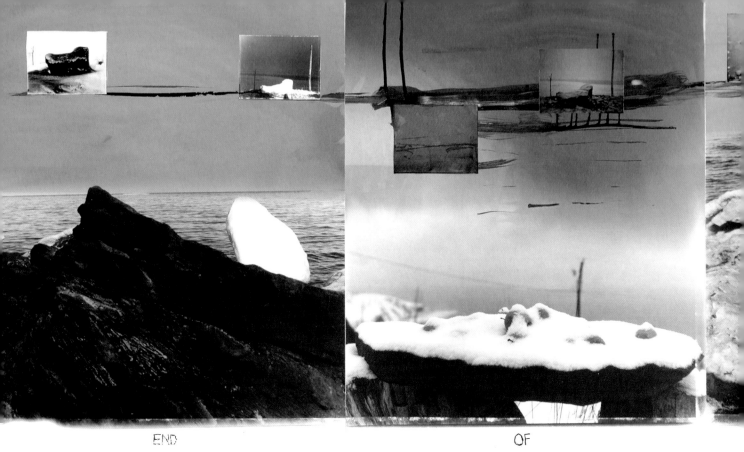

END OF

DREAM

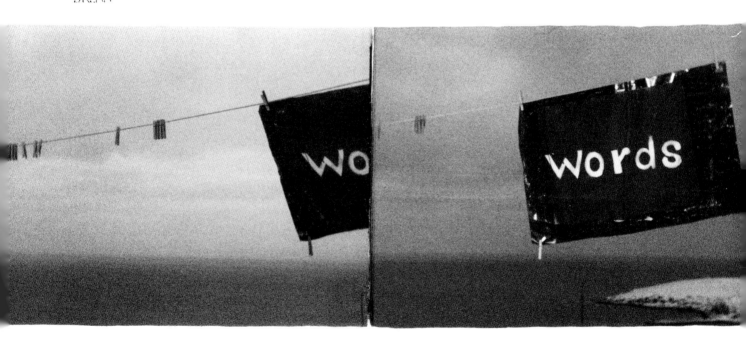

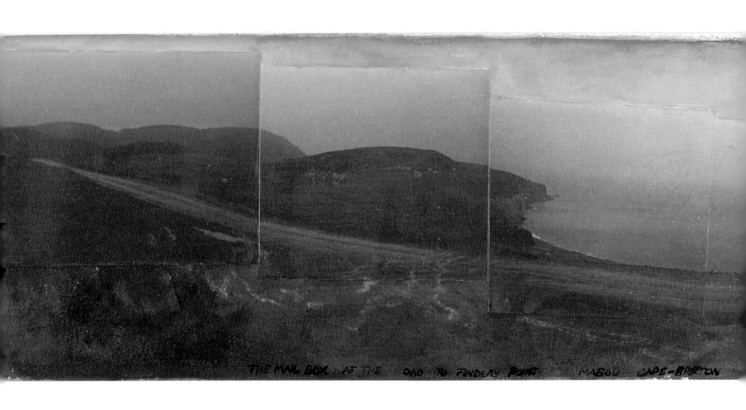
THE MAIL BOX AT THE ROAD TO FINDLAY POINT MABOU CAPE-BRETON

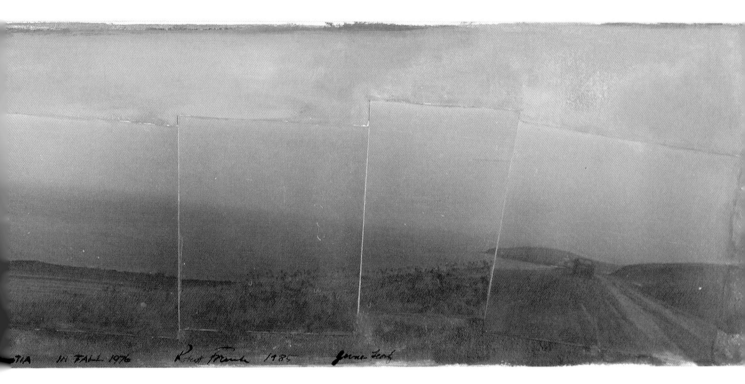

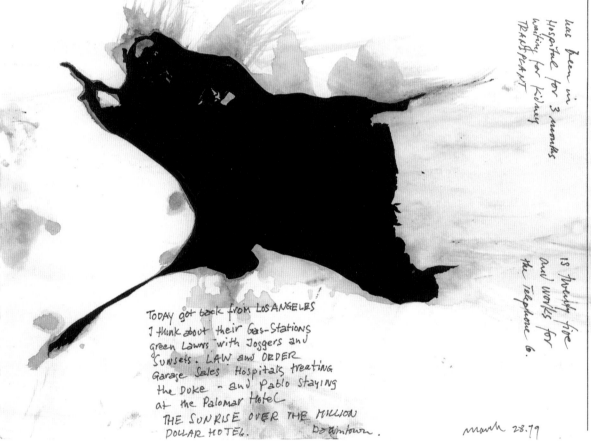

LILLIAN M. GUCCIARDI got married for the 3rd time
 to John R. KLUTE jr.
 10 years her Senior

SUZZY I. TUOMI

has been in
Hospital for 3 months
waiting for Kidney
TRANSPLANT

MICHAEL T. O'BRIEN

is thirty five
and works for
the Telephone Co.

TODAY got back from LOS ANGELES
I think about their Gas-Stations
Green Lawns with Joggers and
Sunsets. LAW and ORDER
Garage Sales Hospitals treating
the Duke - and Pablo staying
at the Palomar Hotel
 THE SUNRISE OVER THE MILLION
DOLLAR HOTEL. Downtown.

march 28.79

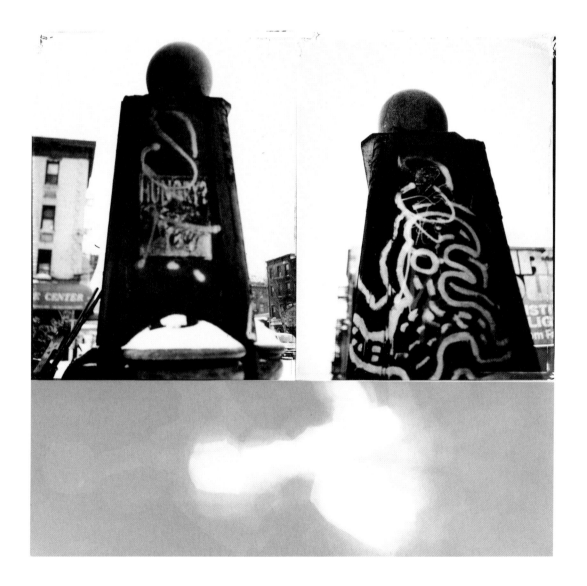

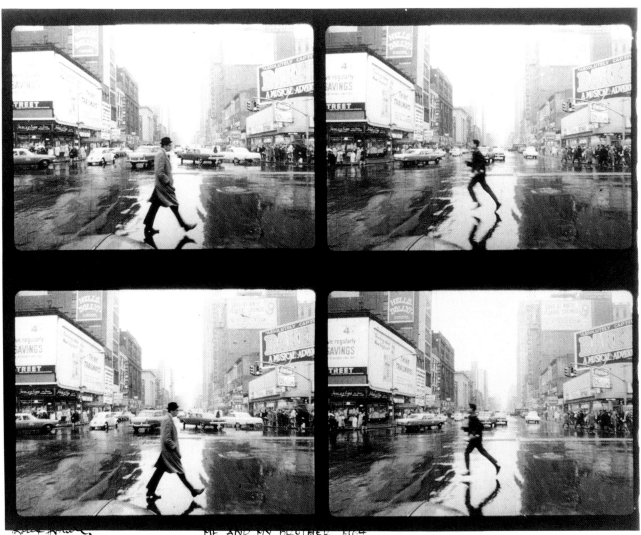

ME AND MY BROTHER 1964

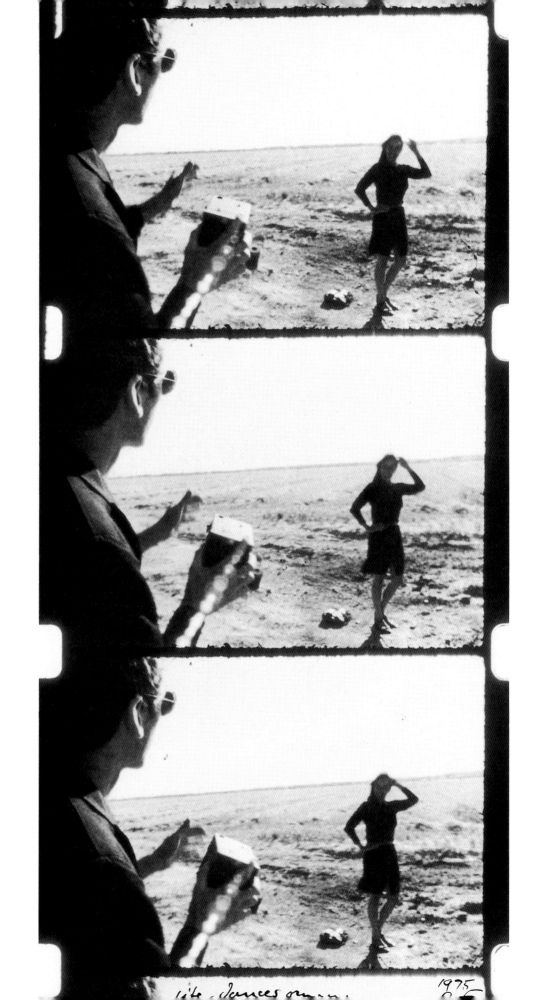

life dances on... 1975

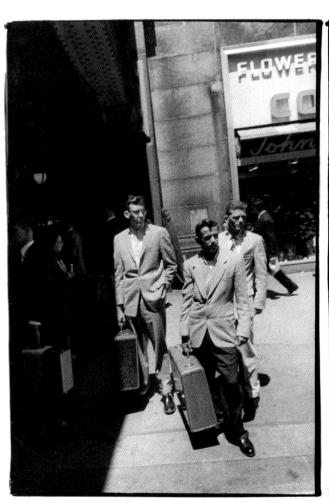

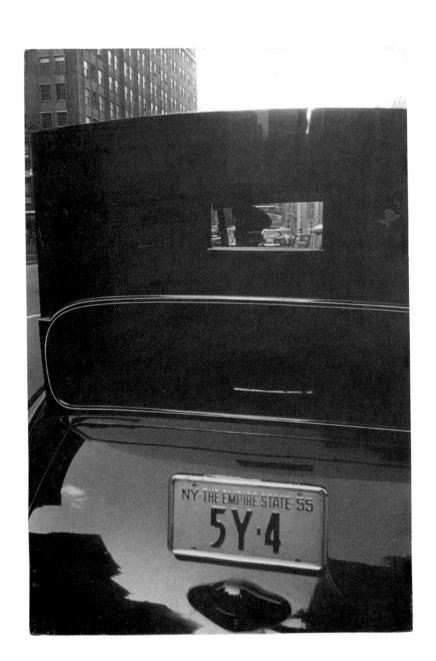

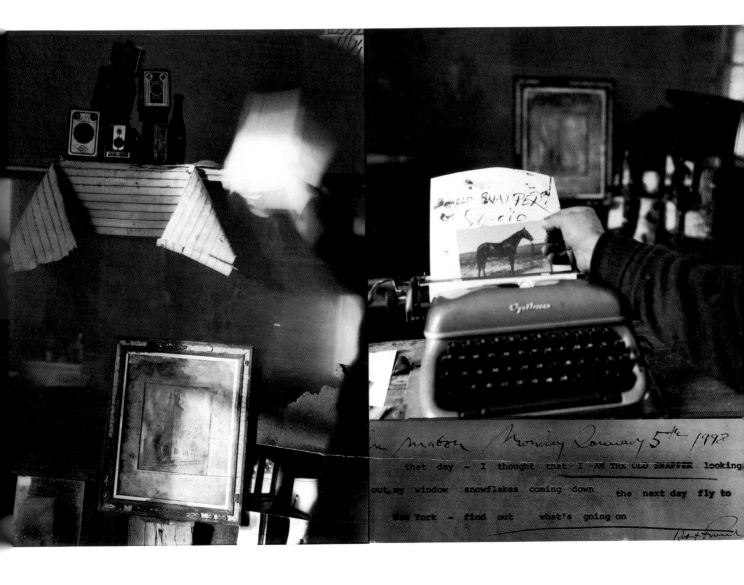

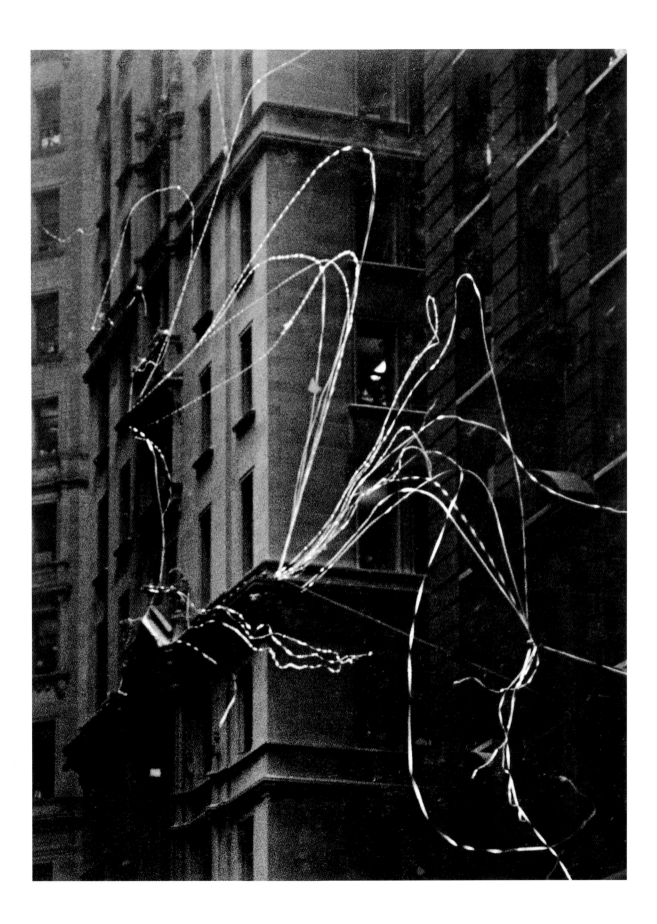

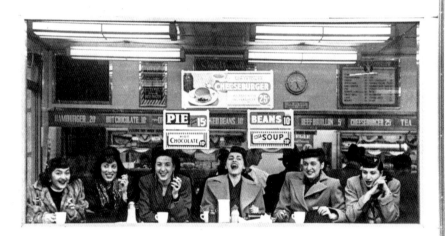

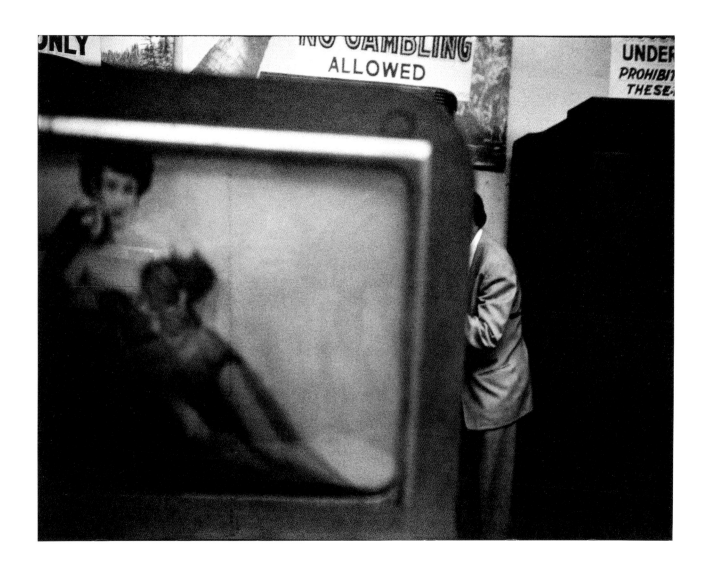

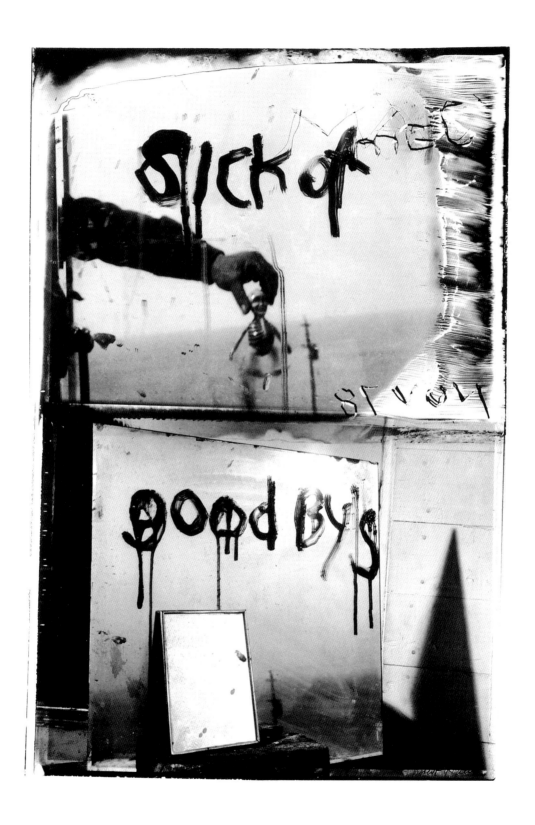

Washington D.C. 1957

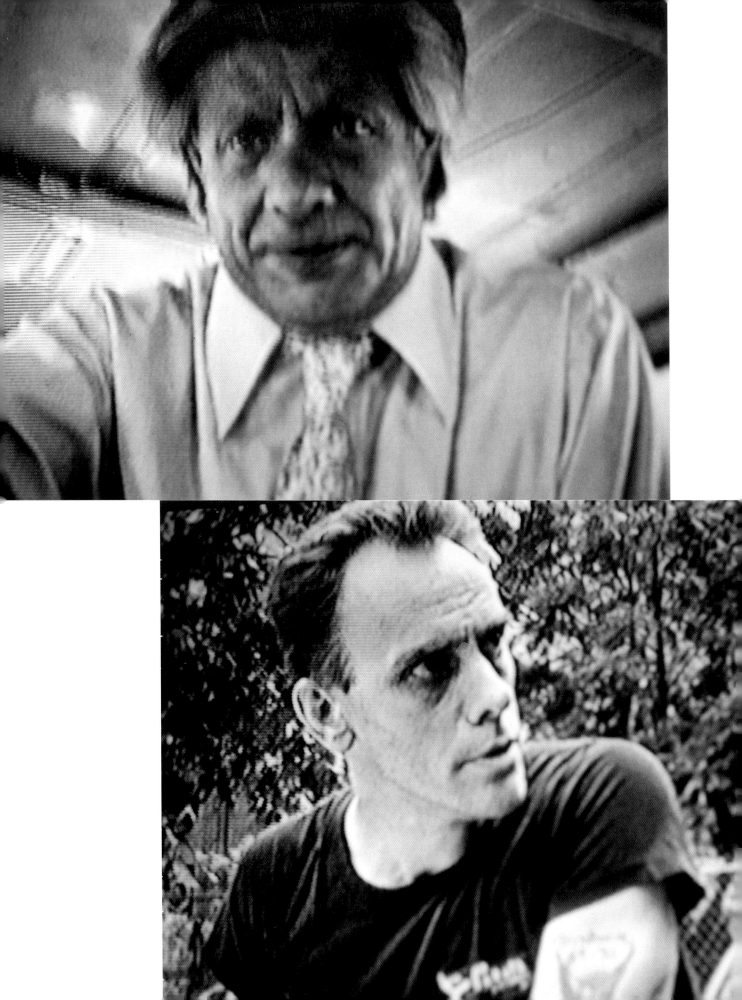

I didn't say anything nasty or
anything.

You criticize her?

No. I just kidded her about
something. I never like... I
swear to God.

Hey! Anybody got any money? Anybody
got any money? Five cents? One penny? Two
cents? One penny? Two pennies? Two pen-
nies? Four pennies? Anybody got a penny?

No! I'll remind you.

Be careful. There's a lot of nuts out there.

(Peter singing opera)

Alright I'll change a tune. Where the deer
and the antelope do. Oh, Home on range.
Where the buffalo and the antelope grow.

A discouraging word. Where
the deer and the antelope
roam.

Oh, here's a policeman. I better sit down.
I'm gonna get in trouble now.
I think I'm under arrest. Mommy! Mommy!
There's a policeman coming for me.
Ha! I didn't do nothing!

Be quiet.

Oy God. Oy vey! Oy vey!
Oy vey! Oy vey! Oy! Oy vey!
Ha! Ha! Ha!
Mommy!

Mommy! Ma! What? 23rd?
Oh my God!
We've got to go back!

Ah. Ha. Mamma!

OK, Peter!

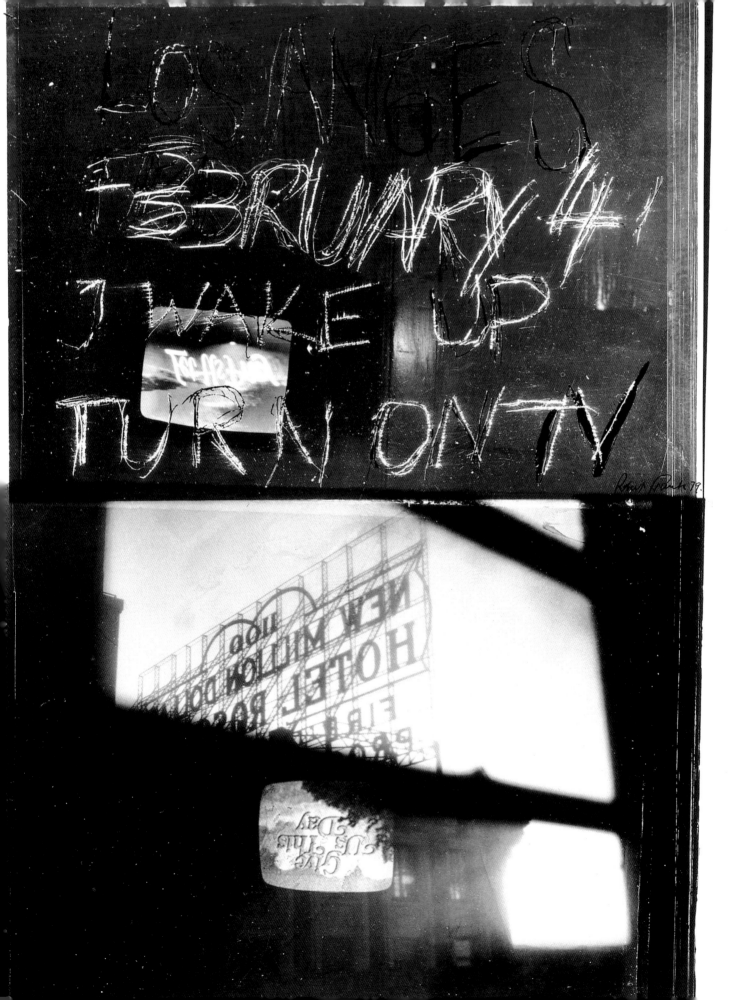

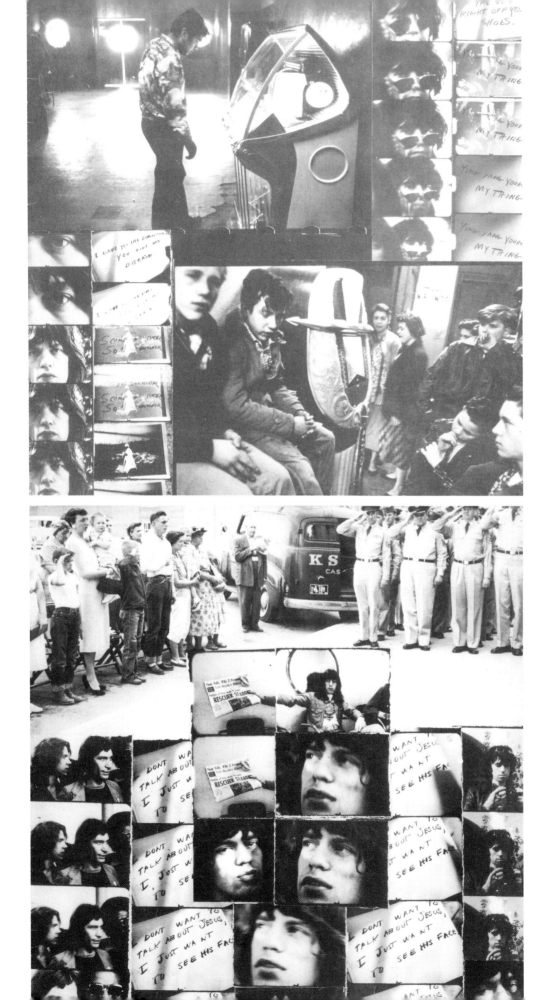

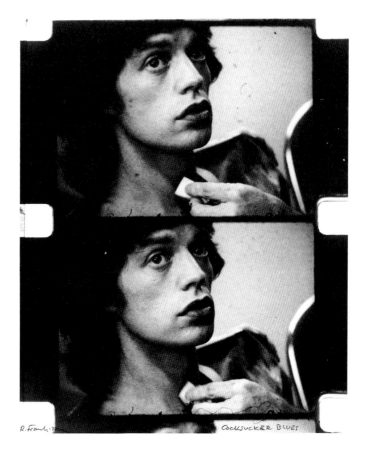

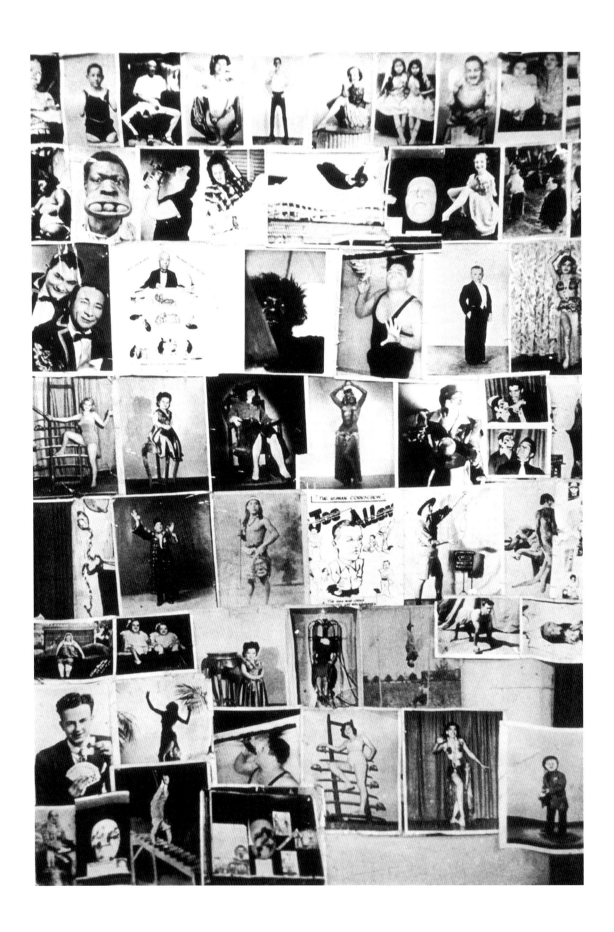

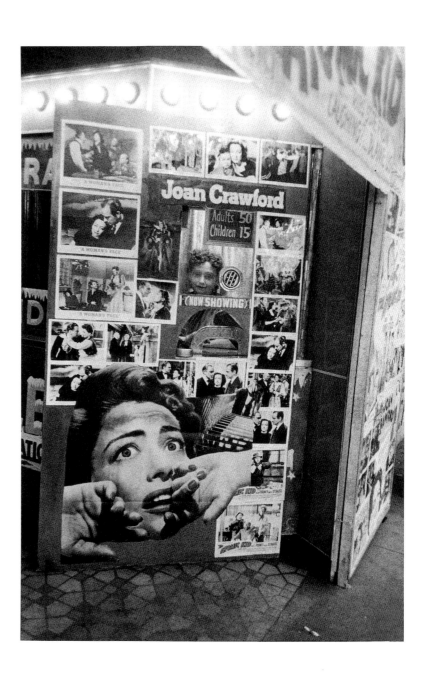

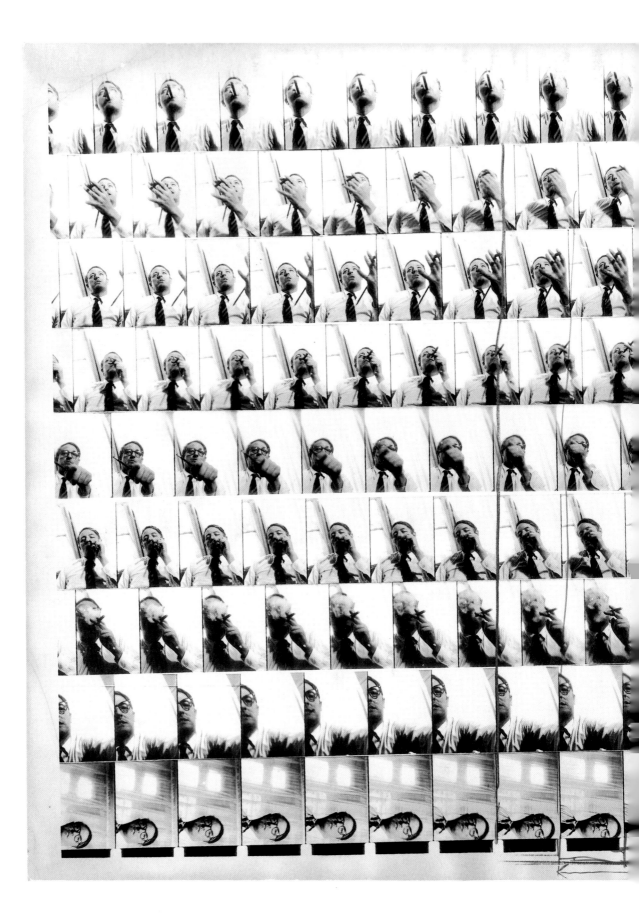

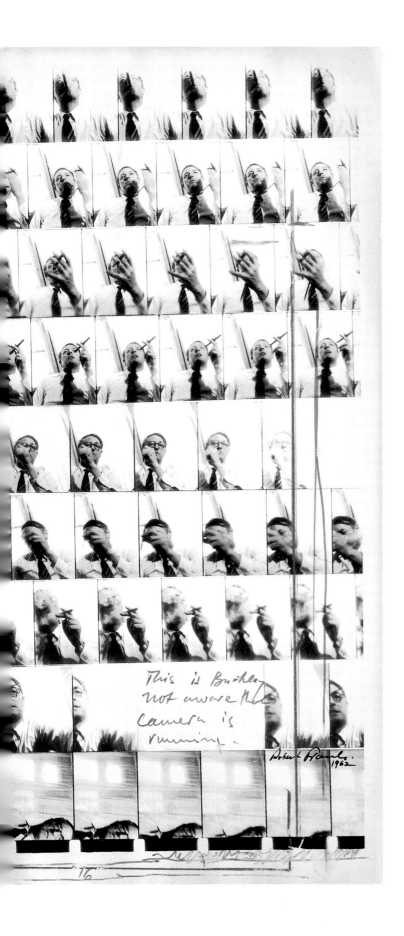

This is Buckley
not aware that
camera is
running.

Robert Frank.
1962

16

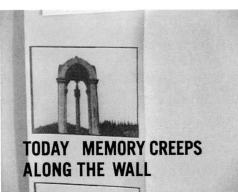

TODAY MEMORY CREEPS
ALONG THE WALL

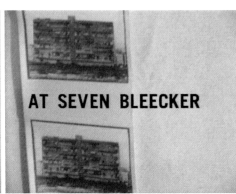

AT SEVEN BLEECKER

IN THE B
OF MY E

IN THE BACK
OF MY EYES

OUTSIDE SOMEONE
IS YELLING ROBERT!

COME WITH ME FOR
MOVING PICTURES

**LONGINGS
AND OBSESSIONS**

**OUTSIDE SOMEONE
IS YELLING ROBERT!**

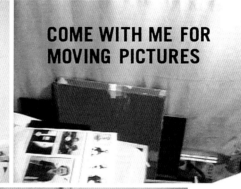

**COME WITH ME FOR
MOVING PICTURES**

**Y MEMORY CREEPS
IG THE WALL**

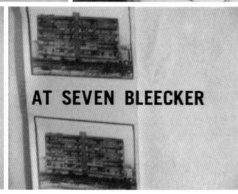

AT SEVEN BLEECKER

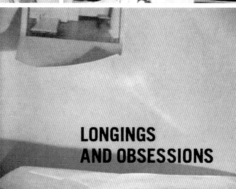

**LONGINGS
AND OBSESSIONS**

Zusammen laufen die Wörter und die Bilder

Ich habe eine Obsession für Fragmente in meinem Leben
diese enthüllen und verbergen die Wahrheit

ohne Ton

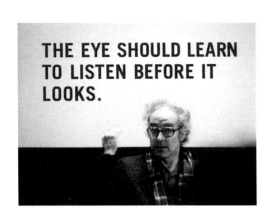

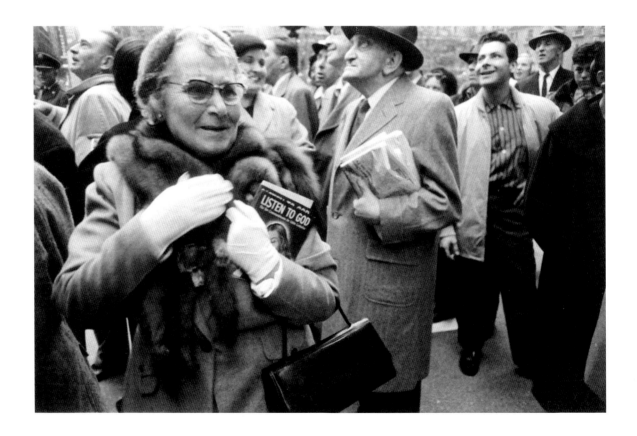

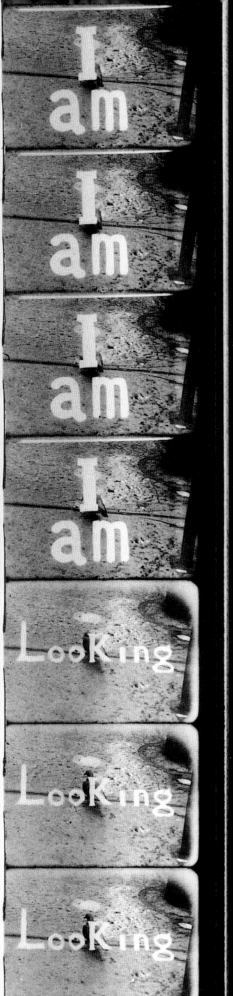
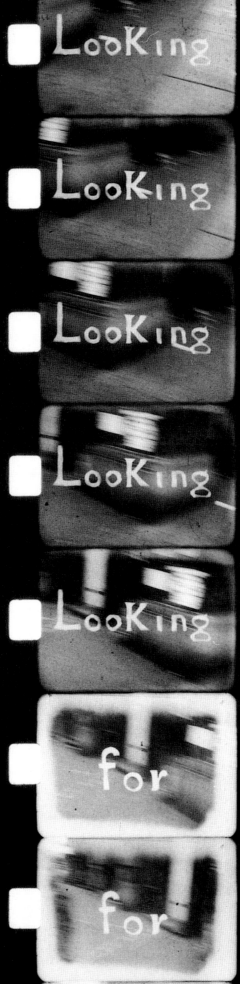
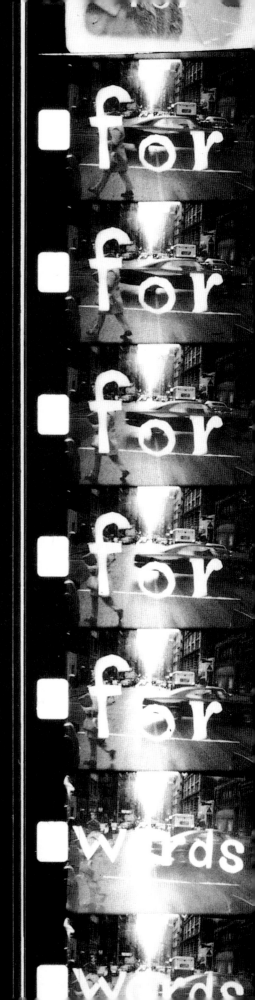

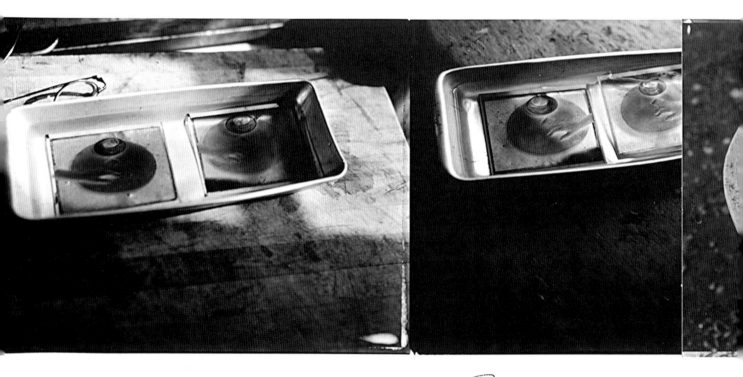

Water . two black and white Polaroid negativs in a
Saucer from Montreal Prison two Stones inside
one negativ is sharp the other is not it is September

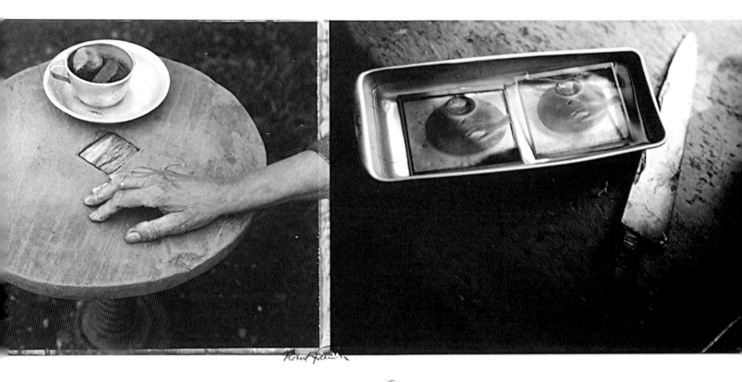

ay June's hand resting on Stone table next to cup an
cup the knife from Japan the glasses are mine
2nd 1996

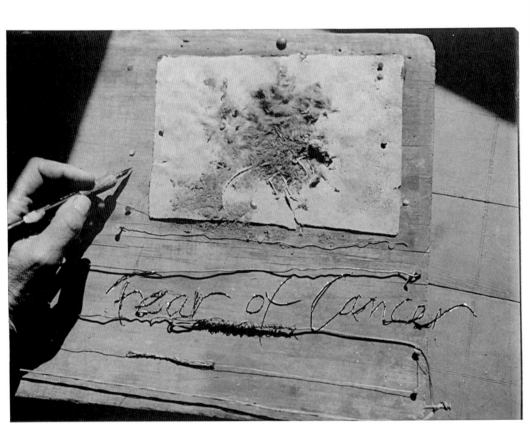

TAKE CARE

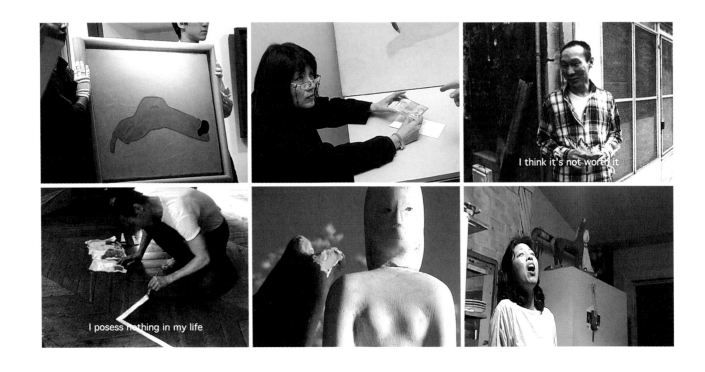

you must forgive me for my silence of not answering your
 kind letters. Because my heart is hurting and making me
have a life without joy, no money not having
 been loved for years.

 San Yu

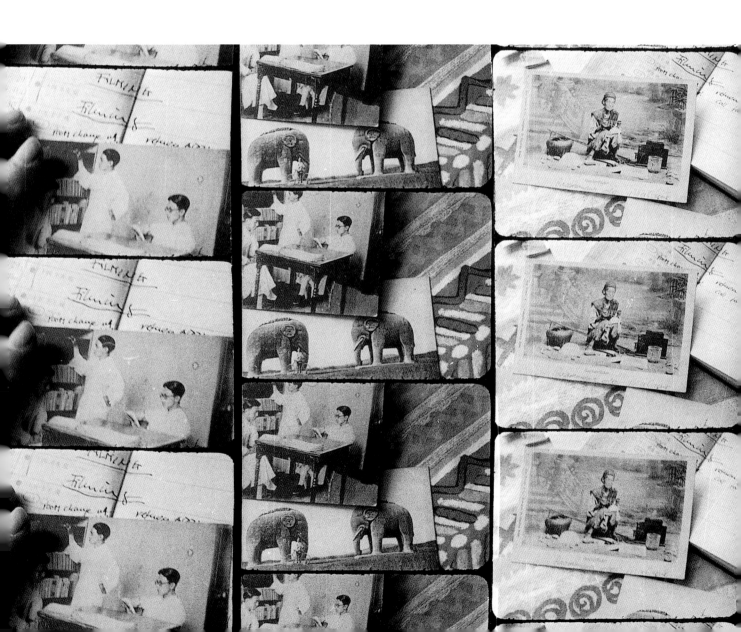

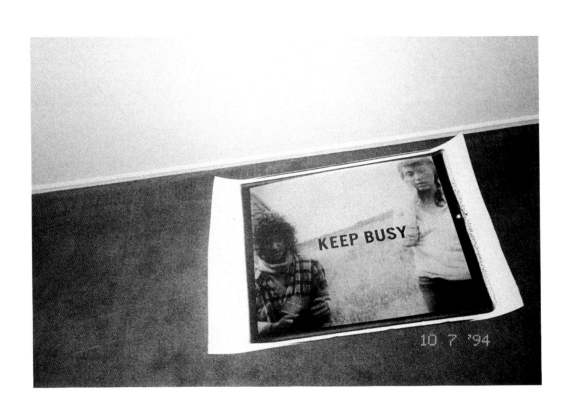

Plates

Unless otherwise indicated, the works
are from the collection of the
artist/Courtesy Pace/MacGill Gallery,
New York City.

40 Photos, 1946
(unpublished)

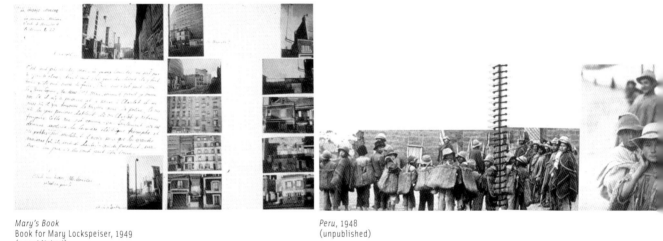

Mary's Book
Book for Mary Lockspeiser, 1949
(unpublished)

Peru, 1948
(unpublished)

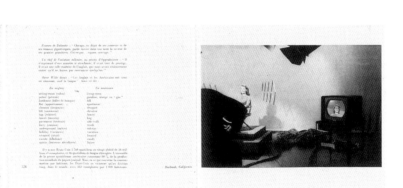

Les Américains
(Robert Delpire), Paris 1958

Black White and Things, 1952
(National Gallery of Art,
Washington/Scalo), Zürich 1994

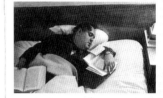

Zero Mostel Reads A Book
(New York Times Inc.), New York 1963

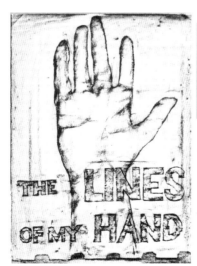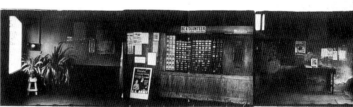

U.S. Post Office, Paint Rock, Alabama

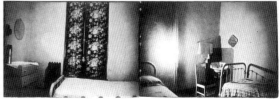

Hotel Room, Gallup, New Mexico

The Lines of My Hand
(Lustrum Press), New York 1972

ACKNOWLEDGMENTS

Robert Frank would like to express his personal thanks to the following:
Sidney Kaplan in light and in dark times, a longtime friend; Laura Israel, a cool cutter for my ideas and images; Do Do Jin Ming, ready to help with her exceptional talent whenever necessary; my friend Peter MacGill, a good buddy in the jungle of New York City.
John Marshall, Provost Street, New Glasgow, Canada, Antiques.

I would like to express my gratitude to Robert Frank for his trust. The understanding of my ideas and the amicable support of the photographer and his wife June Leaf made this project possible.
　　　　On the photographer's wish, this exhibition was conceived in cooperation between the Museum Folkwang, Essen, and the Museo Nacional Centro de Arte Reina Sofia, Madrid. We are very grateful to Juan Manuel Bonet, director of the National Museum in Madrid, and to my colleague Catherine Coleman for the good collaboration. Albano Silva Pereira initiated the exhibition at the Centro Cultural de Belém, Lisbon. We would like to thank its director Magarida Veiga.
　　　　In preparing the exhibition, Pace/MacGill Gallery, New York, provided exemplary support. In particular, I would like to thank to Peter MacGill and Margaret Kelly for their reliable, continuous, and knowledgeable help.
　　　　Further, I would like to thank to Sarah Greenough and April Watson, National Gallery of Art, Washington D.C.; Manfred Heiting, Amsterdam; Eugen Küpper, Münster; and Rainer Rothenberg, Münster, for generous loans of artworks to the exhibition.
　　　　In preparing the film section of the exhibition, Laura Israel; Werner Dütsch, VEGA Film AG, Zürich; Marianne Menze and Karin Wegmann provided valuable information for which I remain very grateful.
　　　　The exhibition in Essen and the German catalogue were generously supported by RWE AG, Essen, as part of their cooperation with the Museum Folkwang in supporting contemporary art. We would like to express our special gratitude for their support.

Ute Eskildsen

in conversation with
r obert fran k

Ute Eskildsen: You are living amidst overwhelming mountains of collected memorabilia. What fascinates me is the variety of visual objects: painted, printed, postcards, objects, words, and texts.

Robert Frank: That's because of Switzerland. I learnt it there, and I have never given it up—it's sentimentality that makes you cling to it. Memory helps you—like stones in a river help you to reach the shore.

U. E. But you also look for this kind of stuff in antique shops. You buy other people's memories.

R. F. I believe it somehow sometimes helps me with the words I write on images—something that is already past and gone. And then the object remains. Maybe the photograph isn't enough, and I combine it with something that is even more important to me. Maybe I got this from learning about the crappy knickknacks that I keep. The postcards are very strong, but that's something different altogether.

U. E. It's interesting that there are hardly any new things, manufactured in our time, among the objects.

R. F. The window is closed... I was very interested in photography crossing over into video. Video, Polaroids, film, Polaroid on TV—back to photography—I played a lot with that. These new things were very interesting to me, and now things are getting too fast for me.

U. E. I want to return to the collection of used objects. They are connected to the past.

R. F. Good observation. Well, isn't this the case with painters, too? You are asking me why my environment is what it is. I don't know whether I can give you a good answer, or whether I want to. Everything immediately becomes old with me, maybe it just walks along with me.

U. E. This fascination for small, old things—do you think it has something to do with America, that you were confronted with an entirely different, much faster culture? Did you already collect things when you were a kid?

R. F. I never liked to throw away anything. You weren't supposed to have leftovers after a meal.

U. E. 'I do not like the adoration of great old men'—what you said in 1969 about Edward Steichen might be said about you today. You are one of the most influential photographers of the 20th century, and you managed not to be paralyzed by fame. What kept you going as an artist?

R. F. That has to do with my personal life. You try to go on. I made myself stronger, so I couldn't give up. After the success of *The Americans*, I didn't want to repeat myself, and so you keep looking for something. And it continues, even when I go back to my old stuff. So, this search is something more interior, related to my sentimentality. I always say that I don't want to be sentimental, that the photographs shouldn't be sentimental, and yet I am conscious of my sentimentality.

U. E. These days you allow yourself to be sentimental.

R. F. Yes, grand old man. But I don't want to take pictures of the tree in spring and in fall, like Steichen did. So I just sit here and observe the light. You know, photographs immediately make everything old.

U. E. In 1947, shortly after your arrival in the U.S., you wrote to your parents: 'The whole way of life here is based on saving time. Only fast and as simple as possible. For elder people who do not have much Dollars it is terrible here. Nobody has any considerations for anybody else.' You still live in New York, you're older now, but not poor. What made life worth living here? Why is N.Y. still important to you?

R. F. In N.Y. you have to give everything to achieve something, to defend yourself. I would just fall asleep here (Mabou). N.Y., on the other hand, forces me to go to the countryside and do something, because N.Y. is not peaceful enough for me. It's too noisy, too demanding to work there. But it's still my place to look and think. I still like going there. I see the new, I feel the new—I think about it, and afterwards it's good to come here.

U. E. In one of your most recent interviews you said: 'In Switzerland, I am courteous. In N.Y., I am not.' Does this mean you need to be rude in order to be courteous again? Do you need the tough metropolis that leaves no room for courtesy? Do you need to immerse yourself in the two extremes?

R. F. Might be assimilation. When I think about what I had to go through in N.Y., how hard I fought, just so they wouldn't take away my leg or my eye, all of this has left its traces. I have learnt not to be quite so courteous anymore—it was the hard way. It's what you have to pay. It's very clear to me that they take away a part of you, and I don't want to accept that anymore.

U. E. In 1955, you wrote in a letter to your former wife Mary: 'It was good that I got so worked-up about that Guggenheim—because if I would not have been so determined about going to Detroit by now I would call it a game and lie down anywhere it is nice and not thinking about photography.' Does that mean projects are necessary for you?

R. F. That was long ago, but I was aware that if you leave your family, it's going to get difficult. I thought: What am I doing here, after all, far away from my family and my kids, in the heat of Detroit? It was just too much. You get arrested, you get screamed at. Yes, why don't I just lie down and make it easier for myself to earn some money. But I didn't want to; I wanted to pay the price. I could hardly work without a project, do something without it—I didn't believe in it. Once you have ten good pictures, that helps, because it becomes a collection. Around 1950, when we had small kids, the family, the grant was very important to me, because otherwise I would sit around and wait for a call to get an assignment. By the way, it never bothered me to do commercial

work. I got very few assignments, but I got them from good people who wanted exactly what I did. So, I was lucky.

U. E. When you got in trouble with the police while working on your Guggenheim project, you turned to Walker Evans. Was he a friend of yours?

R. F. I really considered him a friend, and this thing with the police was a confrontation with all the bad qualities of American culture. It really bothered me. It hit me like a wave. The only one who had certain influence—I didn't know anyone else—was Walker, and I wanted to tell him. I wasn't an American citizen yet, and it was a serious matter to be arrested and suspected, all that shit. He was the only one who could help me.

U. E. You never got your file with the fingerprints back, but you became an American citizen.

R. F. At the INS, there was this black clerk who asked me about my arrest. I told her that if I could not become an American citizen, because a black person was seen in my car, I wasn't interested in America.

U. E. In the same year, you wrote to your parents: 'America is an interesting country, but there is a lot here that I do not like and that I would never accept.' Did this contradictory attitude ever change, one way or the other, in the 53 years that you've been living here?

R. F. My attitude changed when I saw the South for the first time. That was the strongest and most unforgettable impression. The injustice to people who have another skin color. I came from Switzerland as a Jew—there was a similar injustice. I was very impressed, in particular by the power of Southerners who considered this justified, and who became very aggressive against anyone who didn't want to accept this. The answer was always: 'Get out of here.' What moved me was how intimidating they were. In N.Y., you forget about it. But then, you drive out to California, and you see the injustices to Mexicans in Los Angeles. That's the way you learn about human nature. New York isn't America. Welcome here: God's little island—back there: the Big Apple. Getting older you need some peace and quiet. But in 1969, I also said to June: 'We live in a loft—dying here doesn't work.' Back then, I had the idea and the energy to build something here (Mabou), and it was a good thing to do with June. We did a lot together, and that helped me a lot. It was a difficult time for me; I needed help, and she was there.

U. E. Did you initially think of Mabou as a summer house?

R. F. I wanted to work here—I didn't want to come here as a tourist. Another climate—other ideas.

U. E. Did you get yourself a little piece of Switzerland back?

R. F. I was looking for solitude. We really wanted to get away from N.Y., and we could afford it here.

U. E. At that time, a lot of communes were founded on the countryside. But you weren't drop-outs who suddenly wanted to get into farming?

R. F. I wanted the experience of solitude you can find up here. There used to be no other houses for miles.

U. E. In your columns for *Creative Camera* that were published as 'Letters from N.Y.' in 1969, you wrote: 'It's all too easy to be established and respected.' Was your success as a photographer the actual reason for your involvement in film?

R. F. The moving image was a natural step. But it was also my aversion against profiting from my success, against repeating myself. However, I think it's natural, and you see young people doing it, switching from photography to video and back again.

U. E. But with you, it was a radical break— afterwards, you didn't take photographs for quite a long time.

R. F. It took me quite some time. After all, I still had to do assignments. My assignments provided the funding for my films.

U. E. What did you perceive as the difference between photography and film back then? You often pointed out that your work isn't planned in advance—is that true for your films, too?

R. F. You can get lost. 'Chaos'—that's the punishment for not having a script. It's like going up to the mountains without ropes.

U. E. You made the first films without a script—is that true for *Pull My Daisy*?

R. F. Kerouac's story was the leitmotif of *Pull My Daisy*. But then, a lot happened spontaneously. It was based on a few sentences. Basic things—no dialogue. Kerouac recorded his voice over spontaneously.

U. E. Where do you place your earlier work in the context of the New American Cinema of the 1960s? What movies were you interested in? Did you see yourself in opposition to the Hollywood system?

R. F. I was most interested in Jean Vigo and, in America at that time, Cassavetes. Certainly Morris Engel (*Little Fugitive*) and Shirley Clarke's interviews and the films that she made with black Americans, and I knew Jonas Mekas. It was a good time, no financial successes. We still dreamt of success in Hollywood. This is where Jonas was ahead of us. He always said: 'There's no other way. You must believe in what you do. No compromises.' He was a kind of visionary priest. Everyone else, including me, was still playing with the thought that suddenly a door might open.

U. E. The Russian director Andrej Tarkovskij titles his notes on film *Sealed Time*. Film offers the unique possibility to fix time and to show it after the fact, thus opening up new opportunities for our experience of time. What can you tell us about the relation between the documentary and the fictional aspects of your films?

R. F. I always hope that the combination is good—that it works, the documentary against what comes from me. It should be mixed. And in the end, you shouldn't know exactly what is fiction and what is not. The last movie *SAN YU* was very interesting in that respect. It's a movie about a friend of mine, a painter, who meant a lot to me, and from whose death I materially gained a lot. But I didn't want to just show his pictures. I was very ambitious. I wanted to show something between him and me, and not just his pictures. Something came out of it. (R. F. laughs.) Maybe it isn't that good, but I am always for doing something difficult and not giving up. The form is not ideal—it's not like a poem. It has always been my ambition to fight my way to the end.

U. E. But first you had to decide that you wanted to make a film.

R. F. In this particular case, it was obvious. It was a unique, decisive experience. You know the story: Here's a poor painter, he dies, and then he becomes famous.

U. E. No matter, you were interested in the material.

R. F. It was a task that I set myself—here's a well-known story that has gotten to me finally, after a long time.

U. E. 'Photography is a lonesome journey. It's the only road a creative photographer can take.' Was it this point of view that made you curious about filmmaking, which is necessarily the effort of a group of people? Did your interest in film relate to the necessity of using sound and language?

R. F. Film was an opportunity to learn how to communicate. That was maybe the most

important thing to me, personally. It helps you to talk in real life, too.

U. E. 'I guess when one is a visual person, one has a fear of the word. It's natural.' Did your work in film help you to overcome this fear of words?

R. F. I am strongly influenced by writers like Albert Camus or Samuel Beckett. When I write a letter, I talk about Now—but that doesn't really exist in photography. It's always the past. When a photograph really satisfies me, I see no reason to insert anything— sometimes the combination is a help. I am not so convinced of photography anymore.

U. E. Why?

R. F. It's pale—like writing on the wall—*it washes out*.

U. E. Did your experiences as a filmmaker inspire you to use your own words and texts in your photographs?

R. F. Yes.

U. E. How did the dialogues in your films come about—and how does someone collaborate with an artist who hates to plan his work in advance?

R. F. In *Me and my Brother*, there are dialogues by Sam Shepard, and in *Keep Busy* by Rudi Wurlitzer, too.

U. E. I imagine that the *combination* of written dialogue and improvised texts could prove to be rather difficult.

R. F. It's only difficult if you're working with a big 'machinery.' That's what almost killed me when I did *Candy Mountain*. It was all downhill—and it destroyed our friendship (with Rudy Wurlitzer). A little bit later, I learned that you have to be very strong to be able to work with this machinery in a more immediate way.

U. E. Did working in film, as a way of collaborating with other people, help you to open up your solitary work?

R. F. In the end, film has driven me further into solitude. It's difficult to be together with so many people all the time. It's like constantly being on a stage. It was difficult for me, and it was good to come here (Mabou) and to step away. I never thought: 'This work is fun.'

U. E. In 1972, you talked about finding a better way to work that would take into account the fun part. At this point, you seemed to be very open to projects that other people proposed to you—granted that they would guarantee you an open-ended working process.

R. F. Back then, I still believed that this was possible.

U. E. At that point you had numerous offers to teach. Now and then, you actually did. Did teaching give you any ideas for your own work?

R. F. It's a two-sided thing, and the students, the young ones, gave me something. So I got something in return.

U. E. In the mid-70s you wrote to Peter Schlesinger: 'My life is on one track and the work on another track, at times the one overtakes the other and at other times they cross each other.' Did this change, now that you're old? Have 'life and work tracks' become closer?

R. F. Maybe you're more interested in getting them together. Or you don't want everything to be so closely intertwined. Let's wait a few minutes. It's a good question.

June Leaf *interrupts*: Not all artists are that way—some artists don't want—they say: 'With all my experiences I want to keep distance.'

R. F. There's a big change when you accept it—especially as a photographer. It doesn't have to be true. It's rather late in my life that I would think that way. It doesn't have to represent something. You can contradict with words what you are showing.

J. L. It gets close in the collages; this man is a great collector.

U. E. Apart from the decreased energy, are there aspects of old age that give you a different and productive momentum for your work?

R. F. Well, at my age, the pills keep the old man going, so he can still walk and take pictures. But, most of all, he has time to think. It becomes, very carefully and slowly, a reminiscence.

U. E. *HOLD STILL—keep going*, the title of our show, was taken from one of your works. Other titles refer to *Fear, Hope, Sick of Goodby's*. What keeps you busy?

R. F. *Keep Busy* was the only movie I made in Cape Breton (with Wurlitzer). It was about survival on a small island. From the lighthouse on top of the island the captain gives orders to people below. Keep busy—winter is coming. I do the same now—winter is cold.

U. E. In the recent interview I already mentioned you said: 'I've given too much thought to it.' You were talking about art.

R. F. Art that influenced me, mainly two things: European literature (Albert Camus) and later American Music, country music, like Hank Williams and Bob Dylan. And then art: my first wife was a painter, then there is life with June, my second wife. That's where I learnt a lot about what it means to be an artist—these are great experiences.

U. E. Did the integration of photography in an art context change the quality of photographic work and the level of criticism in a positive way?

R. F. It's a question that is often asked. It just had to turn out that way—like with video. Jean-Luc Godard said that it is a dirty trick, a little Japanese dirty trick. Making money with photography wasn't the right thing. That happened unexpectedly—suddenly.

U. E. If the question was too general, I'll get more specific. At the time when you started to take pictures, it was more important to publish a book or, at least, get a photograph published somewhere—the idea that photographs would hang on a wall wasn't around, right?

R. F. No—I think of the scene in the little Stieglitz film. The photograph as object—I never believed in that—now I have to. It taught me that I could do other objects after I had sold them. It's a real business—it's as simple as that. And I understood that it is a big business, selling this. In 1977, I realized this when the little art dealer and the big lawyer handed me the contract to sign. And then I wanted to do something they didn't have, something they hadn't filched from me. Every artist fights for his life. They recognized early on that photography would turn into a 'big business,' and they used it to help poor Robert Frank a little bit.

J. L. It's wonderful that Robert kicks off that problem which all of us artists have with the increasing commercializing of art. The artist is the dealer and no longer the artist. Dialogue between dealer-artist-curator. There is no longer a difference between an artist using photographs and traditional artists. And I have seen so many artists being influenced by photographers. We had to live from day to day and I never thought it would change. And when Robert did the deal Paul Katz and all of Robert's friends warned him. He said you better take care before you sell out. He knew that Robert would give away everything. (In 1977, Robert Frank worked out a contract with lawyer Arthur Penn, which included the copyright to his works. This agreement was later bought back with Peter MacGill's help.)

R. F. For me, at that time in 1977, to get $ 30'000 a year for ten years meant a lot.

J. L. But it also refers to the fact that Robert likes to get rid of things. 'I don't want this problem anymore.'

(At the end of our conversation, we started talking about the artist Dieter Roth. Robert Frank expressed his admiration for him.)

R. F. I was very moved by his desperation.

J. L. Why are you so moved by desperation?

R. F. Because he could express it.

J. L. I think it's a romantic view and dramatic, and Robert is like this. But I find it very interesting.

R. F. I think I have enough of it in my life.

U. E. But isn't it a kind of empathy on Robert's part for an artist that he understands particularly well because of his own mind set?

J. L. Robert likes to surprise you all the time. He always goes the opposite way. He is a performer. He knows that he is a historical figure. Being famous had an effect on him.

R. F. I never believed that a photographer as a photographer could have gotten a name like this.

U. E. What about Walker Evans?

R. F. Walker Evans was a *Time* and *Life* man. When I knew him he was walking around like an Englishman. He had influence—he was safe; he would never walk towards beatnik people who had no breeding. No dirty shirts, clean style, sharp intelligent eyes, and the photos had to be classic and many are and so they (museums, critics, curators, editors, businessmen etc.) built him a stairway to heaven, even before he was dead.

U. E. Did your trust in Walker Evans, or his interest in a young Swiss photographer in New York, have anything to do with his love of French culture?

R. F. Yes, his idea of culture, that was his way of valuing somebody. In the end, he preferred to have me in his car, rather than a *Time/Life* man.

U. E. Can your most recent work *Tools*, dedicated to your mother and Walker Evans, be read as an ironic commentary on the current Walker Evans renaissance?

R. F. A lot has changed since I assisted Walker on his *Tools* series. Back then, I admired his ability to achieve this extraordinary precision with very basic technical equipment (shaky tripod and so on). It was impressive, but there was a coldness to it. Walker Evans chose his tools with the experience and the taste of the elite. In my room in Mabou, familiar objects are just lying around, and I just have to wait for the right light. That's enough for me.

U. E. Since *The Lines of My Hand* you prefer montage in your photographic work. This choice is influenced by film, but what do you particularly like about this way of expressing yourself?

R. F. I appreciate montages, which you could also call 'series,' because I am always happy with chance. And with several photographs and text I can always invent the rules for every work. I couldn't just continue with my previous images, but I stuck to the language of photography.

U. E. Your work *Roots* shows a barren tree, you explaining something, and a part of a sentence that reads *My Roots explain*. It is an ironic approach to this subject. You like to show it side-by-side with another work. It once again shows a barren tree, but this time it's not free-standing; it's in a backyard. Next to it, we see a map, which we can't quite make out, with the letters ' Palestine' written across. What significance does Jewish religion have for you?

R. F. In old age 'stories' accumulate. So, there's a kind of second horizon. The knowl-

edge and experience of anti-Semitism will remain forever in my memory. I will never forget that I am Jewish, and why should I?

U. E. Memory, or rather remembering, is a recurrent topic in your work of the 80s and 90s.

R. F. You do your work as a photographer, and everything immediately becomes past. Words are more like thoughts; the photographer's picture is always surrounded by a kind of romantic glamour—no matter what you do, and how you twist it.

U. E. You repeatedly explained your emigration to the U.S. with the narrowness, both spatial and cultural, of Switzerland. Weren't the experiences and fears of a Jewish family living threateningly close to fascist Germany as much of a reason for your emigration? After all, becoming a Swiss citizen wasn't easy, despite your Swiss mother.

R. F. I am sure that was part of it. But also the American movies you could see after the war. They made you curious, and Europe seemed simply old. It was easier to leave than to stay. Why not move on—further—a New Horizon, New York 1947.

Mabou, July 2000

behind words
r obert fran k's
ameri can poetry

CHRISTOPH RIBBAT

Love is something spoken, and it is only that. (Julia Kristeva)[1]

Only love can break your heart. (Neil Young)[2]

A juxtaposition of quotes from a singer/songwriter and a psychoanalyst/philosopher reeks of frivolity. But in this instance it should help us to locate Robert Frank's work. Because the territory of this great photographer is exactly in between Julia Kristeva and Neil Young. He moves back and forth between these two ways of talking about love. On the one hand, we have the long-haired melancholy American, singing ballads on being lost in loneliness to this wide-open country, singing about the agonies of lovers, accompanied by his guitar. On the other, Julia Kristeva represents the stereotypical European coffeehouse, next to a university, where maniacally smoking intellectuals decide that the world is a mere text and emotions just language. Frank stands at an immeasurable remove from academia and would probably rather give away his favorite camera than drink sparkling wine with post-structuralist photo-theory hacks. So, it is the simple rock'n'roll hero who uses a camera instead of a guitar, seducing his fans to dream along simple visual chords? This mask wouldn't quite fit, either. Sure, he knows that only love will break your heart, and not a botched discourse analysis in grad school. But he also knows that without language there's no love; he constantly reflects on the grammar of intimacy in his art.

Pop stars incessantly offer you emotions and make them seem authentic, as if you could touch them. Philosophers hide their emotions behind the vast gray expanse of written words. Frank keeps the balance and makes visible both happiness and pain—but words keep forcing themselves in between viewer and emotions. They destroy the myth of the camera as a machine of truth. As photographer, Frank is neither pop star, nor philosopher but a poet. One who mastered both the grand, well-composed epic narrative, swept forth by history, and the intractable fragment, fissured and pasted together, written on in sloppy handwriting. Frank's photographs were repeatedly called 'poetic' by critics. On the following pages, we'll take this associative label seriously. We will discuss Robert Frank, the Swiss photographer, as an American poet. We will explore the proximity of his photographic work to literature.

1 Kelly, Oliver (ed.), *The Portable Kristeva*, New York, 1997, p. 170
2 Young, Neil, 'Only Love Can Break Your Heart,' on: *After the Gold Rush*, 1970

'When people look at my pictures,' Frank said in 1951, 'I want them to feel as if they were reading a line of a poem twice.' This early statement in itself indicates the literary ambitions of his work. But only in 1970, after moving to the small coastal town Mabou, does Frank's biography start to resemble the quintessential American poet's life. Two of the greatest names of American poetry created their works in the isolation of the American Northeast: Emily Dickinson and Robert Frost.

Dickinson (1830-1886) solitarily lived in her house in Massachusetts, hardly ever leaving it, and wrote poems on universal topics, such as love, death, life's transience. At the same time, they offer an incredibly intimate view of her private sphere: a fly in her room, a bird on a garden path. Such details, described in seemingly innocuous poems, almost nursery rhymes, reveal a dark and complex way of thinking. The public only got to know about the recluse's poems long after her death.

Robert Frost (1874-1963) was less reticent and became one of America's most famous poets. He was a genuine performer of poetry, to whom presidents listened, and who was interrogated about the meaning of life by journalists. He focused on a narrowly circumscribed area in his poems: *North of Boston* was the title of his first book of poems—almost provocatively provincial.

Frost's poems treat quaint agricultural tasks, like mowing, laying bricks, raising cattle. As readers were only too willing to confuse the poetic 'I' with Robert Frost, he quickly assumed a role in American culture that was hard to escape: he was the farmer poet. Simple, soothing poetry on the rough beauty of living on the countryside, meditatively grounded in his native New England. It was easily forgotten that the actual Frost bore little resemblance to this persona. He had studied in Harvard, had lived in England for a long time, and had chosen his exile in New England for the same reasons that Robert Frank would later settle on Mabou, Nova Scotia: it was a refuge. In regard to the popular image, Frost and Frank both suffered from the same problem. The public imagined Frost as writing poetry on the simple truths of (rural) life, just like it pictures Frank as a wandering augur proclaiming the simple, yet melancholy truth on America. The inaccessible surfaces of Frank's late photographs is the result of an attempt to escape this pigeonhole.

In his poems on farming, Frost uses strategies similar to Frank's to prevent the delusion that art could ever present clear and simple truths. In *After Apple Picking* (1914), he cleverly deceives the reader—in a poem apparently on apple picking. The narrator, however, is more interested in the psychology of perception, rather than in Granny Smiths. He is particularly fascinated by the moments between sleep and wakefulness, the time period when outward and inward vision are bewildering and blurred. 'I cannot rub the strangeness from my sight/I got from looking through pane of glass/I skimmed this morning from the drinking through/And held against a world of hoary grass.' The familiar view of the farm, the cows, the trees, the dung heap isn't clear in Frost's work, either. Between the eye of the artist and this apparently simple world, there is always a pane of ice, translucent, yet strangely distorting. Thus, the artist will never sleep the sleep of the woodchuck, of the mare, or the goose, only the sleep of man, full of nightmares and self-reflections.

You'll find just this 'pane of glass' in many of Frank's late images, for example in *Brattleboro, Vermont* (pl. 1). Apparently, the photograph shows a hotel

room. There's an open suitcase on the drawer, a TV set. A naked woman stands in the middle of the room, one arm raised like a Spanish dancer's. At the first glance, it looks like tired bohemian eroticism, and you want to just move on. But on the surface of the image, between us and this scene, words in Frank's handwriting impose themselves '4 AM Make Love To Me.' Twice. First, it just raises a few questions. Why does it sound so imploring? Why four capital letters? Who is speaking? And it arouses a slight envy. 'These artists... four in the morning and they ask their lovers to sleep with them.' But then, the scene behind the words is encompassed by these doubts, too. You ask yourself why this ghastly light emanates from the TV, whether the gesture of the woman, which would appear inviting without the words, is mere mockery of the one writing 'Make Love To Me.' Not bohemian love, but its ridicule? There is a shift from sensuality to doubt. As in Frost's poem, an opaque pane of glass imposes itself between the viewer and the bed.

There is, however, a significant difference between the two poets of the Northeast—and it lies exactly in the presence of the desired lover. Proud, soft, tender, strong, present and absent, whatever role she plays in Frank's work: she is there. This indicates Frank's departure from the mainstream of American modernism, characterized, both aesthetically and ideologically, by myths of masculinity. What is true for Frost, whose guys roam alone through fields and forests, also applies to Hemingway. In his classic short-story *Big-Two-Hearted River* even the trouts that the protagonist swiftly cuts apart are male.

The intentionally masculine gendering of American photography in the 20th century can hardly be ignored, as numerous art historians have pointed out in recent years. Colin Eisler described how the dominant agenda of 'straight photography' was used to turn photography into an all-male club.[3] The great photographers of the landscapes of the American West may serve as an example.

In Edward Weston's and Ansel Adams' work, it's the precise technique that makes their art masculine and wards off—beware!—the female and the sentimental. They systematically stylize their gaze, developing precise scales of gray tones, scrutinizing the intricate geometrical shapes of nature with mathematical precision. They don't intend to disappear in Mother Nature's womb. They rather want to analyze these regions in detail. In his nude studies, Weston's gaze is almost gynecological. The vulva as the 'heart of darkness' for the technocratic eye. In the end, it is irrelevant whether they photograph the desert of the Southwest or the female body. In every instance, the controlling gaze of the photographer will assert itself.

Robert Frost, probably the most elegant poet of traditional masculinity, is a similar case. No one is looking for harmony in his forests. Instead, we witness symbolical dramas. In his beautiful *Birches* (1916), the poet imagines a lonely boy climbing up the 'trees of his father,' higher and higher, until he reaches the top, and the trees start to bend. They bend further and further, until the boy knows that he has reached the right angle and jumps back on the ground. Frost admits that, of course, snowstorms and harsh winds in a winter forest have bent the trees. And yet, he says, he prefers the image of the masculine duel, of the struggle of the son against the father. Again and again, the son climbs up the trees until he overcomes their rigidity. It's the typical archaic American masculine drama of the boy overcoming his rough father on the Mother Nature's stage. In *Birches*, an extraordi-

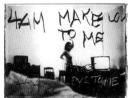

1 BRATTLEBORO, VERMONT, DECEMBER 24, 1979

3 Eisler, Colin, 'Going Straight: Camera Work as Gendering of American Photography, 1900–1923,' in: *Genders*, 30, 1999

narily visual poem, he talks about the 'right moment,' the decisive point in time. He climbs up the tree to jump off with an elegant and athletic leap, just as it is about to touch the ground. In this image, an aesthetic reminiscent of Cartier-Bresson is combined with the American rhetoric of self-improvement. In classic American landscape photography, too, it's the right moment that counts, the perfect light, as much as the will and the self-discipline to wrest crisp images from mountains, trees, and deserts in a perpetual fight with nature. Adams and Weston posed as elegant athletes, conquering the world of photography as artistic scions of tough pioneers.

In his diaries, Weston unfolds on hundreds of pages the heroic battles of a photographer in the service of aesthetic perfection. Only with an absolute mastery of technique and technology, with hard work, will perfection ever be achieved. Whereas a street photographer, like Lisette Model, had her pictures developed in the drugstore around the corner, Weston and Adams transformed the darkroom into a kind of artist's cockpit. Even poets, like Robert Frost, were obsessed with technique. Not to use rhymes would be like playing tennis without a net, he claimed in the midst of a century intent on destroying classic form. Every poem had to be perfectly structured, precise, exact, and rhythmic. There should be nothing chaotic about it, instead it should be 'a momentary stay against confusion.'[4]

Moments of confusion, fear, and blindness, set against the background of harsh landscapes—these are the similarities of the lyrical images of Robert Frost and the poetic photographs of Robert Frank. But fundamentally, the poet pursues entirely different purposes that are closer to Weston's or Adams'. Around the middle of the 20th century, the great masters of American nature poetry and photography claimed the representation of landscape as the domain of precisely working, masculine technocrats.

Among others, we owe it to Robert Frank's works on Nova Scotia that nature was given a different visual language. In clear distinction to the exacting professional landscape photographers, he doesn't treat nature as a space in need of aesthetic domination. Instead, he shows it as an uncertain, dreamlike sphere of memory. His collaborative works with June Leaf prove that there is another way of looking at landscape, renouncing austere and monumental vistas of the American continent (p. 60–61). Their collaborative collage opens on a diffuse photographic panorama, pasted together, surrounded by June Leaf's warm brush strokes. A car stops somewhere in the distance, its rear lights a glowing red. 'There is a town in North Ontario,' Neil Young sings about another place in Canada, 'with dream, comfort, memory, despair/And in my mind, I still need a place to go/All my changes were there.'[5] He sings about consolation, despair, and memory, but also about dreams and transformation. These are neither the precisely captured deserts of Weston, nor the eternally monumental mountains of Adams. In Frank's and Young's work spaces can't be clearly seen; they are always colored by emotions and memories. Unlike in Weston's images, the part of the lover is not restricted to playing the counterpart of a bell-pepper or a sliced artichoke.

In Weston's and Adams' work, the camera is charged with an enormous significance. Yet, it remains invisible—whereas for Frank landscape photography may well entail photographs of a landscape hung on a clothes-line in front of the

4 Frost, Robert, 'The Figure a Poem Makes,' (1939) in: Baym, Nina (ed.), *The Norton Anthology of American Literature*, Vol. 2, New York 1994, pp. 1114–1116
5 Young, Neil, 'Helpless,' on: Crosby, Stills, Nash and Young, *Deja Vu*, 1970

same landscape (pl. 2). Weston's work, in particular, could almost be called schizophrenic. His *Daybooks*, the diaries of his travels, develop an endlessly detailed narrative of the emotional world of this photographer, his affairs, his dinners, his mood swings. Should I drink coffee, or shouldn't I? Should I smoke? Who ate the bell-pepper I wanted to photograph today? These are some of the questions. Some are more moving than others, pondering love and his doubts in art. Inserted in this narrative are the photographs and their clear, supposedly objective view, sober and crisp, of the things in this world. A fiction unfolds, claiming that, on the one hand, there could be an artist creating almost perfect images of true beauty with his ingenious gaze—and who could yet separate them from the imperfections, dramas, and ruptures of his personal life.[6]

Frank doesn't neatly delineate the boundaries between the private life and the work of the artist. There is no fictional contrast between the turmoil of the private sphere and the cold, pure beauty of art. His wife and his children aren't mere pawns in the mind-games of a master photographer. Frank cultivates, as DiPiero writes, a 'damaged beauty.'[7] The private and the personal are integral parts of the photographs. This doesn't suggest, however, that even the most intimate works aren't fictions. But these works have another focus altogether as they emphasize the emotional and sensual aspects of making art in the images themselves.

We can show this succinctly in the most recent series *Tools* (p. 4–5). It shows a broom, a knife, and a fork in a domestic interior—tools of quaint housekeeping. A pencil, a blackboard: nostalgic instruments of writing that may be erased or wiped off. A camera, for example, is not on display, nor darkroom appliances. Shutter-release cords are the only specifically photographic tools on display. Light and shadow surround the objects—diffuse and fleeting presences letting the images appear like sketches. A hand moves across an image. We cannot recognize the object on the palm of the hand as it is blurred by movement. As so often with Frank, these images instigate the interaction of the seen and the unseen. He already devised similar dynamics in *The Americans*, whose first image shows an American flag concealing a face. *Tools* ends with a symbol of blindness, a page covered with Braille signs. The other objects are indicated by words on, or beneath, the image ('blackboard,' 'wrench,' and in German, 'Selbstauslöser'). On the last picture, however, Frank wrote beneath the object, not in block letters, but in script: 'For my mother and W. E.'[8]

The initials 'W.E.' probably conceal Walker Evans, who created a similar series in 1955 called *Beauties of the Common Tool*.[9] But in spite of the similar subject matter the images are strikingly different. The hammers, wrenches, and pliers are perfectly lit, presented in a straightforward manner in front of a neutral background. To a degree, Evans shared the objective aesthetics that are characteristic of Weston, thus his fascination with the machinery of a century shaped by technology. Weston investigated with sacerdotal gravity the 'objective' sensuousness of the feminine curves of the bell pepper and the phallic, bristly radish, whereas Evans' series of tools is a subjective and ironic study. His text, published in *Fortune* magazine, praises the 'swan-like' beauty of a Swedish pair of pincers (Price: $2.49) and the noble ferociousness of a can opener (69 cents). It is not about the passion for the perfect form, but the pleasures of an imagination that transforms

2 MABOU, 1977

6 *The Daybooks of Edward Weston*, New York 1990
7 'Hold Still-keep going: The later photographs,' in: Greenough/Brookman (eds.) *Robert Frank. Moving Out*, exhibit. cat. National Gallery of Art, Washington, D.C., Kunsthaus Zürich, Zürich 1994
8 On braille paper and Frank's mother's blindness in his film *About Me*, see Brookman in: Greenough/Brookman (eds.) *Robert Frank. Moving Out*, exhibit. cat. National Gallery of Art, Washington, D.C., Kunsthaus Zürich, Zürich 1994, op. cit., pp.142–165
9 The original series 'The Beauty of the Common Tool,' in: Rosenheim, Jeff L., *Unclassified: A Walker Evans Anthology*, Zürich 1999, pp. 113–117

the details of the world at its whim. Frank, Evans' 'pupil,' goes one step further and shows what happens to our perception of quotidian objects, when we take intimate spheres into account. He is interested in what they look like when they are charged with the emotions we feel for our mothers, mentors, and teachers.

No wonder that the only properly photographic tools on display here are shutter-release cords. Comparing these fragile, gracious, slim instruments to today's digital cameras seems like comparing *Death on the Nile* to *The Matrix*. On the quaint wooden table we see the coiling shutter-release cords besides the three coins. Photographers tend to make inventories. When the Bechers set out, the water towers of this world stand at attention. In Frank's work, on the contrary, intimate disorder reigns supreme.

In *Tools*, it's once again words that impose themselves between our gaze and these intimate scenes. Their very presence raises some fundamental questions. Their redundancy—'Broom' written across a broom—stimulates speculations. What is the purpose of this inventory? Should it just ascertain the mere presence of the world? Is it therapeutic—as in Hemingway's work, where traumatized heroes recapture life with basic, constantly repeated words? We read six words in English and one in German—maybe Frank hasn't completely arrived in America yet? And then, there's the dedication to the great photographer and to the mother, an incomplete sentence, referring to the personal and to art at the same time, a sleight of hand transforming the *Tools* into instruments of the heart. Because the words seem sketchy and inconspicuously placed, they completely change our perception of the series of images. They transform an objective record into a subjective protocol of love for these things, for the mother, and for the mentor. Frank's images impose words in between our gaze and these intimate scenes. Returning to Kristeva, there is love in language, in the (visual) narrative. And only there. But despite, or exactly because of this, the ligaments of love are everywhere—just like they are in Kristeva's writings. In her *Tales of Love*, she creates imaginary spaces of love with words that could describe some of Frank's images: 'unstable, open, undecidable spaces' could be the rooms of love, 'phantasmatic, daring, violent, critical, demanding, shy.'[10]

Images of love call for frayed edges. Even a photographer as subtle as Harry Callahan stages intimacy in a manner that sometimes seems ill-at-ease. We'd love to hand a bath robe to his Eleanor who constantly has to pose naked in front of an ugly radiator. You feel an urge to discreetly advise Callahan that he should stay with his trees. We never have this feeling with Frank and his subjects—because he so obviously questions the power of the single image and of unequivocal surfaces. The closeness to his subjects and the pain of loss threaten the authority of the images and make their borders fragile, their surfaces diffuse. His photographs make the sea, the trees, and the mountains seem less monumental. The precision of the unreflected, realistic gaze is replaced by the imprecise aesthetics of an art that knows, as Salman Rushdie writes, that 'realism isn't a set of rules, it is an intention.'[11]

This thought is from a passage on Robert Frank in Rushdie's *The Ground Beneath Her Feet*, his wild novel of global dimensions, published in 1999 and immediately hailed as a masterpiece. Two thirds into the 600-page epic, the man from Mabou gets his cameo appearance. On several pages the narrator (a fictive photographer) describes Frank's work—*The Americans*, however, is never men-

tioned. Only the late works, only the intimate photographs of the Canadian coast, are interesting to him. They open up a new world and provide some answers to the unresolved problems of photography.

But why this summit—what is interesting about Frank to Rushdie? When I quote Kristeva and Neil Young to explain his oeuvre, this may seem equally strange. At least, an interest in, or even passion for, the fragmentary connects them. They approach it from different perspectives: Young with his simple craftsy aesthetics (songs with three chords, D, A, G, performed by an untrained voice; lyrics that suggest only elementary and fragmentary images). Kristeva goes the other way. She sings her psychoanalytical and philosophical cerebral ballads with extraordinary complexity and with references to the Western concept of man. Finally, they arrive at the same end, the necessarily fragmentary, insecure spaces of love. 4 AM—Make Love To Me.

Rushdie's work displays no interest in the fragmentary. It is narrated by a photographer, yet it hardly relates to photographic aesthetics. Michael Ondaatje's novella *Coming Through Slaughter* operates in an entirely different fashion. Inspired by the New Orleans-based photographer E. J. Bellocq, Ondaatje's intermedial text seems to be a collection of snapshots of the wild and ragged life in Louisiana. *The Ground beneath Her Feet*, however, is formally a grand epic narrative. It is an example of excessive story telling. It concerns itself with documentary aesthetics on the level of mere argument. Instead, it once again recounts another great love story, the story of a couple whose tragic passion for each other knows no limits. The two of them become the greatest pop stars of their time. Rai, the narrator and a friend of the two lovers, follows their rise, the tragic disagreements, and their end. It's a new version of the myth of Orpheus, as much as it is a panorama of global pop culture—a narrative that ambitiously reaches from India to England. It wants to demonstrate the potential of great literature.

The most wonderful of these possibilities, naturally, is the power of writers to re-write contemporary history in order to show different versions of our lives, removed from the harsh realities of facts. Rushdie makes generous use of this possibility. His book spans from the 1950s to the 1990s—historic characters occasionally turn up, but mostly in an altered form. There is, for instance, an American Rock'n'Roll superstar, whose gyrating hips send teenagers around the globe in ecstasy. He is Jessie Garon Parker. Only in a passing Rushdie mentions that Parker's twin brother, a child called Elvis Presley, died at birth. On a hot day in Dallas, Texas, the amateur filmmaker Zapruder saves the American president John F. Kennedy from an assassin. There is a French photographer whose art consists in recording decisive moments. He isn't called 'Cartier-Bresson,' but 'Henri Hulot,' and he roams the streets of Bombay with the narrator.

All of these masked and altered characters show Rushdie's intention to highlight the power of imagination. They demonstrate that literature is not so much about mirroring the world, but about developing fictions. Amidst this literary fancy-dress ball, where all sorts of prominent characters are given new identities and new lives, why is there one character appearing as himself: Robert Frank? Why didn't he get a new name, a different biography?

There might be a programmatic character to this. Frank appears as a mentor, showing a direction to a not quite happy artist/journalist, the photogra-

pher Rai. From Cartier-Bresson's *doppelgänger* the young Rai learns about the decisive moment. But with growing wisdom, he realizes that the chase for the perfect moment will not deliver everything to the artist. Frank, the observer of the 'moments in between,'[12] seems to have a more moving vision. These images, Rushdie's narrator writes, gave him what he wanted, made possible a new beginning for him. The images from and of Mabou allow him to learn 'imagination's alphabet' anew. They teach him to give up pretensions, for example, representing the universal. 'Yes, Robert Frank, I thought. This was the sign I'd been waiting for.'[13]

We may surmise that Rushdie erected a literary monument to Frank because of their related subject matters, because the pleasures and pains of love can be so viscerally felt in Frank's photographic oeuvre that the author of the last great love story of the 20th century just had to use it. But something much more general connects Frank and Rushdie: their malcontent with plain realism. They share an artistic philosophy intent on preventing the audience—by means of an artfully altered surface—from using the work to apprehend its author. The pictures of the typewriter in front of the window are mentioned in the novel (pl. 3). The words written on this series 'Fear—No Fear' probably have a very special significance for Rushdie. Threatened by the fatwa, he had traumatic experiences with an audience lacking an understanding of the fact that art is an illusion, and not a mirror of the world, or the author. In Frank's case, it took (only) the overly enthusiastic reception and subsequent use of his infinitely personal book *The Americans* to make him emphasize the fictional nature of his work.[14]

One author, whom I obviously ignored so far in these ruminations on Frank and his diverse relations to writers, shaped to a certain degree the public (mis-)perception of *The Americans*: Jack Kerouac. He wrote the preface to the book and called Frank a 'poet of the camera.' Frank, he wrote, extracted with his camera a sad poem from America, recorded it on film, and was thus among the most tragic poets. Kerouac, it seems, is Frank's Siamese twin brother, and the Beat Generation is Frank's generation, in which and with which he developed. Why should we summon Julie Kristeva from the Sorbonne, why should we take the rock legend Neil Young off the stage, why should we tap into Salman Rushdie's work? It would have been considerably easier to describe Frank as a part of this movement that took a look from below at America, introduced an imperfect, sketchy aesthetics to art and literature. They improvised, fragmented, and provocatively exposed intimacy.[15] In this case, Frank would be a Beat photographer, just like there are Beat poets and Beat filmmakers. (It would be difficult to deny that he was the latter. *Pull My Daisy*, his most famous collaboration with Kerouac, testifies to this.)

However, it would be limiting to see him in just this context. The shadow that *On the Road* casts on *The Americans* is too oppressive. Both seem to be part of one vision of America. One is an enthusiastic epic narrative on liberation by and on the road; the other is a melancholy meditation on a very similar journey. This interpretation would reduce Frank to being just another travel photographer. His work would be only about 'keeping going,' but not about 'holding still.' That Kerouac's comments on Frank's photographs are not always the most useful ones, becomes obvious when we read Kerouac's report on their trip to Florida. In this text, furious as usual, we learn a lot about travelling, quite a bit about Florida, some things about Kerouac, but hardly anything about Frank.[16]

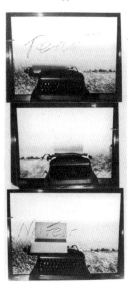

3 FEAR – NO FEAR, MABOU, NOVA SCOTIA, 1987

12 Gee, Helen S., 'Photography in Transition: 1950–1960,' in: Enyaert, James (ed.), *Decade by Decade: Twentieth-Century American Photography*, Boston 1989, p. 71
13 Rushdie, Salman, op. cit., p. 446
14 See Papageorge, Tod, *Walker Evans and Robert Frank: An Essay on Influence*, New Haven, 1981, p.9
15 Phillips, Lisa S. (ed.), *Beat Culture and the New America 1950–1965*, New York 1995
16 Kerouac, Jack, 'On the Road to Florida 1958,' in: Rabb, Jane M. (ed.), *Literature & Photography: Interactions 1840–1990*, Albuquerque, 1995, pp. 394–397

The pictures created in Mabou make it obvious that this photographer is interested in staying in a place. He cares about the familiar and the abysses of intimate relationships. Sadness and lust, pleasure, bliss, and absence, the ever changing light in always the same place. Yet another poet, William Carlos Williams, wrote in 1938 about Walker Evans' *American Photographs*.[17] He notes his pleasure that these pictures portrayed America, and not France. There is neither nationalism, nor Francophobia, behind these lines. Williams admired Evans for having found an artistic vocabulary for the place where he lived—he claims that it is much harder to transform one's own environment into art than a place abroad. The fact that they are specific of place, Williams writes, is what makes them universal because they make thus possible an art for every place. Today, the 'open road,' which may still be a place to be rediscovered in *The Americans*, has degenerated to a mere stereotype. What the dreamy French bistro was in the time of William Carlos Williams, Route 66 is today: cheap exoticism, the most simple option for the travelling photographer. After *The Americans*, Frank quickly bid his farewell to the road. Static states became more important than movement. He consequently withdrew from the Beat movement, for which ceaseless travel was a *leitmotif*, and for which any kind of acceleration—whether it was cars, drugs, or jazz—was just right. 'We gotta go and never stop going till we get there,' someone pontificates in *On the Road*. Someone further inquires 'Where we going, man?' The answer is 'I don't know, but we gotta go.'[18]

The only thing that counted for the Beats was an intense and authentic experience. They believed that they could touch a part of America if they penetrated the surface of Frank's photographs. This may be charming when Kerouac asks for the name and address of an elevator operator. But Frank's often quite hermetic work rebuffs this approach. Allen Ginsberg, the most famous Beat poet, emphasizes, for example, the high degree to which Frank's work is determined by his spontaneity and ingenuity.[19] Much of what we see in *The Americans* is artificial and not spontaneous at all. The pictures are hesitant and uncertain. They question the medium. In the 1950s, Frank already showed the obstacles in the way of the travelling photographer. For every visible person there is, at least, one other who is partially obscured. For every image that shows something, there is a corresponding image that deals with emptiness and invisibility. In Frank's later photographic work, immediate experience is further complicated in even more radical ways. In Mabou, love displaces itself behind words.

'The humor, the sadness, the EVERYTHING-ness and American-ness of these pictures!'[20] Kerouac exclaimed in his preface to *The Americans*—enthusiastic, charged with energy, like so much of what Beats proclaimed. But Frank's images are not universal, they are not about 'everything,' about 'the American,' about 'sadness itself.' Their brittle surfaces, their relation to the world of writing, make them self-reflective, if infinitely sensual, photographs. They are wise like Kristeva's texts, rough and sweet like Young's ballads. They are about love and language, light and dark. Well, maybe this is 'everything.' But it's not EVERYTHING.

17 Williams, William C., 'Sermon with a Camera,' in: Rabb, *op. cit.*, pp. 309–312
18 Kerouac, Jack, *On the Road*, New York 1957, p. 196
19 Ginsberg, Allen, 'From Allen Ginberg's Sacramental Snapshots: An Interview by Mark Holborn,' in: Rabb, *op. cit.*, p. 517
20 Kerouac, Jack, 'Preface, ' in: Frank, Robert, *The Americans*, New York 1978, p. 1

Dr. Christoph Ribbat, assistant professor for English literature at the University of Bochum, is currently a visiting fellow at the University of North Carolina, Chapel Hill.

a film
by r obert fran k

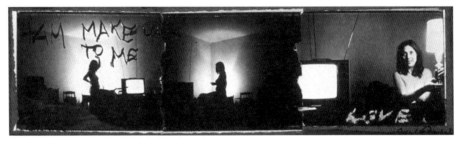

1 BRATTLEBORO, VERMONT, DECEMBER 24, 1979

I. Changing the medium

'These Photographs represent my last project in photography. When I selected the pictures, I knew and I felt that I had come to the end of a chapter. And in it was the beginning of something new...'[1] The photographs we are talking about are called *Bus Series*. It's a disorienting title as you ask yourself why the associations engendered by the first word of the title are not redeemed, as the reader tends to expect of a common composite, like *Bus Lines* or *Bus Stop*. It is a title that arouses our curiosity because it compels you to ask yourself what this combination of technical movement and aesthetic structure implies, and why Frank picked exactly this title for a change of medium that presumably proved itself to be inevitable for him. From this perspective—this could be a starting point—the particular dynamics of this step might be the crossing of two initially separate lines, travelling and an interest in serial work. Their connection literally forces the change from photography to film. In November 1958, he completed *Les Américains/ The Americans*—in January 1959, he began shooting *Pull My Daisy*.

Frank's biography registers the traces of a traveler. These traces are first outbound and lead us to different countries and cities. Soon, however, there is a movement back-and-forth between two extreme places and spaces, between the locations of the film *Home Improvements,* mentioned in its opening credits, New York and Nova Scotia. These two places figure again and again as points of reference in his diary notes: ‚Mabou, 5. 1. 1998: ...that day—I thought that I am the old snapper looking out my window snow flakes coming down the next day flight to New York—find out what's going on.' (p. 69) In Robert Frank's case travelling, however, is much more than just a set of biographical dates. Travelling, movement, a life on the road, they are all related to his photography. Working on *The Americans*, his itinerary shows the dynamics of a temperature-chart, or a stock-market index. These images show, as was pointed out time and again, the gaze of someone travelling 'in a strange and wonderous world always in

WOLFGANG BEILENHOFF

1 Quoted in Schaub, Martin, 'FotoFilmFotoFilm: eine Spirale. Robert Franks Suche nach den Augenblicken wahrer Empfindung,' in: *Cinema* 1984, 30, p. 75

search of himself.'[2] The destination are still wide open spaces in this series. The *Bus Series*, which Frank considers decisive in his movement from photography to film, takes a conspicuously different approach. He no longer expands in an open space, but delves into the realm of a single city. He uses no longer a car, the medium of total mobility, but takes the bus instead, the medium of urban communication. Through the windows of the bus, or at bus stops, he photographs people on the streets of New York City, among them passengers ready to leave, their eyes focussed on the uncertain (p. 66–67).

The *Bus Series* is not just determined by the impulse to travel. At the same time, there is a specific aesthetic quality to it as the title points out. It has a serial quality because Frank replaces the single image with sequences of images, groups of three or four photographs shot in rapid succession. In traditional photography, the transgression of the single image leads to a linear sequence of single moments[3]. Frank, however, has an other approach to serial photography. He is not interested in chronology. He is looking for an intrinsic, intelligible movement that is not built from rigid segments of time. Not quite accidentally, he describes this movement with the metaphor 'riding by' as a an attribute of his own gaze. 'I like to see them one after another. It's a ride bye and not a flashy backy.'[4]

In this metaphor we see the two lines of the serial and of travel conjoined, pushing towards another medium, film. The 'riding by' Frank is talking about is imaginary. He alludes to the transformation of exterior and literal travel into an interior and imagined travel. Historically, this shift was introduced by film, the successor of photography. Consequently, the decisive aspect is not the various vehicles of transport that we encounter time and again in film history, either as narrative devices or alluring spectacles, all those locomotives, steamships, cars, airplanes, or spaceships. They rather have a merely symptomatic status. Decisive is that film is itself, both technically and aesthetically speaking, more or less synonymous with travel. The serial quality of film, technically speaking, consists in the leap from a mere combination of numerous single images to one moving picture, made up from countless single frames. 'Dissection and synthesis will only coincide in cinema.'[5] 'Aesthetically speaking' means that the movement of a person, still a prerequisite of the *Bus Series*, is replaced by an imaginary movement, a continuous displacement 'between here and there,'[6] as John Berger writes.

Robert Frank repeatedly spoke about the difference between photography and film, photography's Other. Like John Berger, he thinks about modes of looking in relation to their specific technical and aesthetic medium: 'When I make films, I continue to look around me. But I am no longer the lonely observer who turns away after clicking of the shutter. On the contrary, I try to regain what I have heard and seen, what I have felt, what I have known. There is no 'decisive moment.' You have to create it. I have to do what is necessary to make it appear in front of my lens.'[7]

Robert Frank's films created these 'decisive moments' again and again in the following years. However, he didn't systematically bring them about, rather step by step. Chance and contingencies—experiments, new imaging technologies, social configurations—determine his films to a degree that would not permit a systematic approach. Chance and accidents are not only trademarks of the production of his films, but also of the films themselves, governed to a high degree by the poetry of chance and contingency. Consequently, I will not talk about them in a linear order[8], but with a focus on certain decisive developments. I will not focus on the systematic merit of single works. Instead I will look at conspicuous details that highlight Frank's unique approach. An

2 Brookman, Philip in: Greenough, Sarah and Brookman, Philip (eds.), *Robert Frank. Moving Out*, exhibit. cat. National Gallery of Art, Washington, D.C., Kunsthaus Zürich, Zürich 1995, p. 148
3 See Ruchatz, Jens, 'Ein Foto kommt selten allein. Serielle Aspekte der Fotografie im 19. Jahrhundert,' in: *Fotogeschichte. Beiträge zur Geschichte und Ästhetik der Fotografie*, 1998, 68/69, pp. 31–46
4 Quoted in Greenough, Sarah and Brookman, Philip (eds.), *Robert Frank. Moving Out*, exhibit. cat. National Gallery of Art, Washington, D.C., Kunsthaus Zürich, Zürich 1995, p. 204
5 Engell, Lorenz, *bewegen schreiben. Theorien zur Filmgeschichte*, Weimar 1995, p. 54
6 Berger, John, 'Ev'ry Time We Say Goodbye,' in: Berger, *Begegnungen und Abschiede. Über Bilder und Menschen*, Frankfurt a.M. 2000, p. 17
7 Quoted in Schaub, Martin, 'Das Leben tanzt weiter,' in: *Zoom* 1999, 1, p. 18
8 See Horak, Jan-Christopher, 'Daddy Looking for the Truth, or Authorial Power and Despair: The Films of Robert Frank,' in: *Afterimage*, 16, 1989, pp. 8–13

open encyclopedic list is the form I chose to show this, including places and spaces, people, historical incidents, aesthetic programs, or puns. The recourse to an alphabetical order is indebted to the mise-en-scène of the alphabet in American experimental movies from the 1970s, such as those by Hollis Frampton. Like in his cinematic experiment *Zorn's Lemma* (1970), there will be only one 'take' for each letter.

II. A Throw of the Dice

A animal locomotion

The title of a famous series of photographs by Eadweard Muybridge (GB, 1887): the movement of a galloping horse, dissected in single shots, a pure study of movement. A decade later, animals start their career in film with Auguste Lumière's *Le Déjeuner du Chat* (France, 1896), as part of a narrative. We often encounter animals in Frank's work. They are part of his everyday life in Mabou and are starting points for questions and views. In *The Present*, we see a horse, while we hear the filmmaker's voice, sounding as if he were reading out an entry in an encyclopedia. 'What kind of animal is this? This is an animal that is called.' The voice abruptly stops. 'Photography's fear of the word,' the fear of being assimilated by words, is among Frank's recurring topics.[9]

B blind

In *About Me*, Frank, while visiting the house of his parents, addresses the disability of his mother. 'My mother is blind.' In *Life Dances On*, June Leaf tries to teach a blind friend of Frank's how to take pictures with an old camera. The old camera and the clicking noise of the shutter remind us of a corresponding scene in *About Me*. It takes place outside. June's disheveled hair indicates a strong wind. On the sound track we hear a toy windmill. Frank comments off-screen: 'The part where June is trying to teach the blind man to photograph, I like that.' The idea of a blind man taking photographs—the very paradox of this image, generated by a blind man looking through a view finder—clearly indicates that Frank considers photography an attempt to inscribe something accessible only to imagination and to memory onto the visible world. The particular role of the wind in this context is an aspect the blind Slovenian photographer Evgen Bavcar emphasizes, too: 'The wind has the wonderful power to recall to my eyes images of a time long past...'[10]

C chaos

'searching... explaining... digging... looking... judging... erasing... pretending... distorting... lying... judging... recording... crying... singing... encouraging... cutting... whispering... hoping... talking... instructing... screaming... hoping... helping... trying... trying... trying... running... telling the truth... running... climbing ... searching for the truth... what a chaos until everything is done.'[11]

9 See Eskildsen, Ute, 'In Conversation with Robert Frank,' pp. 106ff
10 Bavcar, Evgen, *Das absolute Sehen*, Frankfurt a.M. 1994, p. 30

A succession of words, guided by the serial principle. Verbs in close-up. A text that reveals Robert Frank's intensity and restlessness, postulating chaos as the ferment of every activity.

D diary

Film diary/diary film: Diary film becomes popular in the mid-60s as a new kind of self-discovery. The filmmaker points his camera at himself and his own private life. Jonas Mekas has filmed fragments of his everyday life since 1949 ('If I can film one minute—I film one minute. If I can film ten seconds—I film ten seconds.'[12]). Twenty years later, he assembled this material in a diary film called *Diaries, Notes and Sketches*. Mekas considers the necessity to immediately record any event as it occurs as the specific challenge of the film diary in comparison to the literary diary. The connection of the diary to absolute immediacy shows itself in an exemplary fashion in one of Frank's film titles: *The Present*. On a very basic level, we encounter it as a mere note, as a spoken diary entry: 'Today is the 26th of January. I'm celebrating the new jacket.' A more intricate example is a diary, written after the death of his friend Werner in Zürich. We first hear Frank's voice, saying good-bye to his faraway friend: 'Good bye, Werner. Good bye, Werner.' We see a portrait of his friend, then a bed with a shabby covering. We see the diary, the camera pans from the right page, covered with writing, to the left page on which we read a single sentence: 'New Year's Day 1996/Werner died in Zurich.'

E Erinnerung (memory)

Frank's voice off-screen in *The Present*: 'Today I'm going to ask Luigi (audible pause) to erase the word memory.' We see the word 'memory' written on a wooden wall and Luigi trying to scrape it off. He only manages to erase the syllables 'ry' and 'mo.' What remains is 'me.' It's a pun on the difference of the two meanings of the word 'memory'—the faculty by which things are remembered and the act of remembering itself, i.e. a representation in memory. We may be able to erase, violently at least, part of our memory. Yet this erasure constitutes a new word 'me' that can't be erased. The contrast between inside and outside, frequently addressed by Frank, is shown here as a pun on the surface of the text.

F Fenster (window)

In *Home Improvements*, the camera pans on a window, looking onto a distant pole and the sea. While the camera zooms in on it, we hear Frank's voice, punctuated by pauses: 'I look out the window. And what do I see? Communication.' The use of the window as subject matter refers to a long tradition of the window as a means of observing. The window reveals the movement back and forth between outside and inside: 'I am always outside, trying to look inside.' At the same time, its very structure makes it possible to draw borders and to emphasize something. As Frank says in *The Last Supper*: 'He took my innermost thoughts and put them in a frame.'

11 Quoted in Schaub, *op. cit.*, 1984, p. 83
12 Mekas, Jonas, 'The Diary Film,' in: Sitney, P. Adams, *The Avant-Garde Film: A Reader of Theory and Criticism*, New York 1978, p.191

G garbage

In *Home Improvements*, Frank carries his trash down to the street. He records this quotidian act on his video camera and treats the two garbage bags almost like stars: 'View to the shore. Reverse angle of garbage bags.' After briefly greeting the garbage man, he exclaims: 'It's a big moment! It's a big moment!' The insistence of his representation of so mundane an act is conspicuous. Like a character in a play by Beckett, he deposits the two trash bags and steps back to observe from afar what will happen to them. Looked at from a distance, the trash already belongs to an another time. The voice, however, is entirely part of the present: 'Wonderful. Some winter.'

H home movie

In the five-minute video tape *Flamingo*, we see a heavy car crane displacing a house. The jittery camera and the voice over are reminiscent of a home movie. Other formal devices, like jump cuts, sudden changes of place and time, various technical shortcomings, are familiar from other home movies by Frank. The recourse to this genre indicates a wish to use the private and the intimate as starting point for and mode of communication. And yet, there is a difference to the amateur filmmaker who uses technology to merely record his private life in order to show it in chronological order to family and friends. The 'private sphere' in Frank's work is discursively investigated and reflected. It is a *Home Improvement*, as one of Frank's film titles suggests.

I iconoclasm

Iconoclasm: the abolition and destruction of religious imagery. Or more broadly speaking: the rejection of any form of representation. In *Home Improvements*, we observe the following iconoclastic gesture: After Frank has negotiated the donation of his photographs to the Museum of Modern Art, he asks a friend to drill holes through a large pile of prints. We see and hear the drilling machine piercing the images. Once again, as with the two trash bags, it is a story encoded in ordinary acts. Frank is aware of his status as an artist and, at least for the time of this action, rebels against it. The prints were later included in a collage *Untitled* (1990).

J Julius

Julius Orlovsky, the catatonic brother of the poet Peter Orlovsky, the protagonist of *Me and My Brother*, a movie from 1968. It is an inquiry into the relation between acting and not acting, an eerie premonition of future TV shows. When Julius, who plays himself, disappears during the shooting, another actor plays him. In one scene we see images of Julius projected onto a screen behind the actor. The sound switches constantly between the two Juliuses.

K Kamera (camera)

'The video camera—I mean the latest and smallest models—is a very per-

sonal and intimate tool. It affects the consciousness of its user in ways entirely different from a photo or film camera. (...) When the video camera is on, I always feel that it is a kind of 'moment of truth.' Working with film never gives you this feeling of intimacy. There are too many machines involved and too many other people. You are alone with your video camera. It's like a pencil. You can say things that you could never say with film.'[13] *Home Improvements*, *The Present*, *Flamingo* were recorded on a video camera: domestic films.

L landscape

In *Life Dances On*, we see photos of his daughter Andrea and his friend Danny Seymour superimposed with shots of a deserted landscape in Canada. In the tradition of Romanticism, landscape always served as a mirror and as a screen for the expression of inner processes, for memories in this particular instance. Open spaces and landscapes are always colored by Frank's own thoughts and feelings. But he also demonstrates the contrary. In *Home Improvements*, we can see the four letters of a compass card flashing up in a window for a few seconds.

M monitor

The photograph *Andrea and Pablo, Los Angeles* (1955) shows Frank's children, Andrea and Pablo, transfixed by a TV set in a motel room. We can vaguely discern a cartoon on the TV screen. The monitor seems like a light sculpture, frontally illuminating the two kids. At a conspicuous distance, we see two framed portraits of movie stars hanging on the wall. The photograph creates a marked tension between the two poles, between the two media film and TV. It amounts to a kind of visual commentary on Hollywood's crisis in the second half of the 1950s.

N NAC

New American Cinema: An association of 23 filmmakers, among them Alfred Leslie, the co-director of *Pull My Daisy*. Point 1 of their *First Statement* of September 28, 1960, signed by Robert Frank, reads: 'We believe that cinema is indivisibly a personal expression.'[14] Robert Frank has an outsider's position among the film avant-garde because he partially rejected the purely intrinsic aesthetics of the avant-garde. In *Life Dances On*, we see a long, vertically almost quadratic hallway, astonishingly reminiscent of the hallway in Ernie Gehr's *Serene Velocity* (USA, 1970). But whereas the hallway triggers hallucinatory perceptions in Gehr's film, it appears as an architectural device of power in Frank's film.

O original sound

In *Conversations in Vermont*, we frequently see Frank with a microphone in his hand. We hear the original sound of his voice. It's a controlled, calm voice with a slight Swiss accent, a reminder that he is in a foreign country with his voice. At times, we hear the sound of the wind, a pronounced reaction to the calm harmony of a soap opera. Both the visual transgres-

13 Quoted in Schaub, *op. cit.*, 1984, p. 89
14 Quoted in Sitney, P. Adams, *Film Culture Reader*, New York 1970, p. 81

sion of the requirement to hide microphones and the aural transgression of standard noise-free sound indicate that Robert Frank's cinema is a cinema of the spaces in-between.

P poetry

'The sun is up,' says a woman's voice. We see—filmed from below and in a sweeping camera movement—the silhouette of wind-swept trees against a morning sky. An uncommon shot for a home movie with the exotic title *Flamingo*. Like the early 'rocking wave' films, whose only purpose was to show the movement of waves, *Flamingo* concentrates in these few shots entirely on the movements of trees and leaves. These takes are consequently silent. And as in the cinema of the 1920s, nature becomes a mirror for a few moments.

R Ruhm (fame)

'Robert's name is fixed in the stars. He knows that he is a historical figure. I'm on the outside. Being famous has had an effect on him.'[15] This effect transforms his films into a stage where Frank negotiates his fame with himself. In *Home Improvements*, someone is leafing through a small photo book, and we see Frank's photograph of the three postcards (p. 30). 'One of my favorite pictures, ' he proclaims. In *Life Dances On*, Frank stages an 'accidental' meeting of the film crew and some art students. In an acted interview, a member of the film crew asks the students for the names of famous photographers. When they mention the name of Robert Frank, besides Dorothea Lange, Edward Steichen, and Edward Weston, the crew says: 'We wanted to see if you know who he is.'

S script

In *The Present*, we first notice an empty note pad and a pencil. A male voice off-screen reads from a letter to Frank about his wife June Leaf's bad health. There's an abrupt cut, and we watch a hand impetuously sprinkling coal dust on the note pad. A finger traces the word 'FIGHT' in the coal dust. In writing we open ourselves to others, not just in the manifest content of the writing, not only in this exhortation to fight, obviously addressed to June Leaf. The writing finger introduces a body, expressing itself in the slow movement, the pressure on the coal dust. Conspicuous about the use of writing in Frank's films is the predominance of hand-writing, the re-connection of writing to the body.

T This & Here

January in Mabou. 'It's a wonderful morning.' Frank walks over to his car. Its windows are frozen: 'I have to scrape the windshields. HERE is the scraper. And HERE is the windshield.' Every language has a group of words that can only be understood in relation to the position of the person speaking in time and space. These are the so-called deictic forms (from the Greek word for 'show'), among them the local THIS & HERE. The effect of the deixis here is an emphasis on the present. The film is called *The Present*.

15 See Eskildsen, Ute, 'In Conversation with Robert Frank,' pp. 106ff.

U underground

Frank's first film *Pull My Daisy* (1958), together with John Cassavetes' *Shadows* (1959), presents a blueprint for the future underground film as an aesthetic, narrative, and existential dissent from American society and the culture industry.[16] The title of the film is taken from a nonsensical poem (1948) by Allen Ginsberg. The plot is modeled on Jack Kerouac's play *The Beat Generation*. In a spontaneous and often improvised manner, the film recounts the story of a young 'bishop' who is invited by Milo, a brakeman, to his apartment where he meets a group of Beat poets and jazz musicians. The film uses numerous 'classic' Beat motifs, like an impromptu poetry reading, a jazz performance, or references to Zen Buddhism. (The Times called it 'Zen Hur.') Thus, *Pull My Daisy* is distinguished by its combination of fictional and documentary material, of art and life. Jonas Mekas remarked in his *Notes on the New American Cinema* (1962) that this film is a perfect combination of 'the element of improvisations and conscious planning. (…) Its authenticity is so effective, its style so perfect, that the film has fooled even some very intelligent critics: They speak about it as if it were a slice-of-life-film (…), a documentary.'[17] They did not realize that Beat poets Allen Ginsberg, Gregory Corso, and Peter Orlovsky, painters Larry Rivers and Alfred Leslie are appearing as themselves, but are simultaneously acting a part, i.e. their own. Jack Kerouac is narrating the voice-over. In one passage, he develops in a kind of spoken singsong an entire litany of the 'holy.' 'Is baseball holy? Is alligator holy? Is glasses holy? Is holy holy?'

V Väter (fathers)

In *About Me*, we see Robert Frank's father in Zürich. He is sitting at his desk, looking at images in a stereoscope. In an iris shot, we see Robert Frank as a boy. In Frank's own films, too, we encounter a number of scenes in which he, as author and narrator, studies a photograph of his son. Both fathers find an approach to their sons by looking at their portraits. Family, as the central social structure for Frank, is visually structured to a high degree. There is a media genealogy, so to speak. The fact that the fathers take the pictures, shows the highly gender-specific importance of Frank's mother's blindness in *About Me*.

W Würfel (dice/cube)

The video work *The Present* ends with the following scene: A man is shaking a transparent, cylindrical plastic container, at least 20 cm long, full of small, colorful dices. He picks out two dices and throws them twice. The first throw of the dices adds up to 10, the second to 7. He says. 'I lost. But so what! That's the question.' Media theorist Vilém Flusser understands the dice and the ball as two different concepts of the world: 'The ball represents perfection, order, and the cosmos. The dice/cube represents edginess, chance, and chaos.' Frank's films are free of any concept of 'perfection.'[18] Instead, there are recurring states where everything can communi-

16 See Brinckman, Christine Noll, 'Vom filmischen Alltag der Beats. Pull My Daisy,' in: *Cinema* 1998, 43, pp. 102–119
17 Mekas, Jonas, 'Notes on the New American Cinema,' in: Sitney, P. Adams, *op. cit*, p. 95f
18 Flusser, Vilém, 'Zum Würfel,' in: Flusser, *Nachgeschichte*, Düsseldorf 1993, p. 185

cate with everything else. Sometimes, like in this video tape, he addresses this kind of communication.

X X-mas

In *Home Improvements*, we look down on Bleecker Street from an apartment on one of the upper floors of the building. Scattered scraps of paper are swept away by the wind, like leaves in autumn. Accompanied by Ravel's *Bolero*, we hear Robert Frank speaking: 'It's Christmas day. It's cold. It's 1984. My camera looks down Bleecker Street.' From the right, cars cross the screen: 'I'm listening to the music. And I'm looking at the Christmas wrapper blowing in the wind.' On the sidewalk across the street, a man is bending down to pick up a piece of paper: 'And I'm thinking of Kerouac when he said: Being famous is like old newspapers, blowing down Bleecker Street.' In the early 1960's, the Film-Maker's Cooperative held its screenings at the Bleecker Street Cinema.

Y GermanY

'A mystical traveler going by train by car thru the Landscape of the German Ruhr. Encounters with inhabitants. Signs of Life, Language and Landscape (...) Unbestimmt, unsicher—this is the process of finding-searching (...).' In this script written by Frank for his film *Hunter,* set in the German Ruhr area, the words 'unbestimmt, unsicher' (vague, uncertain/insecure) are in German. The movie outlines the story of a man who fears that he will never find what his imagination promises to him. Once again, travel functions as a quest for an identity. Repeatedly, we encounter signs of history: written on a blackboard in a schoolroom we read: 'Warum/WhY.'

Z Zitat (quotation)

In his poetological essay *Conversations with Dante*, the Russian poet Ossip Mandelstam conceives the quotation as a voice of its own: 'A quote is not just a copy. A quote is a cicada. It can't be silenced anymore. Once it chimes in, it will never stop.'[19] Frank's films are full of quotations. They open up the film by letting another voice enter it. Photography has special function in this regard. It implants a kind of polyphony of media in Frank's films.

III 'I make home movies—therefore I live.' (Jonas Mekas)

Frank's films are not striving for epic qualities. They show us micro-narratives, stories connected to Frank's biography, to his family, his friends, his work as photographer. They show us things and incidents in his ongoing everyday life: a coal stove, a notebook, crows in January's snow. Frank always stressed the connection of his art work to his own life. 'My works are interwoven with my own life. I can never stray very far from it.'[20] However, he immediately qualifies the metaphor of 'interweaving' with a second metaphor. It not only signals that 'interweaving' is not about the collapse of the distinction between art and life. It also specifies how we should understand this concept. 'The films that I made are the maps of my journey through this life.'

19 Mandelstam, Ossip, *Gespräch über Dante*, translated by Wolfgang Beilenhoff and Gabriele Leupold, with an afterword by Wolfgang Beilenhoff, Berlin 1984, p. 12
20 Quoted in Greenough, Sarah and Brookman, Philip (eds.), *Robert Frank. Moving Out*, exhibit. cat. National Gallery of Art, Washington, D.C., Kunsthaus Zürich, Zürich 1995, p. 146, footnote 9

'Interweaving' and 'map' are metaphors describing the relation of art and life from different perspectives. One is a metaphor suggestive of closeness and the domestic sphere. The other is a metaphor reminiscent of projection and being on the road. In this context, the metaphor of the 'map' has a specific significance. Maps are representations of concepts intended to enable us to orient ourselves. If the films are indeed maps, Frank has to make choices. He must decide on an angle and on the scale. However, the map is no longer related to space, but to 'this life.' Frank specifies this task, too, with a metaphor: the language object *words*, written on black photo-paper (p. 59). A sheet of words, hanging on a clothes-line, stirred by the wind, by life itself, it refers us back to the 'map' we need to reflect and articulate 'this life.' *Words*, after all, is also the title of the English translation of Sartre's *Les Mots*. It is the title of an auto-biography.

'Autobiographical,' the keyword for the word-image described above, characterizes the New American Cinema. Among those who signed its *First Declaration* of September 28, 1960, were (besides Frank) later feature-film directors, like Peter Bogdanovich and John Cassavetes, as well as underground filmmakers, like Gregory Markopoulos and Jonas Mekas. In this declaration, they decidedly set themselves apart from Hollywood and its industrial manufacturing of images and sounds. They advocated the autonomy of the director and proclaimed film a medium of 'personal expression.'[21] This principle not only spurred the development of an impressive variety of individual aesthetics, but it also inspired filmmakers to use film to reflect their own lives to an unprecedented degree. In film diaries they recorded their personal lives as a ruptured sequence of singular, isolated moments whose value lies in themselves. It is epitomized by Jonas Mekas' *Lost, Lost, Lost*, diary notes made public as a film, shot between 1949 and 1969, released in 1975. Another form of cinematic autobiography examines the filmmaker's life as the difference between past and present selves, like in Jerome Hill's *Film Portrait* (USA 1972), a study on the difference of time structures in language and film, or Stan Brakhage's *Scenes From Under Childhood* (4 parts, USA 1967–70), in which manipulation of the film material in post-production marks the presence of the filmmaker.

Robert Frank used both of these cinematic forms of 'mapping' one's own life. Written entries, like '4 a.m. turn on TV,' or spoken comments, like 'Every day I want to make a piece of video,' engender *The Present*'s diary character. At the same time, we encounter other ways of addressing the I, like the 'memory' written on a white, wooden wall, which can't be entirely erased, leaving behind a 'me.' At times, the 'I' is part of the films' title, like in *Me And My Brother* or *About Me, a Musical*. It's the 'I' that Frank wants to chart in the autobiographical genre, to which films, like *Life Dances On*, *Home Improvements*, *OK. End Here,* belong as well as *Conversations in Vermont*, his first autobiographical film, which I will later discuss in detail. Autobiography, and not the diary, turns out to be the map Frank uses to locate his self, to get a clear idea of his present state, of his present and past selves. Frank is always conscious that he doesn't do this as a private person, but rather as an artist. This is an ambivalent concept for Frank, but it is nevertheless crucial as his work is intended for an audience. *Conversations in Vermont* is of exemplary importance in this context.

In a series of extremely short, almost lightning-like shots we see Frank cleaning the lens of the camera with a cloth. Once or twice, he leans back to check whether the lens is

21 See footnote 12, *ibid.*

clean. However, we do not observe this from the outside, we rather see it from the camera's perspective, as if we were on the other side of a pane of glass. We observe Frank approaching us and stepping away from us. In the beginning, we hear the penetrating siren of an ambulance. Frank shows no sign of noticing it. He explicitly points out the bad sound quality of the blues song by Bessie Smith that he plays afterwards: 'Something is the matter with the record player.' He hums the song's melody.

In this sequence, Frank tunes his camera, like a musician would tune an instrument. The extremely blurry quality and the distorting perspective expose the camera not only in its 'technomorphicity.'[22] They also turn the camera—referring back to itself—in an indicator of reflexivity. Frank uses his reflexive tone again, which blocks any sort of illusionism, and intensifies it. We see him performing the motions of a craftsman. It is a person who moreover emphasizes that we are not looking at an actor, but at someone familiar with the technical features of a camera, and who showcases himself as such. He is a filmmaker.

Consequently, we have an obvious progression of self-reflexivity. First, a self-reflexivity in relation to the camera, in the tradition of the classic avant-garde. The second is in the tradition of the New American Cinema, i.e. in relation to the author Frank, introducing and defining himself as a filmmaker. He fuses the identities of himself in and outside of the film in an act that is constitutive for an autobiography. 'Most of these filmmakers share (…) a primary concern with the self as maker and person and make that quest dominate their films.'[23]

The 'I,' the interwoven identity of the pre-filmic and filmic person at the center of this autobiography, defines itself not exclusively as a filmmaker. Immediately after this introductory reflection on the status of the camera, we see family photographs and public photographs of Frank. We hear his voice recounting biographical details. But we don't see Frank himself. It is neither a regular voice off-screen, nor a regular voice-over. It is an autobiographical voice. Speaking in the first person singular, he emphasizes that he is not only making the statement, but is, at the same time, the person who is being talked about: 'This is a film about the past, which goes back nineteen years, when Mary and I got married.' He continues and specifies: 'We got married on 11th Street. I had a loft there, and the first thing we moved in there was a piano.' His voice develops more stations of his own past, the birth of his kids, travels, professional success. Each of these stations is verified by showing the corresponding photographs. At the same time, the voice addresses the present as the other limit of the time frame of this film, when we hear the voice talking about the material 'which I took where my children go to school' in Vermont. At the end of the prologue, we see a superimposition of historic, private, and public photograph moving in opposite directions. Frank is inserted among these super-impositions. As in the beginning, we hear his voice in the off, presenting the time frame of the film with a reference to the first sentence: 'It's about the past and the present.'

Someone is about to start talking about himself, and not someone else. Someone is questioning himself, and not someone else. Someone who initially defines himself as filmmaker and talks as the protagonist of the film about stations of his life. Someone who tells us all of this at the same time, who says 'I' when he talks about himself. All of this emphasizes the concision of the prologue's development of the identity of author, narrator, and protagonist that is constitutive for an autobiography. Philippe

22 I refer to the distinction between a technomorphic and an anthromorphic camera in: Brinckmann, Christine N., *Die anthromorphe Kamera und andere Schriften zur filmischen Narration*, Zürich 1997, pp. 277ff.
23 Ruby, Jay, 'The Image Mirrored. Reflexivity and the Documentary Film,' in: Rosenthal, Alan (ed.), *New Challenges for Documentary*,' Berkeley/Los Angeles 1998, p. 72

Lejeune's extensive study on autobiographies shows that this identity enters into effect only when a contractual 'agreement on identity,' the real essence of the autobiographical genre, is achieved. In a literary autobiography, this is accomplished by using an 'I,' who 'writes down the history of his own life,' and who 'mentions his own name'[24] in this account. In an autobiographical film, or at least in this film without opening credits specifying the author's name, the option of constructing an identity on the basis of language is not used. Instead the 'I' 'mentions his own name' by using photographic and filmic self-portraits throughout the film. At the same time, they make it apparent that 'the autobiographical impulse and a love for anonymity (...) cannot possibly coexist in the same person.'[25]

The aim of the prologue, however, is not just the construction and achievement of an 'agreement on identity.' The narrator not only outlines the specific time axis of the film, he simultaneously specifies the horizon of its subject matter and medium by calling it 'some kind of family album.' 'Family album' is a keyword that not only defines 'map' and 'interweaving' more precisely, but also signals the return of photography in film. The transgression of photography mentioned in the discussion of the *Bus Series* is reversed as film and photography enter in a direct relation to each other. One medium, photography, appears in the other, film. The voices of the two media enter into a dialogue. However, this dialogue never approaches film and photography from the perspective of a critique of media, like structural filmmaking of the 1970s did. Its aim is to aesthetically and emotionally reinforce the poetics of the in-between. On the one hand by translating film and its hundred thousands of frames back in photography, thus paradoxically achieving the status of an exhibit on display (p. 32-33). But mainly by integrating photography in film in various ways: as a carrier of social identity, as a medium of remembrance, and as an aesthetic objet. Photographs become an 'actors,' playing a number of roles. And film itself becomes their 'stage.'

This mise-en-scène first shows the experience of time characteristic of family photographs. The process of recollection, triggered by family photographs, is a paradoxical intertwining of past and present because it enables us to recall past selves in our present state. In *Conversations in Vermont*, this recollection is achieved by series of photographs integrated in the film's narrative (Frank's visit to his kids) as time zones of their own and as thematic indexes.

The first series of photographs is presented without any introduction, just a jump-cut after Frank's arrival in Vermont. It traces the relationship between Frank and his kids. We overhear a short dialogue between Frank and Pablo about the mistakes you can make, as Pablo says, 'when you have children,' and about photographs that show, as Frank points out, 'something that parents created by bringing up a child like that.' In the course of the conversation, Frank ponders not only the memories tied to these photographs, he also makes a conclusive remark: 'Looking all over these photographs, I do realize how tight Mary and I were about living our way and not giving really into the children in any, any which way.'

When we look at the five series, or chapters, each consisting of numerous photographs, we notice that they conspicuously correspond to the visual discourse of a family album. After all, we encounter all the canonical motifs of family photography: the smiling child, the pram, the child and the cat, the parents holding the child on their arms, the first toy, brother/sister. We observe the ritualistic occasions of such photographs: ‚Pablo, six months old,' the visit to a museum, the family outing. In respect to

24 Lejeune, Philippe, *Der auto-biografische Pakt*, Frankfurt a. M. 1994, p. 36
25 *ibid.*

their subject matter and the logic of their production, these photographs, regardless of their specific personal style, show to what a degree families in media societies are constituted as a social formation by the discourse of family photography.[26]

Usually, the father, as the producer of the image, who decides on what it will show, is absent in family photographs. Frank, however, is intermittently present in the photographs, and continuously visible in the film. But this is not the only transgression of the discourse of family photography. He breaks the laws of the media constellation 'family album,' which assigns a chronological measure to the images, by implanting photography in another medium. Thus, he correlates two visual media, each with a temporal structure of its own. Photography with its historical status is integrated in film, and consequently punctuates the continuous present of the filmic image with temporal non-sequiturs, 'breathing-spaces' (R. Frank). His most significant transgression of the family album is the creation of a continuum of film and photography, of past and present, by placing the photographs in the perspective of filmic montage, filling these 'breathing-spaces' with his own voice. It's a voice approaching the photographs mostly from the outside. It addresses, as the voice of the autobiographer's 'I,' another aspect of Frank's work. He called it 'commissioned work' in the prologue, i.e. his public work.

Sometimes Frank stages a direct confrontation of his family photographs with his art photographs. The first series of photographs mentioned above opens with the well-known photograph *Men of Air*, a gigantic inflatable doll, rising up among skyscrapers. For a brief moment, it lies, like a stamp, on top of the pile of family photographs we are about to see. At the same time, he addresses the other context in which public images appear. In *Conversations in Vermont*, we see a close-up of the photograph *Paris* (1951-52). The camera pulls back from it, and we realize that the image is on display in an exhibition. Or we encounter photographs in a book or a magazine. In the prologue, for example, we observe someone leafing through a special edition of *DU* magazine, dedicated to Frank, and we recognize the photographs 'which became famous.' They are no longer part of his personal biographical time. They have become part of the time of history, of the history of photography, of the museum.

Autobiography also implies coming to terms with being an artist, as Frank indicates by quoting his own photographs. The mapping of the 'I' can only be successful if he reflects himself as an artist and shows an awareness of working for a public beyond the confines of the merely private. The reception of regular family photography takes place within a closed private space, where the persons depicted on the photographs are simultaneously the audience. In contrast to this circular structure, Frank has to find an approach to creating photographs under similar circumstances that transgresses the limits of the merely private. To escape mere mediated voyeurism, he has to amplify these family photographs aesthetically if he wants to show the private and the quotidian in its unique singularity, its 'here' and its 'now.' This aesthetic quality results in the photograph gaining the status of an object, a paper object, which may be large or small. It's an object we encounter as either single print or contact sheet. It has a distinct material quality, whereas film constantly denies its own material quality as it is perceived as a projected image.

The material quality of photographs makes it possible for them to literally turn into 'actors.' They enter, as paper objects, the realm of the diegesis. Thus, like any other object in a film, they become subjects for the camera. At the end of *Conversations in Vermont*, a contact sheet fills the entire screen. It's Frank's answer to the structure of

26 See Holland, Patricia, 'History, Memory, and the Family Album,' in: Spence, Joe, and Holland, Patricia (eds.), *Family Snaps: The Meaning of Domestic Photography*, London 1991, pp. 1–14

the family album. The camera pans the sequences and suddenly stops on certain photographs. It looks, zooms in on the image, as if it had found what it was looking for. A woman on a bed, her husband sitting on the edge of the bed. The camera moves on to a similar photograph, moves back to the first. It becomes a comparative camera, recording the photographs in a gesture reminiscent of reading. This is only possible because the photographs are the subjects of this film, thus open to a variety of gestures.

The gesture of reading as an instance of 'mapping' is contrasted with the gesture of 'excavating.' Frank is sitting on a meadow with his children, looking at a pile of photographs, the opposite of the rigid order of a family album. A hand enters the frame from the outside and calmly draws photographs aside, one after the other. It's a gesture very different from leafing through the traditional linear structure of a family album. It is reminiscent of an excavation, laying bare one layer of soil after the other, a kind of archeology.

Frank gave a playful expression to this connection of the technical image to the body, this experimental tactile quality, in *Flamingo*, certainly the most domestic of his home movies. The film stands in a close relation to the later *Tools* (p. 4-5). It demonstrates that cinema, as the medium historically succeeding photography, is a medium of the domestic and the quotidian, just like its predecessor. In the beginning, we see a screen in a living room, lit by a projector. It's a classic home-movie setting. A hand with a sheet of slides enters the image from above. We then see a single slide moving horizontally across the screen, a stop-motion trick. It's like early cinema, it's pure spectacle. And, at the same time, a condensed domesticity.

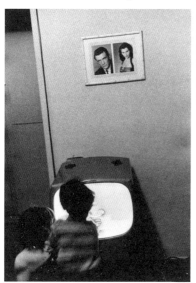

2 ANDREA AND PABLO, LOS ANGELES 1955-56

Prof. Dr. Wolfgang Beilenhoff teaches film and television studies at the University of Bochum.

HOLD STILL _keep g oing

image in image
images to images

UTE ESKILDSEN

'Now I travel maybe more inside than outside.'[1] Robert Frank likes to speak in metaphors that he enjoys to dissolve or contradict with actual concepts in the next sentence. Frank loves jumps and discontinuities—he relies on intuition. He is one of the few photographers of the postwar era who, after working in commercial professional photography, found a way of his own in art photography and became extraordinarily successful.[2]

After his apprenticeship in Switzerland and a brief interlude as magazine photographer in New York, he shunned steady employment, but accepted commissions as he had to provide for his family since the early 1950s. When he left Switzerland in 1947, he dreamt of a career as photojournalist, maybe even of becoming a *LIFE* photographer, i.e. joining the team that, from a European perspective, pushed the limits of photojournalism. If Robert Frank had won the first prize of a LIFE competition in 1951 with his photo-essay *People you don't see*, he most likely could have joined its staff. Yet, we can hardly imagine him tolerating the subordinate position of a magazine journalist for a long time. And a glance at his approach to his own photographs from around 1950 clearly shows that he wanted to publish his photographs in a book.

His various travels in the 1950s were characteristic of the desire of the European postwar-generation to explore the world. The possibility to live from 'travel photography' depended and still depends on photo-editors. Frank got his first commissions from the Russian immigrant Alexej Brodovitch, the powerful art director of *Harper's Bazaar*. Lou Silverstein who was in charge of advertising at *The New York Times* also trusted in Frank's photography and gave him as much leeway as he could.

Frank's professional beginnings in the USA of the late 1940s basically corresponded to the outlook and the opportunities of his peers who later became successful photojournalists, like Elliot Erwitt or the young Bruce Davidson, who was granted membership in the photo-agency Magnum in 1953. In this context, the Guggenheim fellowship that enabled Frank to realize his project on America has to be considered sheer luck. This circumstance made it possible for Frank to pursue his own, self-determined

1 Penman, Ian, Interview: 'The Accident Keeps on Happening,' in *Dazed*, p.94
2 Johnson, William, 'The Pictures Are a Necessity,' in: *Rochester Film & Photo Consortium, Occasional Papers No. 2*, January 1989, p. 46

way of working and to continue to develop a complex body of work to this day. His involvement in photography lead him to film and video, to Polaroid photography and serial imagery, to montage and collage. Frank combined the various media, intertwining fictional elements with found material, the outside world with autobiographical elements. In the course of his development, language and the integration of words and of sentences in his work became increasingly important. In retrospect, these works in various media are linked by his insistence on an authorship that uses authentic, but accidental perception as the starting point for a subjective manner of expression and of inventing pictures.

'I have an interest in stories that come along unexpectedly. I'm just sniffing out what's there and the rest I make up. I think one has to take liberties.'[3] Frank has as little respect for conceptual photography as for teaching at universities, the 'intellectual factories.' The photographer considers the unintelligibility of the relation between the author and his/her subjects a loss comparable to the increasing compartmentalization of life in highly specialized disciplines, a development beyond the realm of our actual experience, yet a decisive factor in our actions.

Frank's statement that 'my images do not follow a pre-conceived plan, they weren't composed in advance,'[4] was provoked by his work in film in the late 1950s. He exchanged the solitary work of the photographer for working in a team. Consequently, communication in general, and language in particular, gained a new significance for his work.

When Frank was questioned in the late 1960s about the conception of *The Americans*, he emphasized his dislike of texts, of captions, of language later added to photography. 'I think every picture was identified geographically—where it was taken. I prefer to have photographs without text.'[5]

In the first edition, published in Paris with the support of Robert Delpire, there was still text accompanying the images, whereas in the American edition it was dispensed with. Frank removed the images from a sociopolitical textual context and showed the photographs, in classic fashion, opposite a blank page.

This presentation of photographs was a forceful statement at a time when photo-reportage was prevalent. It was an assertion of the power of the single photographic image. Photo books focusing on a single subject that followed neither a causal nor a formal-linear narrative structure and thus emphasized the tableau character of the single image, did not conform to the standards of photo-book production in the late 1950s.

From a stock of around 20'000 images of various American cities and regions, 83 were selected for *The Americans*. They were shown out of the context of the series of images they were drawn from. He arranged them according to the places where he had shot them, as Sarah Greenough explains in detail in her essay 'Fragments That Make A Whole. Meaning in Photographic Sequences.'[6] Consequently, the captions identify them only geographically. A lot has been written about the significance of this book and his import on 20th-century photography. In this essay, Robert Frank's manner of using images is the focus.

The pictures in *The Americans* were shot with a Leica, a camera that allowed for 36 pictures on a roll of film. Since the 1930s, it was the camera of choice for photojournalists. The Leica made it possible to work fast and inconspicuously (depending on the photographer's appearance) because of its small size and light weight.

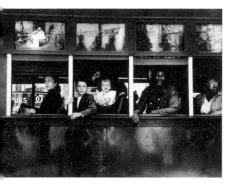

1 COVER IMAGE, THE AMERICANS, N.Y., 1969

3 *Dazed*, 1989, p. 92
4 Quoted in: Schaub, Martin, 'FotoFilmFotoFilm: eine Spirale, Robert Franks Suche nach der wahren Empfindung,' in: *Cinema*, 1984, p. 78
5 *Robert Frank, George Eastman House Interview*, August 17–18, 1967, quoted in: Katalog, 1997, p. 38
6 Greenough, Sarah; Brookman Philip (eds.), *Robert Frank, Moving Out*, exhib. cat. National Gallery of Art, Washington, D.C., Scalo, pp. 99–100 and 112

This is certainly true for Frank. Only in a few photographs we see the subjects acknowledging the photographer. It's not the reticent approach, influenced by Frank's mentality, that I want to emphasize here. Rather, it's the framing and the composition that this type of camera engenders. Either there is an intense and immediate meeting of gazes, or the image traces the gaze of the subject, creating an open and multiple image. The image on the cover of *The Americans* is already an example of what I am talking about. The frontal view of a bus, whose passengers are looking at the viewer, simultaneously refers us to yet more windows reflecting what the passengers are looking at. The photograph contains evidence of the environment of its subjects, thus forcing to viewer look for a sense of direction amidst a number of images. This additional visual information specifies the photographer's and his subjects' place and indicates the context of the situation he encountered.

Repeatedly, Frank manages to convey an, at least, doubled sense of place within an image. We see men in a bar, observing something that is only vaguely and ambiguously discernible in the image. We see a very narrow view of two people driving in a car, looking at the world through an overexposed car window that is not transparent to the viewer. We get to peek inside a TV studio where an actress is visible both on the set and on a TV screen (pl. 2)

Attention is directed to the multiple references contained in these photographs by presenting them as single images in the book. We may surmise that Frank gleaned some insights on how photographs correspond with each other in a book from looking at books by Bill Brandt and Walker Evans, whom he both held in very high esteem. Whereas Brandt used the double page in *The English At Home* as corresponding or contrasting form of presentation, Evans emphasized the importance of the single image in *American Photographs* (1938). The personal influence of his mentor, who had supported his application for the Guggenheim fellowship, was certainly an important factor in Frank's decision to use Evans' successfully tested layout for his book on America.

In regard to the subject matter, the choice is interesting as the isolation of the single image dispensed with the possibility of programmatically confronting two images. Nevertheless, the book incited political controversies. In its departure from the usual ways of using journalistic imagery in magazines, the emphasis on the single image in combination with the authoritative tone of the title of the book (by a Swiss immigrant, nonetheless) must have seemed provocative at the time. But in the end patriotic critics only advanced the recognition of the photographer Frank and his work, which he tried to pursue by doing commissioned work. Retrospectively, Frank never speaks disdainfully of his earlier commissioned work for magazines and advertising. Now and then, he still photographs shirts or pants. After all, 'if you really want to do your own work, you do it.'[7]

When he eventually became an American citizen in 1963, photography as a medium of observation was no longer the focus of his interest. After the Guggenheim fellowship, the publication of *The Americans*, a solo exhibition in 1961 at the Art Institute in Chicago, and a show with Harry Callahan at the Museum of Modern Art, New York, after all these successes in the 'new country,' he was already working on his third film in 1963. The shift from the still photograph to the moving, i.e. additive, image was already

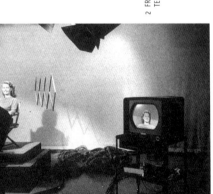

2 FROM: THE AMERICANS, TELEVISION STUDIO – BURBANK, CALIFORNIA

7 Woodward, Richard B., 'A Lost Master Returns,' *New York Times Magazine*, September 4, 1994

indicated in the images of the Guggenheim project, in which he augmented the single image with references to the environment outside the frame. The ability to suggest several images within a single picture is already clearly discernible in Frank's photographs of the 1940s, for example in *Central Park South* (1948) and *Tickertape* (1951), both shot in New York (pls. 3 and 4). Frank shows 'abstract images' within the 'real world,' caused by a reflection, or by movements of the wind. Looking at these photographs, we increasingly feel that we have to penetrate several layers in order to read the image. Intuitively, Frank already postulated his rejection of the single image and its conventionally assumed universality.

On his last trip for *The Americans*, Frank took photographs at the inauguration of Dwight D. Eisenhower, among others *Pennsylvania Avenue, Washington, D.C.* (pl. 5). Once again, it is obvious that he uses and exhausts the possibilities of small-format, single-picture photography in his approach to representation. The saturation of the image with real and photographed people, the problems of interior and exterior space, and the doubled reference to the medium photography, they all indicate the limits of what a photograph might be able to contain.

In his book *The Lines of My Hand*, Frank designated a series of photographs taken from a bus in New York as his last photographic project, his departure from the serial, but static, single image (pl. 6). 'When I selected the pictures and put them together I knew and felt I had come to the end of a chapter.'[8] Although he was primarily occupied with filmmaking, he still took photographs in the 1960s, for example portraits of artist friends, a series on Coney Island, or the photo sequence *Zero Mostel Reads a Book*[9]. But around the mid-1960s he also created *Washington* (pl. 7), a harbinger of the montages and collages of the 1970s. It shows the front page of a newspaper, partially covered with photographs, and only fragments of the headlines are legible. The four photographs arranged on the newspaper show three people taking pictures and a man with a camera hanging from his neck. When Philip Brookman considers the cinematic quality of the *Bus Series* an anticipation of Frank's later work in film, he refers to their sequential character, the flow of images, but not to their cinematic montage and their intertwined presentation. In *Washington*, the single photograph no longer alludes to an authentic situation, but becomes an object that may be transported and used as an element in an arrangement of images. Starting from the reproduction of images in the context of a montage, he developed a specific use of photographs, of language, and of manipulation with paint that runs counter to the fetish of the photographic 'original,' while still allowing him to produce unique works of art.

Whereas Andy Warhol used press photographs as starting point for his work as an artist, Frank restricted himself to his own images that he treated 'the rough way' by cutting, pasting, painting, scratching, tearing them apart, and covering them, time and again, with writing. Asked in 1975 whether photography bored him, he admitted that he had a rather limited interest in his own photographs. 'If I continued with still photography, I would try to be more honest and direct about why I go out there and do it. And I guess the only way I could do it is with writing. I think film is more of a living thing—more of an instant communication between people... Photographs leave too much open to bullshit.'[10]

Three years before, his book *The Lines of My Hand* was published in the USA, after another, more luxurious edition had been published in Japan some time ago.

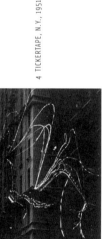

3 CENTRAL PARK SOUTH, 1948

4 TICKERTAPE, N.Y., 1951

8 *The Lines of My Hand*, 1971, n. p.
9 Book project commissioned by The New York Times, published in 1963
10 Parry Janis, Eugenia, Mac Neil, Wendy (eds.), *Photography Within the Humanities*, 1977, p. 58

5 PENNSYLVANIA AVE., WASHINGTON D.C., 1957
6 FROM THE BUS, N.Y., 1958

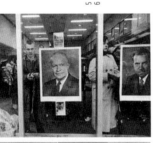

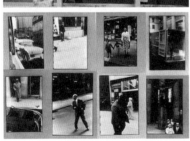

11 Woodward, Richard B., 'A Lost
Master Returns,' *New York Times
Magazine*, September 4, 1994
12 Hughes, Jim (ed.), 'America:
Photographic Statements,' in: *US
Camera/Camera Annual*, 1972,
p.144

Robert Frank was 47 years old (separated from his wife, his children at a boarding school in Vermont) and had retreated to Canada with the artist June Leaf.

The Lines of My Hand is an attempt to look back, maybe even to make a confession—to regain time past. It is not an opulent book that exhaustively integrates all of his works. It rather is a dense and compressed picture book with numerous, sometimes never-before published, photographs. Photographs, contact sheets, and filmstrips in various sizes are arranged on the pages of the book. Contrary to *The Americans*, pictures are placed in close relation and tense contrast to each other. And, naturally, there are family pictures here and there. As there are no public images representing universal truths for Frank, every one of his photographs is first and foremost a subjective way of finding an image, including pictures of family and friends. Only the chronological order is reminiscent of a regular retrospective. The layout, changing on every double page, charges them with an extraordinary vitality.

'This is about life. This is why it's wonderful to be in New York. You use your eyes, and you don't get tired of looking. Even though I'm tired of New York, I'm still looking.'[11]
Frank left his work as photographing observer ultimately behind in the early 1970s. After his autobiographical film works and *The Lines of My Hand*, his work focuses, in almost confessional manner, on his personal, quotidian living and thinking. To this day, Frank is still looking for ways to express himself. His pictures don't have the serenity of 'late works.' In the seclusion on the countryside, he creates works in which his poetic power achieves an almost shameless emotional openness. The texts added to the images often seem to mistrust them. They cover the image and they emphasize it—in a way, they enliven the photographed subjects.

At the end of *The Lines of My Hand*, we open a double page with a panoramic view of the landscape in Mabou. Canada—nature. Written below, we read: 'Will we go back to New York?' Of course, he returns to the city for which he settled in 1953 after a long period of moving back and forth between Europe and America. 'I need a town like this. It's the only town I would want to be in anyhow. Here it's all or nothing.'[12] Frank found his stance as a filmmaker because of the challenges of this American metropolis, which still serves as a corrective to the isolation of Nova Scotia. Frank loves contrast, and his restlessness demands the extremes. The travels 'more inside,' mentioned at the outset, mitigated his fear of sentimentality. In montages of images he examines, ironically and wittily, the use for memory of both the objects he has amassed and surrounded himself with and of his own photographs.
These reflections, as well as his playful examination of the commemorative character of photographs, is only adequately expressed in his late montages of texts and images. Latently, however, it is already present in Frank's early work. His stance is based on a fundamental distrust of truth-mongering, of pigeonholing any medium, of a predominance of the conceptual, and against the empty mechanics of mere conventions. In his photographic, as well as in his filmic, work he resisted prescribed categories. In his films, he mixed genres, tried to combine public and private realities, and made the concept of fiction and documentary more fluid. In the course of this development, the significance of photographs to memory became increasingly important—as sentimental closeness, but also as ironic and humorous distance. For the viewer, this makes, at its best, for a productive, because inquisitive, exchange between image and

subject matter, image, images, and verbal images: HOLD STILL—keep going.

'In the last instance, photography produces the endlessly repeatable crossing of two gazes. One, insisting from within the image, is enclosed in the temporal-spatial distance of the picture; the other, demanding insight, is focussed on the image as present past.'[13]

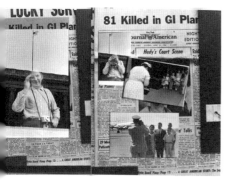

7 WASHINGTON, 1961/66

13 Busch, Bernd, 'Das Fotografische Gedächtnis,' in: Gedächtnisbilder, Vergessen und Erinnerung in der Gegenwartskunst, 1996, pp. 201/202

Prof. Ute Eskildsen is the director of the photography collection and the vice-chairman of the Museum Folkwang, Essen.

"Don't we all know that art is dangerous.
You play it – then you live it."

Stefan Balint

"There is no 'decisive moment.' You have to create it.
I have to do everything necessary for it to appear in my
viewfinder."

(from the film *Conversations in Vermont*, 1969.
Quoted in: *Bild für Bild Cinema*, Zürich 1984)

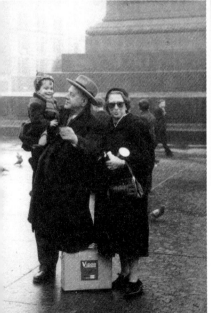

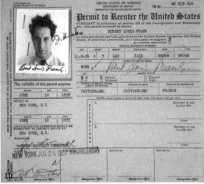

"A copy of the fingerprints has been sent to the FBI by Arkansas authorities.
These may be recovered, but not without a great deal of difficulty."

(from a letter by Robert Frank to his lawyer, Nathaniel H. Jankes,
December 31, 1955)

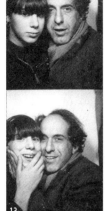

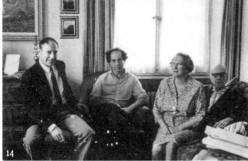

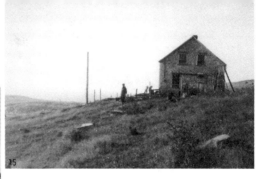

13

14

15

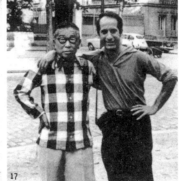

17

"I look back into a world now gone forever. Thinking of a time that will never return. A book with photographs is looking at me. 25 years of looking for the right road. Postcards from everywhere. If there are any answers I have lost them."

(from: *The Lines of My Hand*, Zürich 1990)

"Black and white are the colors of photography. To me they symbolize the alternatives of hope and despair to which mankind is forever subjected."

(*Aperture 9*, 1961)

19

21

22

20

24

23

"If you have a child that died so suddenly, you pretty much think about her every day (...). So many things in life, if life is ended and it's never going to be there again, it makes you strong to remember. Especially in Mabou. I think a lot about a life ended like that."

(*New York Times Magazine*, 1994)

25

26

27

28

"I lock my Leica in the closet. Enough looking out, chasing, tracing. Enough looking for the essential, be it black or be it white. Enough knowing where God might dwell. I make films. Now I can talk to the people sitting in front of my camera."

(Flyer of a cinematheque in the German Ruhr area, no date)

29

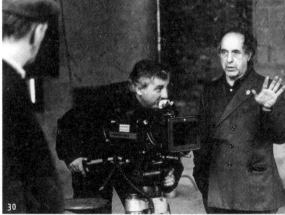

30

31

"I do something because it's necessary, not because of how I think it will look (...). It doesn't come easy, anyhow. There has to be some kind of upheaval in your mind to make it happen."

(*Newsweek*, October 10, 1994)

33

32

35

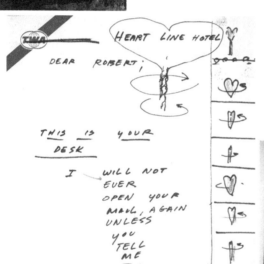

34

"The only thing I'm interested in these days is what I did last. If someone talks about my past, I don't like to go along with it. I don't correct either, whatever people might say about influences and developments. It draws you back in the same old waters that you have already crossed."

(*Bild für Bild Cinema*, Zürich 1984)

36

38

37

"It's hard to have much money and power and be human."

(*New York Times Magazine*, 1994)

40

41

42

Biography

1924
Born on November 9 in
Zürich/Switzerland. Parents: Hermann
Frank and Rosa Zucker. Brother:
Manfred, born in 1922.

1931–1937
Gabler School, Zürich.

1937–1940
Lavater High School, Zürich.

1940
Studied French at Institute Jomini,
Payerne (French-speaking part of
Switzerland).

1941
Apprenticeship with the photographer
and graphic designer Hermann
Segesser, Zürich (until March, 1942).
Still photographer for the film
Landammann Stauffacher by Leopold
Lindtberg.
Although Frank's mother was Swiss,
Frank's father (who had emigrated
from Germany after WW I) and his two
sons had to apply for Swiss citizen-
ship. Earlier in the same year, the
German law on citizenship of the Reich
had proclaimed all German Jews state-
less.

1942
Still photographer for the film
Steinbruch by Sigfrit Steiner.
From August to March 1944:
Apprentice, then employee at the
film- and photo-studio Michael
Wolgensinger, Zürich.

1945
Assistant to Vincent Bouverat in
Geneva.

April: Swiss citizenship.
Starting in June: Swiss military boot
camp, Losone/Ticino.

1946
Mai–August: Worked for the graphic
design studio Hermann Eidenbenz in
Basel.
Friendship with Werner Zryd.
First book 40 Fotos (40 Photographs)
with original prints.
Traveled to Paris and Milan with his
father.

1947
February 20: Left Europe for
New York City.
Employed by Alexej Brodovitch at
Harper's Bazaar and Junior Bazaar as
an assistant photographer. Quit in
October, continued working as free-
lancer. Met Louis Faurer.
Purchase of a 35 mm Leica with range-
finder (so far he mostly used a bino-
cular 6x6 Rolleiflex).

1948
Travels in Peru and Bolivia.

1949
Created two books, with 39 original
prints each, about his trips to Peru.
Met the artist Mary Lockspeiser.
March: Traveled to Europe for a year
(Spain and France).
Met the publisher Robert Delpire
in Paris.
Created a book with 74 original prints
for Mary Lockspeiser.

1950
February: Return to New York City.
Met Edward Steichen.
Marriage to Mary Lockspeiser.

Participated in the group show 51
American Photographers, Museum of
Modern Art, New York City.
Met Chinese painter San Yu in New
York City.

1951
February 7: Birth of son Pablo in New
York City.
November: Move to Paris with family.
Photographed in London and Paris.
Trip to Valencia, Spain.

1952
Meeting with Edward Steichen, who
was researching the exhibitions
Post-War Photography and Family of
Man, in Zürich to introduce him to
Swiss photographers.
Produced three copies of Black White
and Things, with 34 original prints
each, designed by Werner Zryd.
Trip to London.

1953
Photographed in Wales (UK).
Return to New York City.
Stopped working as a fashion photog-
rapher.
Work as freelance photographer for
McCall's, Look, Charm, Vogue,
Fortune, and Ladies' Home Journal.
Friendship with Walker Evans.
First summer vacation in
Provincetown, MA, where he met
artists Jan Müller, John Grillo, Lester
Johnson, Miles, and Barbra Forst.

1954
April 21: Birth of daughter Andrea.
Trip to a Fourth-of-July picnic in
upstate New York, where he shot the
first photographs for The Americans.
Met Allen Ginsberg.

1955
Assistant to Walker Evans for his photo-essay *Beauties of the Common Tool*.
As the first European ever, Frank received a one-year fellowship from John Simon Guggenheim Memorial Foundation to pursue a photo-project on the United States.
Traveled across the US, among others to North and South Carolina, Detroit, Florida, Atlanta, Northern Georgia, Alabama, along the Mississippi to New Orleans, Houston, Texas, New Mexico, Arizona, Nevada, and to Los Angeles on Route 66.

1956
Extension of the Guggenheim fellowship.
Continued to travel, among others to Nevada, Utah, San Francisco, Idaho, Montana, Nebraska, Chicago, via New York City to Pennsylvania, Ashland, and Centralia.
Friendship with Raoul Hague.

1957
Photographed the inauguration of Dwight D. Eisenhower and Richard Nixon. Shot the last photograph for *The Americans*. Selected and printed photographs for the book.

1958
Trip to Florida with Jack Kerouac.
First 16mm short film, with Mary, Forst, Allen Kaprow, and Richard Bellamy, shot in Provincetown.
Photographed through the window on bus rides on 42nd Street, New York City.
November: Robert Delpire published *Les Américains* in Paris, with quotes edited by Alain Bousquet.

1959
Grove Press, New York City, published *The Americans*, with a preface by Jack Kerouac.
Work on the film *Pull My Daisy*.

1960
Film *Sin of Jesus*.
September: Co-founder of the group *New American Cinema*, with Jonas Mekas, Shirley Clarke, Lionel Rogosin, Peter Bogdanovich, Emile DeAntonio.

1961
First solo exhibition *Robert Frank, Photographer*, Art Institute of Chicago (curated by Hugh Edwards).
Spent several months in Europe.
Jack Kerouac's improvised narrative *Pull My Daisy*, illustrated with 49 film stills and 8 photographs of the set by John Cohen, was published by Grove Press, New York City.

1962
Exhibition with Harry Callahan at the Museum of Modern Art, New York City (curated by Edward Steichen).

1963
Directed the film *O.K. end here*, based on screenplay by Marion Magid.
October 18: American citizenship.

1964
until 1966: Worked and traveled as cameraman for Conrad Rook's movie *Chappaqua*. He shot in France, the US, Mexico, England, India, Ceylon, and Jamaica.
Allen Ginsberg wrote a screenplay, based on his poem *Kaddish* (1958), for Frank. The film was never realized.

1965
The George Eastman House, Rochester, NY, acquired 25 prints from *The Americans* in exchange for 35 mm b/w film stock.
Started working with printer Sid Kaplan.
Began to work on his first feature-length film *Me and My Brother* (completed in 1968). Frank was both director and cameraman.

1968
To pay for the editing of *Me and My Brother*, Frank produced a book on the film, combining the script with film stills and set photographs.

1969
Separation from Mary Lockspeiser.
Film *Conversations in Vermont*.
Cameraman for a film by Danny Seymour on the singer Tracy Nelson.
Wrote five monthly columns *Letter from New York* for *Creative Camera* magazine, London.
Documentary *Life–Raft–Earth*.
Film *About Me: A Musical* (until 1971).
Solo exhibition *Robert Frank*, Philadelphia Museum of Art (curated by Michael Hoffman).
Friendship with Kazuhiko Motomura.

1970
Together with the artist June Leaf, he bought a plot of land and a house in Mabou, Nova Scotia, Canada.
Until the mid-1970s, Frank taught at various universities in the US and Canada.
Work on *Goodbye Mr. Brodovitch, I'm leaving New York*.

1971
Cameraman for *Home Is Where the Heart is* by Danny Seymour.
Work with a Canon Super-8 camera.
Short film *About Us*, in collaboration with students at the Visual Studies Workshop, Rochester, NY.
Cover for the Rolling Stones' album *Exile on Main St.*

1972
The limited edition of *The Lines of My Hand* was published in Japan by Kazuhiko Motomura and, later that year, by Lustrum Press, New York City.
Commissioned by The Rolling Stones, he shot *Cocksucker Blues*, in collaboration with Danny Seymour, on their American tour. The Rolling Stones prohibited any public performance of the film.
Began to work with Polaroid negative film.

1974
On December 28, his daughter Andrea died in a plane crash in Guatemala.

1975
Marriage to June Leaf.
Shot *Keep Busy*, in collaboration with Rudy Wurlitzer, in Nova Scotia.
Photographed with a disposable camera LURE (color).

1976
Solo exhibition *Robert Frank*, Kunsthaus Zürich (curated by Rosselina Bischof).

1977
Film *Life Dances On...* (completed in 1980).
Traveled to Utah, with Rudy Wurlitzer and Gary Hill, to shoot *Energy and How to Get It* (completed in 1981).

1978
Solo exhibition *Robert Frank*, The Photo Gallery, Still Photography Division, National Film Board of Canada, Ottawa (curated by Lorraine Monk).
Solo Exhibition *Robert Frank: Photography and Film 1945–1977*, Mary Porter Sesnon Art Gallery, University of California at Santa Cruz (curated by Philip Brookman).

1979
Solo exhibition *Robert Frank: Photographer/Filmmaker, Works from 1945–1979*, Long Beach Museum of Art, CA (curated by Philip Brookman).

1980
Retrospective *The New American Filmmaker Series: Robert Frank*, Whitney Museum of American Art, New York City (curated by John Hanhardt).

1981
Trip to Pukatawagon (Sask.) with Chester Pelkey.
Friendship with Vincente Todoli.

1982
Documentary *This Song is for Jack*, commemorating the 25th anniversary of the publication of Kerouac's *On the Road*.

The publisher Kazuhiko Motomura visited Frank in Mabou to prepare the book *Flower is Paris, Ford is Detroit, Mabou is Waiting*.

1983
Video *Home Improvements* (completed in 1985).
Taught a workshop in Tel Aviv.
Visit by Peter MacGill in Mabou.

1984
Collaborative project with photographers Robert Heinecken, David Heath, and John Wood (never realized).

1985
Erich Salomon-Award of the German Society for Photography.
Solo exhibition *Robert Frank: Fotografias/Films 1948–1984*, Sala Parpalló, Institució Alfons e Magnánim, Valencia/Spain (curated by Vincente Todoli).

1986
Solo exhibition *From New York to Nova Scotia*, Museum of Fine Arts, Houston (curated by Anne Wilkes Tucker, Philip Brookman).
The exhibition was shown at the Museum Folkwang, Essen, in 1987.
Work with Rudy Wurlitzer on the screenplay for *Candy Mountain* (completed in 1987).
Frank taught a workshop in Tel Aviv, together with Allen Ginsberg.

1987
Peer Award for Distinguished Career in Photography, Friends of Photography, San Francisco.

1988
Film retrospective *In the Margins of Fiction: The Films of Robert Frank*, American Film Institute, John F. Kennedy Center for the Performing Arts, Washington, D.C.
Solo exhibition *The Lines of My Hand*, Museum für Gestaltung, Zürich, Switzerland.
Friendship with John Marshall, the 'Antique Man,' in New Glasgow, Nova Scotia.

1989
Music video *Run* for the Band *New Order*.
On an invitation by the Kulturstiftung Ruhr, Essen, Frank traveled to the Ruhr area in Germany and shot the film *Hunter*.
Worked with Stefan Balint of the *Squat Theatre*, New York City.

1990
The National Gallery of Art, Washington, D.C., founded the Robert Frank Collection. Frank donated negatives, contact sheets, work and exhibition prints.

Video *C'est vrai! (One Hour)* for the French TV station La Sept.

1991
Short film for the fashion designer Romeo Gigli in Florence/Italy.
Film *Last Supper* (completed in 1992).
Photographs of Beyrouth, Lebanon, for a project by Dominique Eddé.

1993
Trip to Egypt.
Work on a never-completed film, in collaboration with Dominique Eddé and Dina Haidar.
Trip with June Leaf to Lake Baikal.

1994
Trip to Hokkaido, Japan, with Kazuma Kurigami.
Black White and Things published by Scalo Publishers.
Retrospective *Moving Out*, National Gallery of Art, Washington, D.C. (curated by Philip Brookman and Sarah Greenough).
Film *Moving Pictures* for the retrospective.
Son Pablo died on November 12 in an Allentown, PA, hospital

1995
The retrospective traveled to Kunsthaus Zürich; Stedelijk Museum, Amsterdam; Whitney Museum of American Art, New York City; and Yokohama, Japan.
Met Shino Kuraishi in Japan.
Founding of the Andrea Frank Foundation in New York City.
Solo exhibition *Robert Frank: Flower is...*, Male, Tokyo.

1996
International Photography Award of the Erna and Victor Hasselblad Foundation, Göteborg/Sweden.
Retrospective traveled to the Lannan Foundation, Los Angeles.
Music video *Summer Cannibals* for Patti Smith.
Last visit with Fernando Garzoni to Zürich and Locarno.
Completed the film *The Present*, in collaboration with the editor Laura Israel.
Work on the video *Flamingo* for the Hasselblad Award.
Solo exhibition *Robert Frank: Photographies de 1941 à 1994*, Centre Culturel Suisse, Paris.

1997
Visit to Allen Ginsberg on the night before Ginsberg's death.
Trip to Taiwan and Copenhagen.
Solo exhibition *Flamingo*, Hasselblad Center, Göteborg/Sweden.
Solo exhibition *Robert Frank: Les Américains*, Maison Européenne de la Photographie, Paris.
Solo exhibition *Flower is... Paris*

1949–1951, Pace/MacGill Gallery, New York City.
Restoration and sale of paintings by San Yu.
Met Rita Wong in New York City. He later co-founded the *SAN-YU Scholarship Fund* at Yale University with her.

1998
Began to work on the film *San Yu*.
Video *I remember (Stieglitz)*.
Trip to Madrid and visit to Vincente Todoli.
Car accident in Spain.

1999
Solo exhibition *From the Canadian Side*, Pace/MacGill Gallery, New York City.
Honorary doctorate of the University of Göteborg/Sweden.
Shot the last scenes of *San Yu* in Paris.
Photographs for the French newspaper *Libération*.

2000
Received the *Cornell Capa Award*, International Center of Photography, New York City.
Solo exhibition *Robert Frank: An Exhibition of Photographs and Books 1950–1990*, Scalo Gallery, New York City.

The biography is based on information provided by Robert Frank and on Tucker/Brookman, 1986, and Greenough/Brookman, 1994.

Bibliography

Selected books and publications by Robert Frank

Frank, Robert, *Les Américains*, edited by Alain Bosquet, (Robert Delpire) Paris 1958. Reprinted as *Gli Americani*, edited by Alain Bosquet und Raffaele Crovi, (Il Saggiatore) Milan 1959; *The Americans*, preface by Jack Kerouac, (Grove Press) New York 1959. Enlarged and revised edition *The Americans*, preface by Jack Kerouac, (An Aperture Book, The Museum of Modern Art) New York 1969. Revised edition *The Americans* (An Aperture Monograph) Millerton, New York 1978. Reprint, (Pantheon Press) New York 1986. Reprint, (Scalo) Zürich, Washington 1993. Nachdruck, (Scalo) Zürich 1998.

_ _ *New York Is*, (New York Times Inc.) New York 1959.

_ _ *The Lines of My Hand*, (Yugensha, Kazuhiko Motomura) Tokyo 1972. Revised edition, (Lustrum Press) New York 1972. Revised edition, (Parkett/ Der Alltag) Zürich 1989.

_ _ *Zero Mostel Reads A Book*, (New York Times Inc.) New York 1963.

_ _ *Flower is Paris, Ford is Detroit, Mabou is Waiting...*, (Yugensha, Kazuhiko Motomura) Tokyo 1987.

_ _ *Alberto Aspesi: Shirts*, (Alberto Aspesi) Milan 1989.

_ _ *One Hour*, (Hanuman Books) New York, Madras 1992.

_ _ *Black White and Things*, (National Gallery of Art Washington/Scalo) Washington, Zürich 1994. [conceived in 1952]

_ _ *Alberto Aspesi: Jackets*, (Alberto Aspesi) Milan 1995.

_ _ *Thank You, For the 10th Anniversary of Pace MacGill*, (Scalo) Zürich, Berlin, New York 1996.

_ _ 'Speaking of Pictures: A Photographer in Paris Finds Chairs Everywhere,' in: *Life*, 30, 1951, 21 (May 21), pp. 26–28.

_ _ 'Indiens des Hauts-Plateaux,' with a text by Georges Arnaud, in: *Neuf*, 8, 1952 (December), pp. 1–36.

_ _ 'Ben James: Story of a Welsh Miner,' in: Maloney, Tom (ed.), *U.S.Camera 1955*, New York 1954, pp. 82–93.

_ _ 'The Congressional,' edited by Walker Evans, in: *Fortune*, 52, 1955, 5, pp. 118–122.

_ _ [in collaboration with Werner Bischof and Pierre Verger], *Indiens Pas Morts*, with a text by Georges Arnaud, Paris 1956.

_ _ 'A Statement ... ,' in: Tom Maloney (ed.), *U.S. Camera 1958*, New York 1957, p. 115.

_ _ 'A Pageant Portfolio: One Man's USA,' in: *Pageant*, 13, 1958, 10 (April), pp. 24–35.

_ _ 'A Hard Look at the New Hollywood,' in: *Esquire*, 51, 1959, 3, pp. 51–65.

_ _ [Statement], in: *Film Quarterly*, 14, 1961, 4 (Summer), pp. 5–15.

_ _ [with Alfred Leslie], *Pull My Daisy*, text by Jack Kerouac, preface by Jerry Tallmer, New York 1961.

_ _ 'Edgar Varèse, Willem de Kooning,' in: *Harper's Bazaar*, 3012, 1962 (November), pp. 166–169.

_ _ 'The Fashion Independent: Inside East Europe,' in: *Harper's Bazaar*, 3021, 1963 (August), pp. 82–91.

_ _ 'Portfolio: Robert Frank: 5 Photographs,' in: *The Second Coming Magazine*, 1, 1965, 6 (January), pp. 57–62.

_ _ 'Films: Entertainment Shaken Up With Art,' in: *Artsmagazine*, 41, 1967, 5 (March), p. 23.

_ _ [Letter to Gotthard Schuh], in: *Camera*, 47, 1968, 3, p. 4.

_ _ 'Letter from New York,' in: *Creative Camera*, 60, 1969 (June), pp. 202–203.

_ _ 'Letter from New York,' in: *Creative Camera*, 61, 1969 (July), pp. 234–235.

_ _ 'Letter from New York,' in: *Creative Camera*, 62, 1969 (August), p.272.

_ _ 'Letter from New York,' in: *Creative Camera*, 64, 1969 (October), p. 340.

_ _ 'Letter from New York,' in: *Creative Camera*, 66, 1969 (December), p. 414.

_ _ [with Jack Kerouac], 'On the Road to Florida,' in: *Evergreen Review*, 74, 1970 (January), pp. 42–47, 64.

_ _ [Letter to Danny Seymour], in: *Danny Seymour, A Loud Song*, New York 1971, p. 55.

_ _ 'Coney Island: Robert Frank,' in: *Camera*, 50, 1971, 3, pp. 18–22.

_ _ [Letter to Ralph Gibson], in: Gary Wolfson (ed.), *Young American Photography*, Volume I, New York 1974.

_ _ [with Lee Friedlander], *The Sculpture of Raoul Hague*, Photographs by Robert Frank and Lee Friedlander, New York 1978.

_ _ [untitled], in: John Gossage (ed.), *Charles Pratt: Photographs. Estate of Charles Pratt Millerton*, New York 1982, p. 9.

_ _ *Robert Frank*. Texts by Robert Frank, exhibit. cat. Centre National de la Photographie, Paris 1983. Engl. edition: *Robert Frank*. Texts by Robert Frank, London 1991.

_ _ 'Portfolio by Robert Frank, July 16–19, 1984,' in: *California*, 9, 1984, 9, pp. 123–133.

_ _ 'Three Groups of Photographs Taken 1955/56 on a Trip Across the

USA,' in: *C Magazine*, 3, 1984 (Autumn), pp. 66–70.

_ _ [untitled contribution], in: Bill Morgan and Bob Rosenthal, *Best Minds: Tribute to Allen Ginsberg*, New York 1986, p. 112.

_ _ 'Vortrag auf dem 7. Symposium für Fotografie im Steirischen Herbst. 5.10.1985, Forum Stadtpark Graz,' in: *Camera Austria 22*, 1987, pp. 17–23.

_ _ [Letter to Albano da Silva Pereira], in: Albano da Silva Pereira and Paul Mora (ed.), *Robert Frank*, exhibit. cat. Centro de Estudos da Fotografia de Associacao Academica de Coimbra, Coimbra, Portugal, 1988.

_ _ [Letters to Daniel Price], in: *Shots: A Journal About the Art of Photography*, 24, 1990 (December), pp. 30–35.

_ _ 'October 31, 1989,' in: *The Jack Kerouac Collection*, Santa Monica 1990, p. 20.

_ _ 'From One Hour,' in: *Grand Street*, 10, 1991, 4, pp. 32–48.

_ _ [Letters], in: *Switch* [Tokyo], 10, 1992, 4 (September), pp. 156–168.

Selected interviews with Robert Frank

Swanberg, Lasse, 'Robert Frank,' in: *Fotografisk Årsbok 1968*, Stockholm 1967, pp. 56–61.

'Walker Evans on Robert Frank: Robert Frank on Walker Evans,' in: *Still*, 3, 1971, pp. 2–6.

Kernan, Sean, 'Uneasy Words While Waiting: Robert Frank,' in: Jim Hughes (ed.), *U.S. Camera/Camera 35 Annual: America. Photographic Statements*, New York 1972, pp. 139–145.

'Robert Frank,' in: Wendy MacNeil and Eugenia Parry Janis (eds.), *Photography Within the Humanities*, Danbury, New Hampshire 1977, pp. 52–65.

Wheeler, Dennis, 'Robert Frank Interviewed,' in: *Criteria*, 3, 1977, 2 (June), pp. 1, 4–7, 24.

Schaub, Martin, 'FotoFilmFotoFilm: Eine Spirale: Robert Franks Suche nach den Augenblicken der wahren Empfindung,' in: *Cinema: Unabhängige Schweizer Filmzeitschrift*, 30, 1984 (November), pp. 75–94.

Schmid, Joachim, 'Ein Interview mit Robert Frank,' in: *Fotokritik*, 14,1985 (June), pp. 16–21.

Roegiers, Patrick, 'Robert Frank ou les mystères de la chambre noire,' in: *Le Monde*, Supplement *Le Monde Aujourd'hui*, 12840, Mai 11/12, 1986, pp. VI–VII.

Glicksman, Marlaine, 'Highway 61 Revisited,' in: *Film Comment*, 23, 1987, 4 (July/ August), pp. 32–39.

Revault d'Allones, Fabrice, 'Un Américain à Paris,' in: *Photomagazin*, 88, 1987/88 (December/January), pp. 26–28.

Garel, Alain, 'Robert Frank: Entretien: Images en Mouvement,' in: *La Revue du Cinéma*, 435, 1988 (February), pp. 49–52.

Gehrig, Christian, 'Frozen Moments,' in: *Schweizer Illustrierte*, April 17, 1989, pp. 57–62.

Hachigian, Nina and Tod Papageorge, 'Interview with Robert Frank,' in: *Black and White: The Yale Undergraduate Photography Review*, 1989, pp. 2–7.

Johnson, William S. (ed.), *The Pictures are a Necessity: Robert Frank in Rochester, N.Y. November 1988*, Rochester Film and Photo Consortium *Occasional Papers 2*, 1989 (January).

Skorecki, Louis, 'Robert Frank: L'Arlesien,' in: *Libération*, 2521, 1989 (July 2), pp. 19–33.

'Robert Frank,' in: Switch [Tokyo], 10, 1992, 4, pp. 12–91.

Lyon, Stuart et al., 'Robert Frank at the George Eastman House 17th and 18th August 1967,' in: *Katalog. Journal of Photography and Video*, 1997, p. 39.

Bertrand, Anne, 'Robert Frank de passage/ Passing Through,' in: *Art Press*, 207, 1995 (November), pp. 39–43.

Guerrin, Michel, 'Robert Frank raconte sa passion pour Tuggener et le miracle suisse ,' in: *Le Monde Culture*, February 18, 2000, no page numbers.

_ _ 'I'm polite in Zurich, but not in New York,' in: *Guardian Weekly Supplement*, March 30/April 5, 2000, p. 30.

Selected Publications on Robert Frank

[Läubli, Walter], 'Robert Frank,' in: *Camera*, 28, 1949, 12, pp. 358–371.

[Dobell, Byron], 'Robert Frank: Swiss Mister,' in: *Photo Arts*, 1, 1951, 10, pp. 594–599.

'Life Announces the Winners of the Young Photographer's Contest,' in: *Life*, 31, 1951, 22, pp. 15–24, 30, 32.

Thétard, Henry, 'Magie du Cirque,' in: *Neuf*, 7, 1952 (September), pp. 14–23.

Dobell, Byron, 'Feature Pictures: Robert Frank … The Photographer as Poet,' in: *U.S. Camera*, 17, 1954, 9, pp. 77–84.

Deschin, Jacob, 'Project Awards: Guggenheim Fellowships for Frank and Webb,' in: *The New York Times*, May 1, 1955, Sec. 2, p. 21.

Evans, Walker, 'Robert Frank,' in: Maloney, Tom (ed.), *U.S. Camera 1958*, New York 1957, p. 90.

'Robert Frank,' in: Tom Maloney (ed.), *U.S. Camera 1958*, New York 1957, pp. 91–114.

Schuh, Gotthard, 'Robert Frank,' in: *Camera*, 36, 1957, 8 (August) , pp. 339–356.

[White, Minor], 'Book Review: Les Américains,' in: *Aperture*, 7, 1959, 3, p. 127.

Mekas, Jonas, 'Movie Journal,' in: *Village Voice*, 5, 1959 (November 18), 4, pp. 8, 12.

Caulfield, Patricia, 'New Photo Books: The Americans' (review), in: *Modern Photography*, 24, 1960, 6, pp. 32–33.

Lambeth, Michel, 'Books Reviewed: The Americans,' in: *Canadian Forum*, 40, 1960, 475, p. 120.

MacDonald, Dwight, 'Films: Amateurs and Pros' (review of 'Pull My Daisy'), in: *Esquire*, 53, 1960, 4, pp. 26, 28, 32.

Mekas, Jonas, 'Cinema of the New Generation,' in: *Film Culture*, 21, 1960 (Summer), pp. 1–20.

Millstein, Gilbert, 'In Each A Self-Portrait' (review of 'The Americans'), in: *The New York Times Book Review*, January 17, 1960, p. 7.

Bennett, Edna, 'Black and White are the Colours of Robert Frank,' in: *Aperture*, 9, 1961, 1, pp. 20–22.

Gutierrez, Donald: 'Books, The Unhappy Many' (review of 'The Americans'), in: *Dissent*, 8, 1961, 4, pp. 515–516.

'Robert Frank,' in: *Aperture*, 9, 1961, 1, pp. 4–19.

Talese, Gay, '42nd Street—How it Got that Way,' in: *Show*, 1, 1961, 3 (December), pp. 62–71.

Deschin, Jacob, 'Two-Man Exhibit: Photographs by Callahan and Frank at the Museum of Modern Art,' in: *The New York Times*, February 4, 1962, Sec. 2, p. 21.

'Photographs by Robert Frank,' in: *Choice. A Magazine For Poetry and Photography*, 2, 1962, pp. 97–112.

Rotzler, Willy, 'Robert Frank,' in: *du*, 22, 1962, 1, pp. 1–32.

Tyler, Parker, 'For ›Shadows‹, Against ›Pull My Daisy‹,' in: *Film Culture*, 24, 1962 (Spring), pp. 28–33.

Porter, Allan, 'Robert Frank. A Bus Ride through New York,' in: *Camera*, 45, 1966, 1, pp. 32–35.

'Portraits: The Photographs of Robert Frank,' in: *Art Voices*, 5, 1966, 3, pp. 57–60.

Shainberg, Lawrence, 'Notes From the Underground,' in: *Evergreen Review*, 50, 1967 (December), pp. 22–25, 105–112.

Leslie, Alfred, 'Daisy: 10 Years Later,' in: *Village Voice*, 14, 1968, 7, p. 54.

Hagen, Charles, 'Robert Frank: Seeing Through the Pain' (review of 'The Lines of My Hand'), in: *Afterimage*, 1, 1973, 5 (February), pp. 1, 4–5.

Jeffrey, Ian, 'Robert Frank: Photographs From London and Wales, 1951,' in: Osman, Colin and Peter Turner (eds.): *Creative Camera International Year Book 1975*, London 1974, pp. 10–36.

Stott, William, 'Walker Evans, Robert Frank and the Landscape of Dissociation,' in: *ArtsCanada*, 1974 (December), pp. 83–89.

Mann, Margery, 'West. The Americans Revisited' (review of 'The Americans'), in: *Camera*, 35, 18, 1975, (January), pp. 14, 74–75.

Searle, Leroy, 'Symposium: Poems, Pictures and Conceptions of Language,' in: *Afterimage*, 3, 1975, 1/2 (May/June), pp. 33–39.

Robert Frank, Introduction by Rudolph Wurlitzer. The Aperture History of Photography Series 2, Millerton, New York 1976.

Class, Arnaud, 'Robert Frank et les Avant-Gardes,' in: *Contrejour*, 13, 1977 (October/November), pp. 22–25.

Cosgrove, Gillian, 'The Rolling Stones On Tour—The Film That Can't Be Shown,' in: *The Montreal Star*, 10./12. September 1977, Sec. C, p. 2.

Brookman, Philip, Robert Frank: *An Exhibition of Photography and Films 1945–1977*, exhibit. cat. Mary Porter Sesnon Art Gallery, University of California at Santa Cruz 1978.

Cousineau, Penny, 'Robert Frank's Postcards from Everywhere,' in: *Afterimage*, 5, 1978, 8 (February), pp. 6–8.

'Robert Frank,' in: *The Massachusetts Review*, 19, 1978, 4 (December), pp. 766–773.

Rubinfien, Leo, 'Photography: Robert Frank in Ottawa,' in: *Art in America*, 66, 1978, 3 (May/June), pp. 52–55.

Scully, Julia and Grundberg, Andy, 'Currents: American Photography Today: Robert Frank's Iconoclastic, Outsider's View of America,' in: *Modern Photography*, 42, 1978, 10, pp. 94–97, 196, 198, 200.

Brookman, Philip, *Robert Frank: Photographer/ Filmmaker. Works from 1945–79*, exhibit. cat. Long Beach Museum of Art, Long Beach 1979.

Dugan, Thomas, *Photography between Covers: Interviews with Photo-Bookmakers*, Rochester, NY, 1979.

Katz, Paul, 'Robert Frank,' in: *Photography Venice '79.* exhibit. cat. Mayor of Venice and International Center of Photography. Milan, New York 1979, pp. 311–326.

_ _ *Robert Frank: The Americans and New York Photographs*, exhibit. cat. Sidney Janis Gallery, New York 1979.

Brumfield, John, '*The Americans* and the Americans,' in: *Afterimage*, 8, 1980, 1/ 2 (Summer), pp. 8–15.

Hinderaker, Mark, 'The Family of Man and The Americans,' in: *Photographer's Forum*, 2, 1980, 4, pp. 22–28.

Baier, Leslie, 'Visions of Fascination and Despair: The Relationship Between Walker Evans and Robert Frank,' in: *Art Journal*, 41, 1981, 1, pp. 55–61.

Hill, Gary, 'Energy and How to Get It: Proposal by Gary Hill for a Film by Robert Frank, Gary Hill, and Rudy

Wurlitzer,' in: *CoEvolution Quarterly*, 29, 1981 (Spring), pp. 46–49.

Papageorge, Tod, *Walker Evans and Robert Frank. An Essay on Influence*, exhibit. cat. Yale University Art Gallery, New Haven 1981.

Cook, Jno, 'Robert Frank's America,' in: *Afterimage*, 9, 1982, 8 (March) pp. 9–14.

Ennis, Michael, 'The Roadside Eye,' in: *Texas Monthly*, 11, 1983, 11, pp. 180–183.

'Robert Frank: la photographie, enfin,' in: *Les Cahiers de la Photographie*, 11/12, 1983 (numéro spécial 3), pp. 1–125.

Cook, Jno, 'Photography: Robert Frank's Parody,' in: *Nit & Wit: Chicago's Arts Magazine*, 6, 1984, 3, pp. 40–43.

Johnson, William, 'Public Statements/ Private Views: Shifting the Ground in the 1950s,' in: *Observations: Essays on Documentary Photography*, 1984, pp. 81–92.

Nesterenko, Alexander and Smith, C. Zoe, 'Contemporary Interpretations of Robert Frank's The Americans,' in: *Journalism Quarterly*, 61, 1984, 3, pp. 567–577.

Schaub, Martin, 'Postkarten von über-all und innere Narben: Ein Porträt des sechzigjährigen Fotografen und Filmemachers Robert Frank...,' in: *Tagesanzeiger Magazin*, 44, 1984 (November 3), pp. 8–13, 15–16.

Schiffman, Amy M., 'Politics as Unusual: Robert Frank,' in: *American Photographer*, 13, 1984, 5, pp. 52–57.

Cotkin, George, 'The Photographer in the Beat-Hipster Idiom: Robert Frank's The Americans,' in: *American Studies*, 26, 1985, 1, pp. 19–33.

Robert Frank: Sobre Valencia 1950, exhibit. cat. Sala Parpalló/ Institució Alfons el Magnànim, Valencia 1985.

Tannenbaum, Barbara and Cooper, David B., *Robert Frank and American Politics*, exhibit. cat. Akron Art Museum, Akron 1985.

Todoli, Vincente et al., *Robert Frank: Fotografias/ Films 1948–1984*, exhibit. cat. Sala Parpalló/ Institució Alfons el Magnànim, Valencia 1985.

Alexander, Stuart, *Robert Frank: A Bibliography, Filmography and Exhibition Chronology 1946–1985*, Center for Creative Photography,

University of Arizona, Tucson, in colla-
boration with the Museum of Fine Arts
Houston, Tucson 1986.

Cook, Jno, 'Robert Frank: Dissecting
the American Image,' in: *Exposure*, 24,
1986, 1 (Spring), pp. 31–41.

Frizot, Michel, 'Robert Frank, ailleurs
et maintenant,' in: *Clichés*, 25, 1986
(April), pp. 48–53.

Hagen, Charles, 'Candid Camera,'
in: *Artforum*, 24, 1986, 10 (Summer),
pp. 23, 116–119.

Richard, Paul, 'The Unwavering Vision
of Robert Frank,' in: *The Washington
Post*, April 20, 1986, pp. G1, G5.

Tucker, Ann Wilkes/Brookman, Philip,
*Robert Frank: New York to Nova
Scotia*, exhibit. cat. Museum of Fine
Arts Houston, Boston 1986.

Silbermann, Robert, 'Outside Report:
Robert Frank,' in: *Art in America*,
75, 1987, 2, pp. 130–139.

Sullivan, Constance/Peter Schjeldahl,
Legacy of Light, New York 1987,
pp. 54–55, 127–135.

Gutman, Judith Mara, 'One-Shot Hero,'
in: *Connoisseur*, 1987 (November),
pp. 138–143.

Gruber, L. Fritz, 'Genie des lichten
Augenblicks: Der Fotograf Robert
Frank,' in: *Frankfurter Allgemeine
Magazin*, March 27, 1987, pp. 10–16.

Pereira, Albano da Silva/Paul Mora
(eds.), *Robert Frank*, exhibit. cat.
Centro de Estudios da Fotografia de
Associacao Academica de Coimbra,
Portugal, 1988.

Allan, Blaine, 'The Making (and
Unmaking) of Pull My Daisy,' in: *Film
History*, 2, 1988, 3, pp. 185–205.

Tallmer, Jerry, 'Beatnik's Daisy smells
like a rose,' in: *New York Post*,
December 7, 1988, no page numbers.

Di Piero, W.S., 'Not a Beautiful
Picture: On Robert Frank,' in:
TriQuarterly, 76, 1989, pp. 146–165.

Fresnault-Deruelle, Pierre, 'Les
Américains de Robert Frank,' in: *Revue
Française d'Études Américaines*, 39,
1989 (February), pp. 63–70.

Takata, Ken, 'Towards an Elegance of
Movement—Walker Evans and Robert
Frank Revisited,' in: *Journal of
American Culture*, 12, 1989 (Spring),
pp. 55–64.

Roth, Wilhelm, 'Trauer ohne Hoffnung.
Robert Frank im Fotografie-Forum
Frankfurt,' in: *Frankfurter Rundschau*,
April 17, 1989, p. 8.

Kötz, Michael, 'Odyssee mit Blues.
'Candy Mountain', ein Wurlitzer Film',
in: *Frankfurter Rundschau*, July 20,
1989, p. 20.

Floyd,Tony, 'Pull My Daisy: The
Critical Reaction,' in: *Moody Street
Irregulars: a Jack Kerouac Newsletter:
The Film Issue*, 1989/90, 22/23, pp.
11–14.

Rice, Shelley, 'Some Reflections on
Time and Change in the Work of Robert
Frank,' in: *Photo Review*, 13, 1990, 2
(Spring), pp. 1–9.

Richard, Paul, 'The Artist's Gift of a
Lifetime: Photographer Robert Frank
Donates Works to National Gallery,' in:
The Washington Post, September 7,
1990, pp. B1–2.

Robert Frank. exhibit. cat. Mostra
Internazionale, Riminicinema,
Rimini 1990.

Podolski, Tanja, 'Auf
Vergangenheitssuche im heutigen
Deutschland. >Filmforum< mit der
Premiere >Hunter<,' in: *Neue Ruhr
Zeitung*, September 11, 1990, p. 1.

Schmidt, Axel, 'Oberste Fläche der
Realität. Über Robert Franks '*Hunter-
Ruhrgebiet Herbst 1989*,' in: *die
tageszeitung*, September 13,
1990, p. 6.

Schumann, Jochen, 'Ein Schweizer
sieht das Revier,' in: *Westfälische
Allgemeine Zeitung*, January 26,
1990, no page numbers.

Guimond, James, 'The Great American
Wasteland,' in: *American Photography
and the American Dream*, Chapel Hill
1991, pp. 207–244.

Eddé, Dominique, *Beyrouth: Centre
Ville*, Paris 1992, pp. 138–183.

Jobey, Liz, 'The UnAmerican,' in: *The
Independent on Sunday: The Sunday
Review*, March 29, 1992, pp. 8–10

Woodward, Richard B., 'A Lost Master
Returns,' in: *New York Times
Magazine*, September 4,1994, no page
numbers.

Perl, Jed, 'free radical!' in: *Vogue*,
1994 (October), pp. 219–220.

Greenough, Sarah/Philip Brookman
(eds.), *Robert Frank. Moving Out*,
exhibit. cat. National Gallery of Art
Washington, Washington 1994
(German edition: Zürich 1995).

Ziegler, Ulf Erdmann, 'Der disparate
Blick,' in: *Die Zeit*, June 16, 1995,
p. 50.

Vettese, Angela, 'Novecento in bianco
e nero. Le fotografie di Robert Frank
anticipano correnti quali la pop-art o
l'iper-realismo,' in: *Il Sole 24 ore*,
August 6, 1995, no page numbers.

Wallis, Brian, 'Robert Frank: American
Visions,' in: *Art in America*, 84, 1996,
3, pp. 74–79.

Alexander, Stuart, 'Robert Frank,' in:
*Katalog. Journal of Photography and
Video*, 1997, pp. 34–35.

Horak, Jan-Christopher, 'Robert Frank:
Daddy Searching for the Truth,' in:
*Making Images Move. Photographers
and Avant-Garde Cinema*,
Washington, London 1997,
pp. 161–190.

*Robert Frank: Flamingo.The
Hasselblad Award 1996*, exhibit. cat.
Hasselblad Center, Göteborg 1997.

Bertrand, Anne, 'Le Présent de Robert
Frank,' in: *Trafic. Revue de Cinema*,
21, 1997 (Spring), pp. 50–57.

_ _ 'It's all true,' in: *LimeLight–
Cinéma*, 57, 1997 (February), pp.
32–36.

Robert Frank's SAN YU, in: *Sotheby's:
Werke von Chang Yu (Sanyu
1901–1966)*, October 19, 1997, Taipei
1997.

Gasser, Martin, '...really more like
Russia in feeling and look ...: Robert
Frank in Amerika,' in: Beat Schläpfer
(ed.), *Swiss made*, Zürich 1998,
pp. 79–92.

Persson, Hasse, 'Robert Frank.
Internationaler Fotografiepreis der
Hasselblad-Stiftung' in: *Hasselblad
Forum*, 1, 1997, pp. 34–35.

Sass, Ann, 'Robert Frank and the
Filmic Photograph,' in: *History of
Photography*, 22, 1998, 3,
pp. 247–253.

Penman, Ian, 'The Accident Keeps on
Happening,' in: *Dazed & Confused*,
1998 (September), pp. 88–93.

Thompson, David, 'The Rolling Stones.
Lights, Camera, Suction,' in: *MOJO
Music Magazine*, 78, 2000 (May),
pp. 48–53.

Films by Robert Frank

Order of credits:

Original title, country, & year of production
D: Director
S: Screenplay (based on …)
C: Camera
E: Editor
M:/Sd: Music/Sound
A:/Pt: Actors/Participants
N: Narrator (voice)
P: Production company/Producer
L: Length
F: Format
Pr: Premiere (place and date)
Note:

Pull My Daisy, USA 1959

D: Robert Frank, Alfred Leslie
S: Based on the 3. act of the play *The Beat Generation* by Jack Kerouac
C: Robert Frank
E: Leon Prochnik, Robert Frank, Alfred Leslie
M: Composer: David Amram; musicians: David Amram, Sahib Shahab, Arthur Phipps, Babs Gonzales, Jane Taylor, Al Harewood, Midhat Serbagi, Ronnie Roseman; *The Crazy Daisy* sung by Anita Ellis; lyrics by Allen Ginsberg, Jack Kerouac
A: Mooney Peebles [pseudonym of Richard Bellamy] (bishop), Allen Ginsberg (Allen Ginsberg), Peter Orlovsky (Peter Orlovsky), Gregory Corso (Jack Kerouac), Larry Rivers (Milo), Delphine Seyrig (Carolyn, Milo's wife), David Amram (Mez McGillicuddy), Alice Neel (mother of the bishop), Sally Gross (sister of the bishop), Denise Parker (girl in bed), Pablo Frank (little boy)

N: Jack Kerouac, improvisation based on his own texts
P: G-String Enterprises/ Walter Gutman
L: 28 min.
F: 16mm, b/w
Pr: 11/11(?)/1959 (Cinema 16, New York City)
Note: Awards: Best American experimental film (*Cinemages Magazin* 1959), 2nd Independent Film Award (*Film Culture* 4/26/1960)

The Sin of Jesus, USA 1961

D: Robert Frank
S: Howard Shulman, (based on a short story by Isaac Babel)
C: Gert Berliner
E: Robert Frank, Ken Collins
M: Morton Feldman
A: Julie Bovasso (angel), John Coe (angel), Roberts Blossom (angel), St. George Brian (angel), Telly Savalas (angel), Mary Frank (angel), Jonas Mekas (angel)
P: Off-Broadway Productions/ Jerry Michaels
L: 40 min.
F: 35mm, b/w
Pr: November 1960; 12/10/1961 (Murray Hill Theatre New York)
Note: The film was shot on George Segal's chicken farm in New Jersey.

O.K. End Here, USA 1963

D: Robert Frank
S: Marion Magid
C: Gert Berliner
E: Aram Avakian
A: Martino La Salle (man), Sue Ungaro

(wife), Sudie Bond (woman in restaurant), Anita Ellis (woman), Joseph Bird (her husband), and others, p. ex. Walter Gutman in the restaurant scene.
P: September 20 Productions/ Edwin Gregson
L: 30 min.
F: 35mm, b/w
Pr: September 1963 (Bergamo Film Festival/Italy); 9/14/1963 (First New York Film Festival, Lincoln Center)
Note: First prize at the Bergamo Film Festival

Me and My Brother, USA 1965–1968

D: Robert Frank
S: Robert Frank, Sam Shepard, Allen Ginsberg, Peter Orlovsky
C: Robert Frank
E: Robert Frank, Helen Silverstein, Bob Easton, Lynn Ratener
A: Julius Orlovsky (Julius Orlovsky), Joseph Chaiken (Julius Orlovsky), John Coe (psychiatrist), Allen Ginsberg (Allen Ginsberg), Peter Orlovsky (Peter Orlovsky), Virginia Kiser (social worker), Nancy Fish (Nancy Fish), Cynthia McAdams (actress), Roscoe Lee Browne (photographer), Christopher Walken (director, voice: Robert Frank), Seth Allen, Maria Tucci, Jack Greenbaum, Beth Porter, Fred Ainsworth, Richard Orzel, Phillipe La Prelle, Otis Young, Gregory Corso, Sally Boar, Joel Press, Louis Waldon
P: Two Faces Company/ Helen Silverstein
L: 91 min.
F: 35mm, b/w and color
Pr: 9/1/1968 Film Festival Venice (Italy); 2/2/1969 New York City

Conversations in Vermont, USA 1969

D: Robert Frank
C: Ralph Gibson
E: Robert Frank
Pt: Robert Frank, Pablo Frank, Andrea Frank
P: Dilexi Foundation/Robert Frank
L: 26 min.
F: 16mm, b/w
Pr: TV, Los Angeles
Note: Part of a twelve-part series produced by KQUED in San Francisco. There were no conditions imposed on the artists, either in regard to the length of the film, nor its subject matter. Other films in the series were commissioned from, or about, among others, Frank Zappa, Ann Halprin, Robert Nelson, Yvonne Rainer, Andy Warhol, and Walter de Maria. Two minutes of an untitled first film by Frank were integrated in this film.

Life–Raft–Earth, USA 1969

D: Robert Frank
C: Robert Frank
E: Susan Obenhaus
A: Robert Frank, Danny Lyon, Hugh Romney, Stewart Brand
P: Sweeney Productions/Robert Frank
L: 37 min.
F: 16mm, color and b/w

About Me: A Musical, USA 1969

D: Robert Frank
S: Robert Frank
C: Danny Seymour, Robert Frank
E: Robert Frank
A: Lynn Reyner (Robert Frank), Jaime deCarlo Lotts, Robert Schlee, Sheila Pavlo, Bill Hart, Vera Cochran,
Pt: Sid Kaplan, June Leaf, Allen Ginsberg
P: Robert Frank
L: 35 min.
F: 16mm, b/w
Note: Shot, among others, in a loft in New York City, in the mountains of New Mexico, and a prison in Texas. It was produced with the support of the American Film Institute. Some sequences were copied on tinted b/w film stock. An alternate title was 'About Me: A Musical Film About Life in New York.'

Cocksucker Blues, USA 1972

D: Robert Frank
C: Robert Frank, Danny Seymour
E: Robert Frank, Paul Justmann, Susan Steinberg
Pt: Mick Jagger, Keith Richard, Danny Seymour
P: Rolling Stones Presentation/Marshall Chess

L: 90 min.
F: 16mm, b/w and color
Note: This film was shot on the US-tour of the Rolling Stones in 1972. The film was commissioned and financed by the Rolling Stones.

Keep Busy, CAN 1975

D: Robert Frank, Rudy Wurlitzer
S: Rudy Wurlitzer
C: Robert Frank
E: Robert Frank
A: June Leaf, Joan Jonas, Richard Serra, Joanne Akalaitis, Joe Dan MacPherson
P: Canada Council
L: 38 min.
F: 16mm, b/w
Pr: Berkeley, CA
Note: Shot on an island off Cape Breton in Nova Scotia

Life Dances On..., USA 1980

D: Robert Frank
C: Robert Frank, Gary Hill, David Seymour
E: Gary Hill
Pt: Pablo Frank, Sandy Strawbridge, Marty Greenbaum, Billy, Finley Fryer, June Leaf
P: Robert Frank
L: 30 min.
F: 16mm, b/w and color
Note: The film includes an interview with Pablo Frank and his girlfriend Sandy Strawbridge.

Energy and How to Get It, USA 1981

D: Robert Frank, Rudy Wurlitzer, Gary Hill
S: Rudy Wurlitzer
C: Robert Frank, Gary Hill
E: Gary Hill
A/Pt: Robert Golka, Agnes Moon, Rudy Wurlitzer, William S. Burroughs, John Giorno, Robert Downey, Lynne Adams, Alan Moyle, Dr. John, Libby Titus
P: Robert Frank, Rudy Wurlitzer, Gary Hill
L: 28 min.
F: 16mm, b/w
Note: Shot in early 1981 in Utah. It was produced with the support of the Corporation for Public Broadcasting as a part of their Independent Anthropology Film Series.

This Song for Jack, USA 1985

D: Robert Frank
C: Robert Frank
E: Sam Edwards
Pt: Allen Ginsberg, Gregory Corso, William S. Burroughs, David Amram
P: Robert Frank

L: 30 min.
F: 16mm, b/w
Note: The film consists of material shot by Frank at the conference 'On the Road: The Jack Kerouac Conference,' July 27 to August 1, 1982, at the Naropa Institute, Boulder. At one of the first screenings, it was called 'Twenty five Years Since the Publication of On the Road;' in the catalogue of the 1984 Montreal Film Festival, it is listed as 'Dedicated to Jack Kerouac.' Another title is 'Dedicated to Jack Kerouac,' in reference to the song written and performed for this film by David Amram.

Home Improvements, USA 1985

D: Robert Frank
C: Robert Frank, June Leaf
E: Michael Biachi, Sam Edwards
Pt: Pablo Frank, June Leaf, Robert Frank
P: Robert Frank
L: 29 min. 20 sec.
F: 1/2'' video, color
Note: Shot in New York and Nova Scotia from November 1983 to March 1984. Abriged version of an earlier video.

Candy Mountain, CH, F, CAN 1987

D: Robert Frank, Rudy Wurlitzer
S: Rudy Wurlitzer
C: Pio Corradi
E: Jennifer Auge
A: Kevin O'Connor, Haffis Yulin, Tom Waits, Bulle Ogier, Roberts Blossom, Leon Redbone, Dr. John, Laurie Metcalf, Rita MacNeil, Joe Strummer, Arto Lindsay, David Johansen, Emile deAntonio
P: Xanadu Film, Les Films Plain-Chant, Les Films Vision 4 Inc./Ruth Waldburger
L: 91 min.
F: 35mm, color
Pr: New York

Hunter, D 1989

D: Robert Frank
S: Stefan Balint, Robert Frank
C: Clemens Steiger, Bernhard Lehner, Robert Frank (video)
E: Julie Gorchov
A: Stefan Balint, Günter Burchert
P: Kinemathek im Ruhrgebiet (A project of the Kulturstiftung Ruhr, Essen)/Paul Hofmann
L: 37 min.
F: 16mm/video, b/w and color
Pr: Kinemathek Duisburg

Run/New Order, USA 1989

D: Robert Frank
C: Robert Frank
E: Laura Israel
L: ca. 3 min. 30 sec.
F: 16mm, color and b/w
Note: Music video for 'Run' by
New Order

C'est vrai (One Hour), F 1990

D: Robert Frank
S: Robert Frank, Michal Rovner
C: Robert Frank
Pt: Kevin O'Conner, Peter Orlovsky,
Taylor Mead, Willoughby Sharp, Bill
Rice, Tom Jarmusch, Zsigmond
Kirschen, Sid Kaplan, Odessa Taft,
Sarah Penn, Margo Grib
P: La Sept, Prony Production,
Paris/Philippe Grandrieux
L: 60 min.
F: Video, color
P: La Sept (French TV station)

Last Supper, CH, GB 1992

D: Robert Frank
S: Sam North, Robert Frank,
Michael Rovner
C: Kevin Kerslake, Mustapha Barat
(video), Robert Frank (video)
E: Jay Rabinow
Pt: Zohra Lampert, Bill Youmans,
Bill Rice, Taylor Mead, John Lakin,
Odessa Taft
P: Vega Film, Zürich; Word Wide
International Television/Ruth
Waldburger, Martin Rosenbaum
L: 52 min.
F: 16mm, color

Moving Pictures, USA 1994

D: Robert Frank
C: Robert Frank
E: Laura Israel
Pt: Allen Ginsberg, Raoul Hague, Harry
Smith, June Leaf a.o.
P: Vega Film, Zürich
L: 16 min. 30 sec.
F: Film/video, color and b/w, silent
Pr: National Gallery of Art,
Washington, D.C.
Note: Collected footage of Allen
Ginsberg, Raoul Hague, Harry Smith,
June Leaf a.o.

The Present, CH 1996

D: Robert Frank
C: Robert Frank, Paulo Nozolino
E: Laura Israel
P: Ruth Waldburger
L: 27 min.
F: Video/film, color
Pr: New York

Summer Cannibals/Patti Smith, USA 1996

D: Robert Frank
C: Kevin Kerslake
E: Laura Israel
M: Patti Smith
Pt: Patti Smith & Band
L: 5 min.
F: 35mm, b/w
Note: Music video for 'Summer
Cannibals' by Patti Smith

Flamingo, CAN 1996

D: Robert Frank
C: Robert Frank
E: Laura Israel
N: Miranda Dali
P: Robert Frank
L: 5 min.
F: Video, b/w
Pr: Hasselblad Award Ceremony,
Göteborg, Sweden
Note: Produced for the Hasselblad
Award ceremony

I remember (Stieglitz), CAN 1998

D: Robert Frank
C: Jerome Sother
E: Laura Israel
Pt: Robert Frank, June Leaf,
Jerome Sother
P: Robert Frank
L: 7 min.
F: Video

San Yu, CH, F 2000

D: Robert Frank
C: Robert Frank,
Paolo Nozolino (b/w)
E: Laura Israel
A: Nikolaï Boldaïen
P: Vega Film/Paris: Yves Rion,
Didier Fouquier
L: 27 min.
F: Video and 35mm film (b/w)
P: Film Festival Locarno

Compiled by Tanja Maciosek

List of Exhibited Works

Unless otherwise noted:
- The photographs were printed
at a later date.
- Height x width (size of image
x size of paper)
- Signature and captions are on the
recto of the photograph.
- The works are from the collection of
Robert Frank/Courtesy Pace/MacGill.

v: vintage print
u: unique work of art

Park Avenue Rolls Royce, New York
1948, v
silver-gelatin print mounted on fibre-
board
91,4 x 61 cm

Doll, New York
1949, v
silver-gelatin print
35,4 x 20,6 cm
Museum Folkwang, Essen
Inv. 47/96

*Blind Couple, Central Park New York
City*
1949-50, v
12 silver-gelatin prints
15,4 x 23,5 cm (20,9 x 25,2 cm) each
signed and dated on verso
Collection Manfred Heiting,
Amsterdam

City of London
1951, v
silver-gelatin print
23,3 x 15,4 cm
National Gallery of Art, Washington,
D.C., Robert Frank Collection, gift of
The Howard Gilman Foundation on the
50th anniversary of the National
Gallery of Art
Inv. 1994.23.4

London
1951, v
2 silver-gelatin prints of two
negatives each
30 x 35,3 cm
signed, with date and title on verso

Tickertape/ New York City
1951, v
silver-gelatin print
35,1 x 25,4 cm (35,2 x 31,4 cm)
National Gallery of Art, Washington,
D.C., Robert Frank Collection, gift of
the artist on the 50th anniversary of
the National Gallery of Art
Inv. 1990.28.29.7

London
1952, v
silver-gelatin print
34,2 x 18,9 cm (34,5 x 27,8 cm)
National Gallery of Art, Washington,
D.C., Robert Frank Collection, gift of
The Howard Gilman Foundation on the
50th anniversary of the National
Gallery of Art
Inv. 1994.23.1

London
1952, v
silver-gelatin print
23,3 x 15,2 cm (29,7 x 23,8 cm)
National Gallery of Art, Washington,
D.C., Robert Frank Collection, gift of
The Howard Gilman Foundation on the
50th anniversary of the National
Gallery of Art
Inv. 1990.23.2

London
1952, v
silver-gelatin print
34,1 x 21 cm
National Gallery of Art, Washington,
D.C., Robert Frank Collection, gift of

The Howard Gilman Foundation on the
50th anniversary of the National
Gallery of Art
Inv. 1994.23.3

*White Tower, 14th Street, New York
City*
before 1955
silver-gelatin print
18 x 24,6 cm
Museum Folkwang, Essen
Convolute »Family of Man«
Inv. 219/281

Detroit Movie House
1955
silver-gelatin print mounted on card-
board
91,4 x 60,3 cm (100,7 x 70,5 cm)

Hoboken, New Jersey
1955
silver-gelatin print
31,8 x 47,6 cm (40,6 x 50,8 cm)

Hoover Dam, Nevada
1955
silver-gelatin print
37,8 x 25,5 cm
Museum Folkwang, Essen
Inv. 76/86

*Port Gibson, Mississippi:
in front of the High School*
September 1955
silver-gelatin print
23,5 x 34,7 cm
Museum Folkwang, Essen
Inv. 220/88

Texaco Café, Texas
1955
silver-gelatin print of two negatives
46,4 x 34,3 cm (50,8 x 40,6 cm)
signed and dated

William S., New York
1955
silver-gelatin print mounted on card-
board
91,1 x 60 cm (100,6 x 70,2 cm)

Andrea and Pablo, Los Angeles
1955-56
silver-gelatin print
31,7 x 21,2 cm (35,2 x 27,8 cm)
signed, with title

Pin-up
ca. 1955-1956
silver-gelatin print mounted on card-
board
60 x 90,8 cm (70,5 x 100,6 cm)

Los Angeles
1956
silver-gelatin print mounted on card-
board
60,3 x 90,8 cm (70,5 x 100,3 cm)

Los Angeles
1956
silver-gelatin print mounted on card-
board
90,8 x 60,3 cm (100,3 x 70,5 cm)

Postcards, Long Beach
1956
silver-gelatin print mounted on card-
board
93,7 x 60,3 cm (101 x 70,3 cm)

*Pennsylvania Avenue, Washington,
D.C.*
1957
silver-gelatin print
30,6 x 45,6 cm (40,6 x 50,8 cm)
signed, with title

From the Bus, New York
1958, v
silver-gelatin print
26,1 x 17,5 cm (35,3 x 27,8 cm)
signed on verso in green ink

From the Bus, New York
1958, v
silver-gelatin print mounted on fibre-
board
26,2 x 17,5 cm (35,1 x 27,3 cm)
on verso: sticker of the Museum of
Modern Art, New York City

From the Bus, New York
1958, v
silver-gelatin print mounted on fibre-
board
26,2 x 17,5 cm (35 x 27 cm)
on verso: sticker of the Museum of
Modern Art, New York City

From the Bus, New York
1958, v
silver-gelatin print mounted on fibre-
board
26,3 x 17,6 cm (35,2 x 27,1 cm)
on verso: sticker of the Museum of
Modern Art, New York City

From the Bus, New York
1958, v
silver-gelatin print
26,4 x 17,8 cm (35,4 x 27,5 cm)
signed on verso in green ink

From the Bus, New York
1958, v
silver-gelatin print
26,2 x 17,8 cm (35,6 x 28 cm)
signed on verso in green ink

From the Bus, New York
1958, v
silver-gelatin print
26,4 x 17,8 cm (35,4 x 27,8 cm)
signed on verso in green ink

From the Bus, New York
1958, v
silver-gelatin print
26,3 x 17,7 cm (35,3 x 27,7 cm)
signed on verso in green ink

Pull My Daisy
1959, v
silver-gelatin print
34,3 x 27,5 cm (35,6 x 28,3 cm)
signed and dated on verso with black
felt-tip pen, date and title on verso in
green felt-tip pen

From: The Sin of Jesus
1961
silver-gelatin print
50,8 x 32,7 cm (50,8 x 40,6 cm)
signed, with caption 'Winter Footage
Mabou'

Washington
1961/1966
silver-gelatin print
43,2 x 35,6 cm

Provincetown
1962
silver-gelatin print
36,7 x 24,3 cm (40,6 x 30,5 cm)
signed, with title

William Buckley
1962, U
silver-gelatin print
40,5 x 50,5 cm
signed, with date and caption
'This Buckley not aware
the camera is running'

From: Me and My Brother
1964, U
Collage
silver-gelatin print and typewritten
strip of paper
61 x 50,8 cm
signed, with date and title

From: Me and My Brother
1964, v U
Collage
9 silver-gelatin prints mounted on
cardboard

32 x 61 cm (40,6 x 68,6 cm)
title on cardboard

Me and My Brother
1964-1968
silver-gelatin print
50,8 x 48,9 cm (61 x 50,8 cm)
signed, with date and title in green
ink, date and title on verso

Me and My Brother
1964-1968
silver-gelatin print
36,5 x 45,7 cm (40,6 x 50,8 cm)
signed, with date and title

Me and My Brother
1965
silver-gelatin print
33,2 x 26,4 cm (35,4 x 27,9 cm)
signed, with date and title

Me and My Brother
1965-68, v
silver-gelatin print
35,5 x 27,5 cm
signed, with date and title on verso

Conversations in Vermont
1969
silver-gelatin print
34,6 x 26,7 cm (35,3 x 27,9 cm)
signed, with date and title

Conversations in Vermont
1969
silver-gelatin print
58,4 x 48,3 cm (61 x 50,8 cm)
signed, with date and title on verso

*Goodbye Mr. Brodovitch - I'm Leaving
New York, December 23, 1971*
1971, U
silver-gelatin print
35,6 x 47 cm (40,6 x 50,8 cm)
signed with ball point pen, with date
and title on verso

Cocksucker Blues
1972, v
silver-gelatin print
32,6 x 26,3 cm (35,2 x 27,8 cm)
signed, with date and title

Bonjour–Maestro, Mabou
1974
silver-gelatin print
21,4 x 27,6 cm
signed and dated on verso with ball-
point pen

Monument for my Daughter Andrea
April 21, 1954/December 28, 1974, U
4 Polaroids on an album page covered
with transparent film
10,8 x 8,6 cm each (30 x 38,5 cm
total)
with date and title on transparent film

Fantastic Sandwiches,
Venice, California
1975
silver-gelatin print of 6 Polaroid
negatives
47 x 40 cm (50,5 x 40,5 cm)

June and Blind Man from: *Life Dances*
On
1975
silver-gelatin print
32,4 x 15,2 cm (35,4 x 27,5 cm)
signed, with date and title

Energy and How to Get It
1977
silver-gelatin print
29,8 cm x 13,5 cm (35,4 x 27,7 cm)
with date and title

In Mabou—Wonderful Time—
With June
June 1977
Collage with 11 chromogenic C-prints
and writing paper mounted on
cardboard
40,5 x 48,5 cm
signed, with title

Mabou
1977, U
silver-gelatin print of two negatives
40,6 x 50,8 cm

Mabou Winter Footage
1977
silver-gelatin print and red paint
61 x 50,8 cm
signed, with date and title in blue ink

Halifax Infirmary
1978, U
silver-gelatin print of 13 Polaroid
negatives and blue paint
50,5 x 40,6 cm
signed and dated

Mabou
1978
silver-gelatin print of Polaroid nega-
tive
41,6 x 32,4 cm (50,8 x 40,6 cm)
signed, with date and title

Sick of Goodby's, Mabou
November 1978
silver-gelatin print
48,3 x 33 cm (50,8 x 40,6 cm)
signed and dated, signed on verso

Brattleboro, Vermont,
December 24, 1979
1979
silver-gelatin print of Polaroid negative
33,4 x 44,4 cm (40,4 x 50,8 cm)

Look Out for Hope, Mabou—
New York City
1979
silver-gelatin print of 3 Polaroid
negatives
60,6 x 50,8 cm

Los Angeles—February 4—
I Wake Up—Turn On TV
1979
silver-gelatin print of 2 Polaroid
negatives
50,7 x 35,6 cm (50,8 x 40,8 cm)
signed and dated

Pablo, Santa Cruz
1979
silver-gelatin print of Polaroid nega-
tive
34,4 x 25,9 cm (35,6 x 27,9 cm)

The Sunrise Over the Million Dollar
Hotel, Downtown, March 29, 1979
1979, U
ink drawing on paper
21,5 x 27,8 cm
with date and title

June and the Blind Man
from: Life Dances On
1980
silver-gelatin print
35 x 26,9 cm (35,4 x 27,7 cm)
with monogram, date, and title

Mabou
1981
silver-gelatin print of two Polaroid
negatives
49,2 x 32,4 cm (50,8 x 40,6 cm)

Boston, March 20, 1985
1985
6 Polaroid Polacolors and
white/gray paint
65,8 x 55,8 cm each

Robert Frank and June Leaf
The Mail Box at the Road to
Findlay Point, Mabou, Cape Breton,
Nova Scotia,
Autumn 1976/1985, U
7 silver-gelatin prints and paint on
paper
17,1 x 78,1 cm (65,9 x 102,5 cm)
signed by Robert Frank and June Leaf,
with date and caption '1985'

Fear—No Fear, Mabou, Nova Scotia
1987
3 silver-gelatin prints of Polaroid
neagtives
ca. 37,5 x 50,5 cm each (114 x 50,5 cm
total)
signed, with date and title
on verso in red crayon

Monday Morning in Mabou
(Old Snapper)
January 5, 1988
silver-gelatin print of 2 Polaroid
negatives
32 x 48,9 cm (40,6 x 50,8 cm)
signed, with date and title

Mute/Blind
1989, U
collage with silver-gelatin prints and
thermopaper prints

104,5 x 81,5 x 5,1 cm
National Gallery of Art, Washington,
D.C., Robert Frank Collection, gift of
Isabel und Fernando Garzoni,
Switzerland, on the 50th anniversary
of the National Gallery of Art
Inv. 1990.103.1

Untitled
1989, U
collage with silver-gelatin prints and
thermopaper prints
101,9 x 76,5 16,8 cm
National Gallery of Art, Washington,
D.C., gift of Isabel und Fernando
Garzoni, Switzerland, on the 50th
anniversary of the National Gallery of
Art
Inv. 1990.103.2

Lebanon
November 18–28, 1991, U
silver-gelatin print and black ink
50,8 x 61 cm
signed, with date and title

St. Ritas Hospital #401,
Sidney, Nova Scotia
January 20, 1991
two silver-gelatin prints of
4 Polaroid negatives each
47,3 x 59,4 cm each (94,6 x 59,4 cm
total)
signed

St. Ritas Hospital #401, Nova Scotia,
January 20, 1991, U
6 s/w-Polaroids mounted on gray
paper and blank greeting card
ca. 7,5 x 9,5 cm each (32 x 22 cm
total)
with date and title

End of Dream, Mabou
May 1992, U
collage with 3 silver-gelatin prints, 6
C-Prints and paint
50,8 x 119,4 cm
signed, with date and title

Fear of Cancer—Year of the Squirrel
1992, U
2 silver-gelatin prints of 3 Polaroid
negatives and black ink
60,7 x 100,6 cm
with handwritten caption 'Take Care
Now'

New York City, 7 Bleecker Street
September 1993
silver-gelatin print of Polaroid nega-
tive
35,6 x 45,7 cm (40,6 x 50,8 cm)
signed, with title

Bowery Drinking Fountain
1994
silver-gelatin print of two Polaroid
negatives
50,8 x 40,6 cm

Mabou
1994
3 silver-gelatin prints of Polaroid negatives
50,5 x 40,5 cm each (50,8 x 122,6 cm total)
each signed, with date and title

Untitled (Keep Busy)
1994
silver-gelatin print
33 x 49,2 cm (40,6 x 50,8 cm)

The Suffering, the Silence of Pablo
1995, U
silver-gelatin print of Polaroid negative and black and white paint
41,6 x 32,7 cm (50,8 x 40,6 cm)

(no projector could do justice...)
1996, U
collage with 4 silver-gelatin prints of Polaroid negatives and typewritten strips of paper, mounted on cardboard
23,6 x 30,6 cm each (54,6 x 67,3 cm total)
signed and dated

Untitled
September 1996
2 silver-gelatin prints of 4 Polaroid negatives
40,6 x 91,4 cm
signed and dated

Possessions and Souvenirs
from: Flamingo, Göteborg
March 7, 1997, U
2 silver-gelatin prints of 2 Polaroid negatives each, green paper and white paint
46,7 x 34,7 cm each (46,7 x 69,5 cm total)
signed, with date and title in white ink

Explain My Roots
1997
2 silver-gelatin prints of 2 Polaroid negatives each
47 x 35,5 cm each (47 x 71,1 cm total)
signed, with date and caption 'in Mabou N.S.'

The War is Over
August 24, 1998, U
silver-gelatin print of negatives and green paint
43,2 x 37,1 cm (50,8 x 40,6 cm)
signed, with date and caption 'Canada'

They Will Travel with You
Mabou 1998
silver-gelatin print of 2 Polaroid negatives
50,8 x 61 cm
signed, with date and title in green ink

What is Sin?
1999
4 silver-gelatin prints of Polaroid negatives mounted on cardboard

70 x 54,5 cm (81,3 x 66,7 cm)
signed and dated

Tools—For My Mother and for W.E.
1999–2000
4 Silver-gelatin prints of 2 Polaroid negatives each
38,5 x 59,9 cm each (50,2 x 60,5 cm total)

Tools—Days-For My Mother and for W.E.
1999–2000
8 b/w Polaroids mounted on cardboard
ca. 10,2 x 8 cm each (28,5 x 36,5 cm total)
with date and title

Books/Publications

40 Fotos
1946
originally spiral-bound book with 40 vintage silver-gelatin prints
22,9 x 17,1 cm
signed, with title in blue ink on fly-leaf

Peru
1948
spiral-bound book with 39 vintage silver-gelatin prints
20 x 26 cm
National Gallery of Art, Washington, D.C., Robert Frank Collection, gift of the artist
Inv. 1996.147.7

Les Américains
(Robert Delpire), Paris 1958
19,2 x 21,7 cm
Private Collection

The Americans
(Grove Press), New York City 1959
19,2 x 20,7 cm
Collection Eugen Küpper

New York Is.
(New York Times Inc.), New York City
n.d. [1959]
29 x 21,5 cm
Fotomuseum Winterthur/Switzerland

Zero Mostel Reads A Book
(New York Times Inc.), New York City
1963
22,3 x 15,3 cm
Private Collection

The Lines of My Hand
(Yugensha), Tokyo 1972
35 x 26 cm (slipcase 35,7 x 26,8 cm)
Museum Folkwang

The Lines of My Hand
(Lustrum Press), New York City 1972
30,5 x 22,7 cm
Private Collection

Rolling Stones
Exile on Main St.
1972
record cover and 2 sleeves
print
31 x 31,9 cm (sleeves 30,8 x 30,8 cm each)
Private Collection

Flower is Paris, Ford is Detroit, Mabou is Waiting
(Yugensha), Tokyo 1987
35 x 26 cm (slip case 36 x 26,5 cm)
Collection Eugen Küpper

Sixth Sense, Number 4
(Comme des Garçons Co., Ldt., Atsuko Kozasu), Tokyo 1989
39,5 x 29,7 cm
Museum Folkwang

Black White and Things
(National Gallery of Art, Washington, D.C., and Scalo), Zürich 1994
27,7 x 26,4 cm
Museum Folkwang

Films

Conversations in Vermont
1969, 26 min.
Collection of the artist

Life Dances On
1980, 30 min.
Collection of the artist

Home Improvements
1985, 29 min. 20 sec.
Collection of the artist

C'est vrai (One Hour)
1990, 60 min.
Collection of the artist

Moving Pictures
1994, 16 min. 30 sec.
Collection of the artist

Flamingo
1996, 5 min.
Collection of the artist

I remember (Stieglitz)
1998, 7 min.
Collection of the artist

Museum Folkwang, Essen
December 10, 2000–February 11, 2001

Museo Nacional Centro de Arte
Reina Sofia, Madrid
April 10–June 18, 2001

Centro Cultural de Belém
September 15–November 15, 2001

Conception and realization:
Ute Eskildsen

Assistants:
Simone Förster
Fellow of 'Museumskuratoren für Fotografie'
of the Alfried Krupp von Bohlen und Halbach
Foundation

Curatorial consultants:
Robert Knodt, Christiane König

Secretary:
Gabriele Barth

Organizational assistance:
Horst Biernatzki, Petra Thetard

Reproductions:
Jens Nober, John Back

DVD Producer:
Laura Israel

Carpenter:
Friedhelm Kremer, Susan Rück

Design:
i.de–Sabine an Huef

Scans:
Steidl, Schwab Scantechnik GbR, Göttingen

Translation:
Martin Jaeggi

Production:
Bernard Fischer

Printing:
Steidl, Göttingen

First Scalo Edition 2001
ISBN 3-908247-40-3
Printed in Germany

Front cover:
From
Tools - For My Mother and for W. E.,
1999-2000

Back cover:
Daniel Seymour, 1972